STRANGER THINGS

CONTENTS

FOREWORD

DO YOU copy? This book is for nerds. Repeat. This book is for *nerds*.

So if you're reading this right now, congratulations—you're a *nerd!* Watching our nerdy show apparently wasn't enough for you. You wanted—scratch that, *needed*—to know *how* it was made, which is the kind of thought process we love. And it's why we, as fellow nerds, were so excited when we were told about this making-of book!

When we were kids, one of our favorite Christmas presents was an oversized, glossy hardcover book called *Industrial Light & Magic: Into the Digital Realm*. It detailed the history of ILM's visual effects with pages and pages of incredible behind-the-scenes photographs featuring *Star Wars* models, CG *Jurassic Park* dinosaurs, and *Ghostbusters* puppets, and, well, pretty much everything cool. Keep in mind that this was back in the dark ages of 1996, when the internet moved at the speed of a snail and DVDs didn't yet exist, meaning it was a lot harder to figure out how movies were made. So for movie fanatics like us, this book offered a very rare glimpse behind the curtain of our favorite films, showing in great detail how this company pulled off what we consider to be the greatest magic tricks of our time. Perhaps what surprised us most was the sheer number of artists it took to create these images, to tell these stories.

This was something of an epiphany for us; before this book, we thought that everything sprung from the mind of the director, an auteur. But this was simply not true; it was, in fact, impossible. And the more we studied the art of visual storytelling, the more we began to understand it as a collaborative medium. In particular, the types of stories we love—which so often tend toward the fantastical—cannot be produced by a single artist. They in fact require an *army of artists*. And the same has certainly held true of *Stranger Things*.

We came up with the initial idea for *Stranger Things* in the fall of 2013. So you could say it all began with just us, but that would be disingenuous, as our story was inspired by the work of so many artists before us, most notably Steven Spielberg and Stephen King. We weren't collaborating with them in the traditional sense, but it felt like we were very much in conversation with

them. We like to think they, too, had been in conversation with the artists who had come before them.

After writing our pilot script, we began a more traditional collaboration, joining forces with two incredible producers—Shawn Levy (a mentor as well as producer and director on the show) and Dan Cohen (who was the first "stranger" to believe in the potential of this crazy idea). Shawn and Dan gave our script some clout, and, after a week of rejections, the script somewhat accidentally found its way to Netflix. They bought the project the following day.

Once Netflix was on board, the team grew quickly and dramatically, with more artists joining every day. Before we knew it, over a hundred artists had joined. These artists came from almost every imaginable creative field— they were actors, writers, editors, production designers, cinematographers, costume designers, hair designers, colorists, visual effects artists, painters, musicians, and so much more. Through collaboration among so many artists from such varied disciplines, the show naturally began to evolve, becoming something different—and far greater—than what we had envisioned initially. This was no longer just our vision; it was a collective vision.

Take our favorite scene from season one: Eleven confronts the Demogorgon in Mr. Clarke's classroom. You have Kimberly Adams's costume for Eleven: a pink prairie dress, high socks, and sneakers, a look which was mimicked by countless children on Halloween. You have Tim Ives's flickering lights, staggered to allow for darkness *and* clarity. You have Kyle Dixon and Michael Stein's synth score, which played the scene for emotion rather than horror. You have Chris Trujillo's and Jess Royal's beautifully designed classroom, where even the smallest detail had been carefully considered. You have the Demogorgon design by Aaron Sims, masterfully animated to convey a human-like fear and vulnerability. And, of course, you have the performances: Millie Bobby Brown, conveying a world of feeling with just her eyes, and Finn Wolfhard, shedding a single tear as he watches his first love vanish into thin air. And that is just a small list of the artists responsible for bringing that scene to your screen.

This kind of intensive collaboration took place on every *single* scene in the show. It is, of course, easy now to say that all of these decisions were well thought out and perfectly coordinated, but the truth is that we were *all* just sort of figuring it out as we went; no one was totally sure *what* finished form the show would ultimately take. We just all thought it was . . . *cool.* But how

would it all work together? What . . . *was it exactly?* The answer to that question came slowly. It took so long to finish the show, for all the pieces to lock into place, that we barely realized it happened. But, eventually, it did: a distinct and cohesive shape formed—a look, tone, pace, and feel that reflected the spirit of *everyone* who touched it along the way. It became the show you now know. It became *Stranger Things*.

Stranger Things was finally released to the world in July of 2016. We were all proud of the finished product, but we were all so close to it that we didn't have any idea how or even *if* it would resonate with anyone outside of our *Stranger* family. Some of us were cautiously optimistic; others . . . less so. The brilliant David Harbour, who lives in New York, saw no subway ads and therefore became convinced the show was bound for failure. He buzzed his hair, holed up in his apartment, and stayed off the internet.

We were similarly convinced of looming failure, but after some prodding from our friends, we tiptoed onto Twitter. What we found shocked us; not only did people seem to like the show, many had already finished it! Feeling emboldened, we continued to track the social media response for the next several weeks, reading what the fans had responded to, what they *didn't* respond to, oohing and aahing over the amazing fan art, analyzing their theories, and, of course, watching in shock as the rally for Barb's justice continues to grow in fervor and size.

We're not sure at exactly what point we allowed ourselves to believe that the show was more than a niche success—though it *may* very well have been a giant mural of Barb in Melbourne—but we have never felt such relief, or such gratitude, in our lives. It turned out we had a surprising new companion on this journey with us: *the fans*. For us, it was a dream come true.

So this book is for you, for joining us on this journey and continuing to inspire us; it's for all of the incredible artists who have worked so hard and so passionately to bring this story to life; and, perhaps above all, it's for anyone who dreams for a living or *dreams* of dreaming for a living. Because this world needs more storytellers. It needs more dreamers. And yes, it needs more *nerds*.

So welcome aboard this curiosity voyage, nerd. We're glad to have you.

Over and out,
ROSS AND MATT

PROLOGUE
BEFORE *STRANGER THINGS*

I T WAS impossible to know it at the time, but it was Tim Burton's journey to Gotham City that led Eleven to Hawkins, Indiana.

The year was 1989, and Matt and Ross Duffer were imaginative young boys living in Durham, North Carolina, when they began to see television ads for what looked like an extremely arresting story—a blockbuster retelling of the Dark Knight's crusade against the Joker. In an era before superheroes dominated the big and small screens, *Batman*[1] was the event movie of the summer. Advertising for the film was inescapable. The images of a masked vigilante flying through the streets of a fictional metropolis battling a leering clown with green hair and white skin against the backdrop of Danny Elfman's symphonic score captivated the twins.

"When we started to see TV commercials for Tim Burton's *Batman*, it looked like the most mind-blowing thing I'd ever seen," Matt Duffer says. "But we weren't allowed to see it—it was [rated] PG-13. About a year after it had come out, once it was on VHS, we were so annoying to our parents that we finally got to see this movie. It lived up to our expectations and then some. That was really the first time we realized what a movie director was— Tim Burton's style was just so distinct. Then we started to watch all of his films. His visual style, his art direction, the music in those films really have a very personal stamp on them."

1 Michael Keaton donned the cape and cowl of the iconic comic-book hero for Tim Burton's landmark superhero film. Years later, the Duffers would cast Keaton's *Beetlejuice* costar, Winona Ryder, in their breakout Netflix series.

From then on, the Duffer brothers knew that they, too, wanted to make movies. So they did, crafting elaborate two-hour adventures for their toys. "Initially, we didn't have a camera or anything," Matt says. "We were just playing with our toys, but we knew movies were about two hours long, so we would put a timer on for two hours and then sort of improvise a movie. We were training very early on to tell a story in a two-hour time frame."

When they were in third grade, they received a camera[2] as a Christmas gift, and their productions became slightly more elaborate—or at least, as elaborate as films made by elementary-school students starring stuffed animals could be. Says Matt, "We made something called the *Stuffed Father Trilogy*. We'd not even seen *The Godfather*, but it was our dad's favorite movie. So we took the title and made these silly little movies starring our stuffed animals as mobsters."

Their first feature-length film was based around *Magic: The Gathering*,[3] the collectible-trading-card game centered on battling wizards that had become something of an obsession for young Matt and Ross. The brothers recruited Tristan Smith, their best friend and next-door neighbor, to star in and codirect the production. "It was mostly just us hitting each other with plastic swords," Matt says. "It's pretty unwatchable."

By the time they reached middle school, the brothers had branched into comedies. Eventually, though, they began to develop a fascination with darker storytelling, which led them to the novels of Stephen King and classic horror cinema. The 1996 Wes Craven hit *Scream*, which carefully walked the line between horror and comedy as it referenced various genre landmarks, sparked in the Duffers a strong desire to revisit not only Craven's

2 In the decades before smartphones granted everyone access to moviemaking technology, a handheld video camera was the gateway to a film career. But the portable devices didn't come cheap: the average model cost several hundred dollars. In *Stranger Things 2*, a then-state-of-the-art camcorder captures otherworldly footage on Halloween night.
3 Call it the 1990s answer to *Dungeons & Dragons*. First produced in 1993, *Magic: The Gathering* involves two or more players acting as wizards, using cards to cast spells and summon creatures to fight on their behalf. If *Stranger Things* had been set a decade later, you can bet Mike Wheeler and his pals surely would have loved it.

STRANGER THINGS

WORLDS TURNED UPSIDE DOWN

Foreword by
MATT AND ROSS DUFFER

Afterword by SHAWN LEVY *Written with* GINA MCINTYRE

DEL REY · MELCHER MEDIA
New York

Published in the United States by Del Rey,
an imprint of Random House, a division of Penguin
Random House LLC, New York.

Photo credits, which constitute an extension of this
copyright page, appear on page 224.

Del Rey and the Del Rey colophon are registered
trademarks of Penguin Random House LLC.

ISBN 978-1-984-81742-6
Library of Congress Control Number: 2018951519

Printed in China

randomhousebooks.com

987654321

First Edition

This book was produced by Melcher Media, Inc.
MELCHER.COM

Cover and interior design by Paul Kepple and
Alex Bruce at Headcase Design
HEADCASEDESIGN.COM

Set in Plantin and ITC Benguiat

earlier films, but also movies made by such visionaries as John Carpenter, David Cronenberg, and Sam Raimi.

Raimi's *Evil Dead* movies—*The Evil Dead*[4] in 1981, and *Evil Dead II* in 1987—proved especially influential. When the Michigan-born director was twenty-one years old, he and his friends had created the ultimate DIY exercise in fear by scraping together all the money they could, heading to a remote cabin in the Tennessee woods, and unleashing hell on the screen with a tale of demonic forces out of control. "Sam Raimi, like Tim Burton, has a very sort of aggressive visual style," Matt Duffer says. "We started to try to emulate that with our video camera. We made all these sort of *Evil Dead*–style horror shorts in high school."

Using readily accessible filmmaking software such as iMovie, Matt and Ross Duffer began to craft short films with a more polished finish. The twins dreamed of attending the prestigious film school at the University of Southern California in Los Angeles, the alma mater of directors George Lucas, Robert Zemeckis, and John Carpenter, among many others. The thinking was that going to school on the West Coast would help a pair of brothers from North Carolina make the all-important connections that might lead toward a career in Hollywood. "We were pretty young and pretty naïve about things, but we were right about that," Matt Duffer says.

Although they weren't accepted into USC's film school, they did make it to Chapman University's Dodge College of Film and Media Arts in Orange, California, a private institution with fewer than 9,500 students. During their undergraduate days, the Duffers began to focus on screenwriting; before that, their films had been improvised with friends. "It was a lot of trial and error, trying to figure out how to structure a story," Ross Duffer says.

4 Banned for years in the United Kingdom, *The Evil Dead* starred a baby-faced Bruce Campbell in a lo-fi tale of terror; the action kicks into high gear after demon-resurrection passages are read aloud from a *Necronomicon Ex-Mortis,* the book of the dead. (A poster for the film is prominently featured in Jonathan Byers's bedroom.) Motifs from *The Evil Dead* pop up in *Stranger Things*: the cabin in the woods that harbors deep secrets under its floorboards, otherworldly monsters who slip in and out of our dimension, and a protagonist who wields household tools as weapons of defense. The 1987 sequel took a more overtly comedic tone, which was amplified further in Raimi's 1992 follow-up *Army of Darkness*. The original was remade in 2013; it also spawned a TV series, *Ash vs. Evil Dead*, two years later.

VIDEO NIGHT

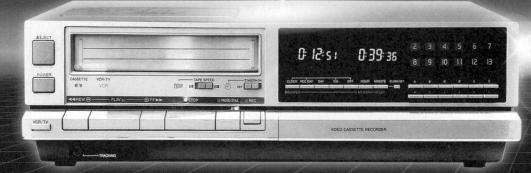

DON'T SETTLE FOR SECOND-RATE INSPIRATION.
YOU DESERVE BETA.

From the time Matt and Ross Duffer were in grade school, they knew they wanted to become filmmakers—their passion for the art form was influenced greatly by some of the cutting-edge directors who got their start in the 1970s and '80s crafting unforgettable sci-fi, horror, and fantasy films. Sometimes, though, getting the opportunity to actually see the films required a little ingenuity. "With *The Evil Dead*, we tricked our mom so she would rent it for us. I told her it was unrated, but Leonard Maltin said it would be PG-13, which is just not true," Matt Duffer says. "We were sneaky children." (In that era, the Duffers would have been watching movies on videotape with a VCR similar to the one shown above.) Reviewing these now-classic titles, it's easy to see the ways in which some of the ideas and imagery would become embedded in the brothers' imaginations and help inspire *Stranger Things*.

MATT'S PICKS

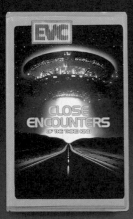

CLOSE ENCOUNTERS OF THE THIRD KIND (1977)

An exemplary achievement in Spielberg's nearly unrivaled filmography. The story of an Indiana everyman (Richard Dreyfuss) whose life is forever changed by a visitation from another sphere, *Close Encounters* informed many of Matt Duffer and Ross Duffer's ideas about visual language on-screen and helped them hone their cinematic style.

ALTERED STATES (1980)

A science-heavy spin on *Dr. Jekyll and Mr. Hyde*. William Hurt stars in director Ken Russell's trippy, cerebral sci-fi thriller about a Harvard scientist whose renegade experiments—involving hallucinogenic substances and an isolation tank—trigger a surprising physical regression. The film's lab-set sequences would help guide the eventual look of the interiors of Hawkins National Laboratory.

THE EVIL DEAD (1981)

A group of friends heads to a remote cabin for a carefree getaway and are plunged into a living nightmare after unwittingly unleashing an ancient evil. Sam Raimi's dizzying debut was made for next to nothing and went on to earn great notoriety for its inventiveness and gleefully transgressive edge. As teenagers, the Duffers became devoted fans of the horror classic—falling hard for the film's brazen, bratty splatter style.

E.T. THE EXTRA-TERRESTRIAL (1982)

The story of a strange visitor from another world who is taken in by a young boy. As their friendship solidifies, they begin to share a psychic connection—but the boy must go to great lengths to shelter his buddy from both his mom and government agents. Recognized as one of Steven Spielberg's greatest achievements, *E.T.* serves as a foundational text for *Stranger Things* in tone and tenor.

ROSS'S PICKS

THE THING (1982)

An expedition to the Antarctic proves deadly for a team of scientists led by Kurt Russell. John Carpenter's legendary update on the 1951 sci-fi favorite *The Thing from Another World* has become recognized as a standard-bearer. Rob Bottin's revolutionary special effects were achieved in-camera, an approach the Duffer brothers borrowed in their early episodes.

ALIEN (1979)

Ridley Scott's masterful film stands as the ultimate exercise in outer-space horror. Its Xenomorph monster influenced the design of the Demogorgon. Sigourney Weaver reprises her signature role as traumatized warrant officer Ellen Ripley in James Cameron's follow-up, *Aliens* (1986). The film featured future *Stranger Things* star Paul Reiser as a slippery villain.

JAWS (1975)

The Duffer brothers' favorite film. Steven Spielberg invented the summer blockbuster with this horror about a predator terrorizing a beachside community. Roy Scheider's police chief character was a direct influence on the character of Jim Hopper, and the Duffers often cited the villainous shark as a key inspiration for the monster haunting Hawkins.

POLTERGEIST (1982)

Steven Spielberg produced this chilling haunted-house classic. The film's terrifying images were unforgettable and kept an entire generation cowering under the covers. Bonus *Stranger Things* connection: In a season-one flashback scene, Joyce agrees to take Will to see the film as long as he promises not to have nightmares.

IT CAME *from the* STACKS

"I am on a curiosity voyage, and I need my paddles to travel. ...These books are my paddles."

—DUSTIN HENDERSON

Reading Stephen King's early works of horror fiction is as much an adolescent rite of passage as learning to drive or attending the prom. Throughout his decades-long, wildly prolific career, King has tapped into something powerful and primal with stories of outsiders and outcasts confronting supernatural threats. Those who make it out alive are forever changed by their experiences, and not always for the better. His tales are especially relatable as metaphors about the horrors of leaving childhood behind, but King's deftness with character is often overlooked. His books are filled with fully realized heroes and villains whose relationships are well drawn and compelling.

Although the wildly prolific author isn't the only literary figure who inspired Matt and Ross Duffer—the list also includes Dan Simmons, Clive Barker, George R.R. Martin, and many more—King's novels serve as a foundational text for *Stranger Things*, no question.

The Hawk
USED BOOK STORE

CARRIE (1974)

Stephen King's debut novel offers a terrifying look at the life of bullied Carrie White, a high-school student with telekinetic powers living with a deranged, abusive mother. When Carrie is pushed too far, she channels her extraordinary abilities to exact bloody revenge on her tormentors. Eleven would come to share many of Carrie's unique gifts—and when confronted by "the bad men," she would turn out to be just as deadly.

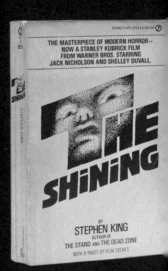

THE SHINING (1977)

Writer's block turns lethal when Overlook Hotel caretaker Jack Torrance descends into madness fueled by alcoholism and the ghosts of the past. King revisited the idea of a gifted child with an abusive parent in his third novel—Jack's young son, Danny, can see the bloody history of the Overlook haunted halls. *The Shining*'s influence would be keenly felt in *Stranger Things 2* once Will Byers acquired second sight ("now memories") through his contact with a supernatural menace

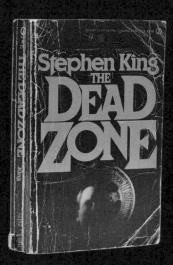

THE DEAD ZONE (1979)

Former high-school teacher Johnny Smith awakes from a coma after nearly five years to discover that he can see the future, and things don't look good. With his clairvoyance comes a brain tumor and the knowledge that a rising-star politician is a deeply unhinged man destined to start nuclear war (filmmaker David Cronenberg brought *The Dead Zone* to theaters in 1983, with Christopher Walken as Smith). The novel features many of the hallmarks of King's best work, which the Duffers would channel for their series—a small-town setting, a protagonist with extraordinary abilities, richly drawn supporting characters, and an overarching feeling of escalating dread.

DIFFERENT SEASONS (1982)

This collection of four novellas includes *The Body,* a poignant coming-of-age tale about four twelve-year-old boys who venture along a set of train tracks looking for the corpse of a missing child. Along the way, they're pursued by dogs and a pack of bullies; persevering through the adversity, they form a deep bond. The story inspired the 1986 film *Stand by Me,* which, in turn, became one of the principal cinematic inspirations for *Stranger Things.*

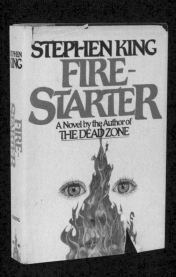

FIRESTARTER (1980)

King crafts another gifted girl in Charlie McGee, who inherits psychic powers from her parents as a result of a covert government program involving mind-altering substances—a story line that clearly parallels the foundational elements of *Stranger Things.* Eleven could be seen as Charlie's literary cousin; both girls struggle to understand and harness their abilities. *E.T. the Extra-Terrestrial* star Drew Barrymore played Charlie in the 1984 film.

IT (1986)

"We all float down here," Pennywise the Dancing Clown tells little Georgie Denbrough before luring the boy to his demise. Pennywise is the favored form of a mythic, ancient evil terrorizing a small town, but it's a group of social misfits who get wise to the supernatural nature of the threat. At one time, the Duffers had hoped to direct a movie adaptation of *It,* but instead, they turned their attention to developing their own series about friends in a rural community confronting the paranormal. (Finn Wolfhard, who plays Mike Wheeler in *Stranger Things,* would star in the 2017 film adaptation of the novel.)

Their student short film *Eater*, about a cannibal on the loose in a police precinct station house, showed tremendous promise. Veteran producer Mace Neufeld (*The Hunt for Red October*, *Patriot Games*) served at Chapman as filmmaker-in-residence and worked with the brothers, and he was struck by their talent and their unique visual style. "I quickly realized they were ready for prime time," Neufeld says. "They really knew what they were doing."[5] While attending Chapman, the Duffers took as many internships in Hollywood as they could find and continued to write scripts. One idea, about a Cold War–era mystery, seemed to have potential, but they couldn't find the right way to shape the story, so they shelved the idea. Then, in 2011, they had an aspiring filmmaker's dream experience.

Warner Bros. picked up their screenplay for *Hidden*, a tightly scripted thriller set almost entirely in a bomb shelter, and green-lit the project with the Duffers at the helm as directors. Alexander Skarsgård (HBO's *True Blood*) and Andrea Riseborough (*Birdman or [The Unexpected Virtue of Ignorance]*) were cast as the parents of a young girl who are forced to take shelter after a viral outbreak decimates their town. Venerable producer Richard D. Zanuck briefly came aboard to help shepherd the project; before filming could begin, however, the Hollywood legend—who had produced six of Tim Burton's films, including *Big Fish* (2003) and *Charlie and the Chocolate Factory* (2005)—suffered a fatal heart attack at the age of 77.

Shooting began in Vancouver in August 2012, but during production, the twins began to get the sense that Warner Bros. was having second thoughts. "We were at this studio that we looked up to when we were kids," says Matt Duffer. "Warner Bros. is the studio that made *Batman*. At the end of the day, Warner Bros. didn't know what to do with the movie because it was so small. We got a call. Someone high up at Warner had just realized the whole thing is set in a bomb shelter and wanted to know if we could open it up. We were in the middle of shooting. There was nothing to do."

The unfinished film sat on a shelf for nearly a year before the Duffers were able to complete postproduction work on the project. It received only a

5 In *Eater*, a rookie cop reports for work not realizing he's about to experience the worst night of his life. The 18-minute short based on a Peter Crowther short story features many hallmarks of what would come to be the Duffers' storytelling style—slow-burn tension, classical camera moves, a police officer encountering the supernatural in the corridors of a nearly deserted facility. *Eater* opens with an evocative title sequence set to an eerie electronic score.

cursory release in September 2015. "It was a hard experience to go through," says Matt. "It felt like we were pounding on the door, begging to get let into the party, and then we were kicked out almost as soon as we got in. Our 'big break' suddenly felt like an accident."

The Duffers' promising career appeared to have come to a screeching halt. But in an unusual twist of fate, M. Night Shyamalan[6] intervened. (The man does have a knack for creating twists of fate.)

The Oscar-nominated writer-director (*The Sixth Sense*, *Unbreakable*) had read the brothers' *Hidden* script, and he was impressed with their sense of storytelling. The screenplay follows contours viewers may recognize from the best of Shyamalan's productions—it's a melancholy story about characters who find themselves imperiled by a vaguely supernatural threat that finishes with a gut punch of an ending. Shyamalan invited the Duffers to his Pennsylvania home, where he offered to hire them to work on the sci-fi TV series he was executive producing for Fox, *Wayward Pines*.[7]

"They were family-based storytellers, which was something of great interest to me, probably because I grew up on Spielberg," says Shyamalan. "That kind of a doorway into talking about unknown things and supernatural things has always felt very right for me."

Although the Duffers had no background in television, they accepted the assignment and headed back to Vancouver, where the show had gone into production in August 2013. A mystery set inside a small town harboring a dark secret, *Wayward Pines* (pictured below) featured a stellar ensemble cast that included Matt Dillon as Secret Service agent Ethan Burke and

6 The writer-director's third feature, 1999's *The Sixth Sense*, about a young boy who could see the dead, became a box-office sensation that went on to earn six Academy Award nominations (including one for star Haley Joel Osment). The Duffers would, of course, enjoy similar success with their own supernatural-themed hit centered around a youthful protagonist with otherworldly gifts.

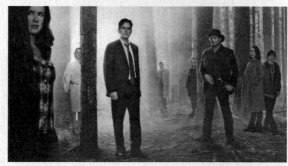

7 The Duffer brothers brought their flair for smart genre material to the episodes they wrote for the dark mystery set in a town harboring an unsettling secret. The premise, worthy of *The Twilight Zone*, came courtesy of a trilogy of novels written by Blake Crouch and published between 2012 and 2014.

Oscar-winner Melissa Leo as the nurse who cares for Ethan when he wakes up in the seemingly bucolic Idaho community after a nasty car accident. Slowly, Ethan learns that the residents of the town abide by an unusual set of rules that prevent them from leaving its confines.

The Duffers penned four of the first season's ten episodes, including a bloody finale that sees *Wayward Pines* overrun with monstrous mutants known by locals as Abbies (short for *aberrations*). That experience would change the course of their career. They began to take note of the creative possibilities afforded by serialized storytelling, and they learned to write and revise scripts on the fly. They also watched experienced actors move through scenes efficiently. "We were forced to figure out how to work fast," says Matt Duffer. "We came out of that feeling we had enough tools to at least pretend like we knew what we were doing."

They also came away with a newfound respect for the medium, underlined further by the premiere of HBO's compelling crime mystery series *True Detective*. All eight episodes of the first season of the dark drama were directed by Cary Joji Fukunaga (*Beasts of No Nation*), and the brothers were struck by how intensely cinematic the series felt. The notion of crafting a narrative that would unfold over a season of television became intensely appealing, and the brothers began to cast through discarded script ideas for a possible story line. One stood out: the sci-fi story set during the Cold War.

The original concept for the story as a feature film was a found-footage-style project (though they were never fans of that genre). But as they thought about a possible television series, they realized the mythos around covert government experiments in the 1950s and '60s had real potential. The brothers also drew inspiration from director Denis Villeneuve's harrowing 2013 thriller *Prisoners*, which centers on the race to find two girls after they are abducted in suburban Pennsylvania. "Because we're still children at heart, we started talking about monsters," Ross Duffer says. "Then we got really excited."

Secret CIA testing. A missing child. Storybook monsters from another world. Seemingly disparate elements began to come together in the brothers' minds. "It happened very quickly," Ross Duffer says. "We had the base, and once we agreed on the setting, we realized we could also pay homage to the stories that inspired us in the first place."

1

THINGS COME TOGETHER

THE SCRIPT for the pilot of *Stranger Things* was written in a matter of weeks—except it wasn't actually titled *Stranger Things*. In tribute to their favorite film of all time, Steven Spielberg's *Jaws*, the brothers set their story on the East Coast and called it *Montauk*.

The sleepy Long Island town proved an ideal location for an eerie mystery. Montauk Air Force Station,[1] colloquially known as Camp Hero, rivals Nevada's Area 51 as a favorite touchstone for the conspiracy-minded.[2] Initially established in 1942 to guard against a German invasion, the facility was later expanded during the Cold War. Rumors began to circulate that the government conducted unsettling experiments involving electronic

1 Built in the 1940s, the U.S. Air Force Base Fort Hero in Montauk, at the eastern tip of Long Island in New York State, was conceived as a defense during World War II, but it is rumored to have been the site of experiments in mind control. It became the inspiration for Hawkins National Laboratory.
2 This top-secret military base in the Nevada desert created during the Cold War is central to conspiracies about alien life. It, too, played into the Duffers' ideas about Hawkins National Lab.

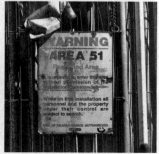

surveillance and mind control in a warren of offices and hallways concealed beneath the sand.

Although certain key details were different, the broad strokes of the first episode were all there. In the early 1980s, in the basement of Mike Wheeler's nondescript suburban two-story home, twelve-year-old Mike and his best friends, Lucas Sinclair, Dustin Henderson, and Will Byers, are in the throes of a *Dungeons & Dragons* campaign.[3] Confronted by the sinister Demogorgon, the party of adventurers can't agree on the best course of action. Chaos erupts as the boys shout out ideas for how to defeat the monster, but they lose a critical roll against the beast, and young Will's wizard appears doomed.

Riding his bike back home that night, Will encounters another kind of beast—a mysterious creature that chases him through the woods and into a shed behind the Byerses' ramshackle home. And then, suddenly, silently, the boy is just…gone.

"The first scene we wrote was the *Dungeons & Dragons* scene," Ross Duffer says. "It just sort of wrote itself. The voices were easy to get. That gave us a lot of confidence, as far as the script was concerned. We figured if it's working this quickly, that's a really good sign."

From the outset, the Duffers knew that they wanted to structure the series like a feature film, with the search for Will serving as the spine of the story. As they fleshed out ideas, they broke the narrative into three acts,[4] as they would have done for a feature screenplay. The first three episodes would examine what happens once Will goes missing. The next three episodes would

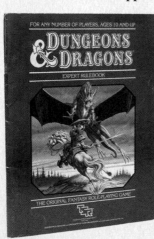

see the town become increasingly haunted as the characters edged closer to solving the mystery. Finally, the heroes would be forced to outsmart the military to save Will and restore peace in the community.

3 The 1983 edition of the expert *Dungeons & Dragons* rule book *(left)* featured a cover by American fantasy artist Larry Elmore. The table-top fantasy role-playing game served as a foundation for season one of *Stranger Things*, with the boys embarking on a real-life "campaign."

4 Every screenplay can be broken into three distinct elements, or acts: the setup, the confrontation, and the resolution. Given the Duffer brothers' film-school education and their grounding in movie history, they naturally approached the series as they would have a feature.

———

Once they had a completed draft of the first episode in hand, the Duffer brothers assembled a "look book" that would serve as a companion document, describing in detail their ideas for the series and the inspirations behind it. For the cover, they channeled the popular Signet paperbacks from the era.[5] A single image of Will's abandoned bike lying on the side of an empty rural road appeared on a black background beneath the one-word title rendered in red. A tagline beneath the image promised readers "An epic tale of sci-fi horror."

The document ran twenty-three pages and included a summary of the story, character breakdowns and biographies, and explanations of the tone and style the Duffers imagined for the show. "It was still rough, but it gave a hint of where things were going," Ross Duffer says. "We included pictures and stuff from the movies that had inspired us—whether it was *Stand by Me*, or *E.T.*, or *A Nightmare on Elm Street*—and we put it all together so people could see the tone we were going for."

The Duffers' original vision for the series was somewhat darker than the tone eventually struck in *Stranger Things*. In the look book, the twins posit that the horror elements would be supernatural in nature yet rooted in science, and the design of the monstrous entities would reference the work of Guillermo del Toro,[6] Clive Barker,[7] and H.R. Giger,[8] the Swiss experimental artist who designed the terrifying Xenomorphs for Ridley Scott's 1979 classic *Alien*. Silent Hill, a terrifying video game about a town consumed by shadows and overrun with sinister malformed creatures, also served as an influence.

5 The *Montauk* "look book" mimics the Signet logo at the top of the company's paperbacks *(right)*.
6 Writer-director Guillermo del Toro (*Pan's Labyrinth* and *The Shape of Water*) is famous for his love of monsters; his films always feature painstakingly crafted creatures, some not dissimilar to the Demogorgon.
7 English author, artist, filmmaker, and playwright Clive Barker emerged as a powerful voice in genre fiction in the 1980s, endorsed by Stephen King himself as "the future of horror." Like del Toro and the Duffers, Barker's work, too, features monstrous creatures from other dimensions.
8 The Surrealist painter Hans Ruedi Giger (1940–2014) was renowned for unsettling, sexually charged imagery, and he applied his aesthetic to the sleek, ebony predator stalking the crew of the *Nostromo* in *Alien*. The Xenomorph was played by an actor in a suit, as was the Demogorgon for most of its screen time in *Stranger Things*.

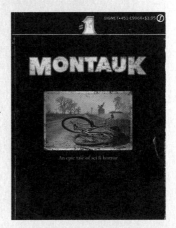

As the brothers began pitching *Montauk* to various companies around Hollywood, they found little to no interest—it was rejected between fifteen and twenty times. The 1980s period setting was a strike against the project, as was the fact that the show centered on middle-school protagonists yet wasn't targeted to children. "A lot of the concerns were based on the fact that this is a show about kids, but it's not a kids' show," says Matt Duffer. "People couldn't figure that out. The other big thing was that no one wanted a show set in the 1980s. It's funny, the two things that made the show successful were the two things that were red flags for everybody."

But for the brothers, the 1980s setting was essential to the premise. Not only was the show a love letter to the films that had influenced them growing up, almost all of which took place in the decade, but it was also vital to the plot. Mike and his friends needed to have a certain degree of autonomy that kids in the era of helicopter parenting[9] and social media are rarely afforded.

"We grew up a little bit later than the period when the show is set," Ross Duffer says, "but without the internet and without cell phones, we weren't as tethered to the world. I remember growing up, I felt like I could step out of my house, go with a friend out into the woods, and feel like we were going on some grand adventure. I feel like it's harder to have that experience nowadays when your mom can just text you and say, 'It's time to come home for dinner.' That sense of freedom, and nostalgia for that freedom, was something that we really wanted to capture."

Eventually, *Montauk* made its way to Dan Cohen, an executive at 21 Laps Entertainment, the production company overseen by Shawn Levy. Filmmaker Levy is known principally for directing family-oriented hits, such as the *Night at the Museum* movies, *Real Steel,* and *Cheaper by the Dozen,* and for producing such acclaimed films as *Arrival*[10] and *The Spectacular Now*. He'd never worked in television, and neither had Cohen.

9 In the 1970s and '80s, a more laissez-faire philosophy prevailed; children walked to school on their own and rode bikes to friends' houses without supervision.
10 In *Arrival,* Amy Adams is a linguist whose encounters with extraterrestrials change the course of her life in the 2016 film. In her interactions with alien visitors, she wears a hazmat-style suit much like the ones worn by the Hawkins National Lab scientists (and later Joyce and Hopper) when called upon to venture into the Upside Down.

In searching out new projects, Cohen had been in the market for a project that recaptured the sense of wonder of Steven Spielberg's Amblin Entertainment[11] movies or Stephen King's classic novels, but none of the scripts he'd read quite found the mark. "There was really nothing that resembled that storytelling of yesteryear," Cohen says. "I was constantly hearing about this love for this forgotten genre from people, and I was always looking for something in the vein of it. When I came across the Duffers' pilot, the quality was so high, the characters were so real. It wasn't trying to be any of the things that inspired it. It just was great and felt like you were transported to 1980."

He brought the project to Levy's attention. "He is never wrong in matters of taste," Levy says. "It was an undeniably great script." After meeting with the Duffers, Levy agreed to back the show. "It became very clear to us that he got the show and he didn't want us to change anything," Matt Duffer says. "He wanted it exactly as it was."

Around the same time, Netflix tasked content-development executive Matt Thunell with finding programming that might appeal to viewers in their teens and twenties. The streaming service had enjoyed outsize success with prestige projects *House of Cards* and *Orange Is the New Black* and was looking to broaden the scope of its original series offerings.[12] The Duffers' script made its way to Thunell, who read it over the course of a weekend and was hooked. He brought it to his bosses, vice president of original series Brian Wright and vice president of original content Cindy Holland, who also responded to the show's compelling mix of supernatural suspense and emotional character drama.

11 Founded in 1981, Spielberg's production company is responsible for some of the most beloved films of all time—and some of the Duffers' most profound influences (its name came from the director's 1968 short *Amblin'*, about two people hitchhiking through the desert). Among them is 1985's *The Goonies*, which follows a group of kids on a winning adventure, not unlike the crew of kids in *Stranger Things*.

12 The rise of such subscription-based streaming services as Netflix helped fuel the era of so-called "Peak TV," in which showrunners like the Duffers began to approach the medium with a more cinematic mind-set. Rather than a traditional focus on lengthy seasons of standalone episodes, creators instead began experimenting with bolder, interconnected narratives unfolding in eight or ten or thirteen installments. Netflix's unique model of releasing every episode simultaneously allowed audiences to "binge" an entire season in one sitting, mimicking the experience of watching a feature film.

"They both thought the writing was remarkable [and] loved how fresh the coming-of-age story was, the fact that it had all these really sincere themes like a great 1980s movie[13] does," Thunell says. "The Duffers were great at capturing a feeling. You really feel something on the page. You feel like you did when you were a child. You feel what it was like to grow up, to be innocent, to have your whole life in front of you."

Thunell scheduled a meeting with the Duffers and Levy in March 2015 to talk in more depth about the series. The writer-directors by that point had assembled a "sizzle reel," essentially a short teaser trailer for the show, using clips from other films to convey the spirit and visual language they had in mind, all accompanied by music from director John Carpenter. At the end of the sizzle reel, they spliced together a montage and used a moody instrumental track from the Austin-based synth quartet Survive to punctuate the action.

The idea always was to underscore the cinematic nature of the project. In conversations with Thunell and other executives, the Duffers and Levy emphasized that *Montauk* would play out as an eight-hour movie with the brothers serving as the directors for every installment. "The lower episode count was important, because the Duffers have a really fast-paced style," Thunell says. "I think stretching it over ten or thirteen episodes would've just diluted what was a really special, tight story."

After relatively little deliberation, Netflix ordered the series in April 2015. It was a leap of faith for both parties. "We were green-lighting a season of television from two creators who had no track record whatsoever, and we're going to give them, say tens of millions of dollars to make a season of television," Thunell says. "This was absolutely terrifying. It was a trial by fire."

"This is the kind of thing I can't underline enough—none of us in that room had ever produced hit television, so this was a real big bet," Levy says.

13 With films including *Sixteen Candles*, *The Breakfast Club (left)* and *Ferris Bueller's Day Off*, writer-director John Hughes reigned throughout the 1980s as the master of the coming-of-age comedy. His protagonists helped inspire the Duffers to create *Stranger Things*' trio of teens, Nancy Wheeler, Jonathan Byers, and Steve Harrington.

24

With shooting slated to begin that fall, the Duffers and Levy had enormous challenges ahead of them—finding a home for the production, casting actors for each of the key roles, writing or hiring writers to complete the remaining seven scripts, bringing on the behind-the-scenes crew members who would help them shape the series.

They began by scouting locations on the northern tip of Long Island, but the community—so integral to the script—didn't look as they had imagined, and its distance from New York City made the idea of anchoring the production there unfeasible. A new approach was required. "We started talking about some of our favorite films. Whether it was *Breaking Away*[14] or *Close Encounters of the Third Kind*, those were movies that were set in Indiana, which is sort of an Anywhere, USA, kind of place," Ross Duffer says.

The Duffers realized that, given their own backgrounds, they were better suited to telling a story that took place in a conventional suburban setting than they were to setting a story in a beachside town. "I know what it's like to grow up in a small inland town," Ross Duffer says. "It was a more familiar environment to us. Even though it was heartbreaking at the time, it made for a better show." Suddenly, Hawkins, Indiana, was born, and the series was no longer titled *Montauk*.

It would now be called *Stranger Things*.

14 *Breaking Away* (1979) centers on four young men whiling away their days at an abandoned rock quarry in Bloomington, Indiana. The film's Middle America settings and its depiction of everyday life in a college town feel authentic and familiar; *Stranger Things* easily might have unfolded in the same working-class neighborhoods that abut the Bloomington campus.

READY YOUR PARTY

A PRIMER ON *DUNGEONS & DRAGONS*

FOR A GENERATION raised on the literature of J.R.R. Tolkien, H.P. Lovecraft, and Robert A. Heinlein, *Dungeons & Dragons* became an epic basement pastime.

Published in 1974 by Tactical Studies Rules, Inc. (TSR), the board-game/amateur-theater hybrid created by Gary Gygax and Dave Arneson sent groups of friends on colorful journeys dreamed up by a Dungeon Master, or DM. Players adopted alter egos of varying races and abilities and faced down untold dangers—like armies of troglodytes, or the dreaded Demogorgon. Campaigns could take hours, days, sometimes weeks. Not every character made it out alive.

The granddaddy of all role-playing games genuinely struck a chord with the fantasy-inclined, and in subsequent years, TSR published updates and variations, even spinning off *Advanced Dungeons & Dragons* for higher-level enthusiasts. Not everyone was a fan—the game's occult-like subject matter and dark themes sparked a minor moral panic in the late 1970s and early to mid-80s.

Like sci-fi and horror, collectibles and comic books, *Dungeons & Dragons* (now published through Seattle-based company Wizards of the Coast) has reached a level of mainstream popularity that would have seemed unimaginable in the days when it was mostly an underground sensation. D&D clubs have begun springing up at high schools across the country, and players also meet at gaming stores and board-game cafés. It doesn't take much to get started.

THE RULE BOOK

Basic Rules for Dungeons & Dragons covers, well, the basics—how to create a character, how to play the game, and how magic works inside the game; a separate *Dungeon Master's Guide* exists for those who wish to learn how to run campaigns. And there's the *Monster Manual* with important details about the beasts adventurers might encounter.

POLYHEDRAL DICE

A set of six multicolored multisided dice are included with the game and have various functions. The DM often will cast the dice to determine whether the actions of a player or a group of players succeeded or failed; adventurers use the dice when initially creating their characters to determine their abilities in six key areas: strength, constitution, dexterity, intelligence, wisdom, and charisma.

CHARACTER SHEETS

Preprinted forms are used to record all the relevant data for a player character, or PC. These include attribute scores, race (human, elf, dwarf, and so on), character class (such as fighter or wizard), and alignment.

THE MINIATURES

D&D players have the option of purchasing and painting tiny figurines—originally produced from a lead alloy, now made from plastic and generally ranging in size from twenty-five to twenty-eight millimeters, or just under one inch to just over one inch—to represent PCs or the monsters who turn up along the way.

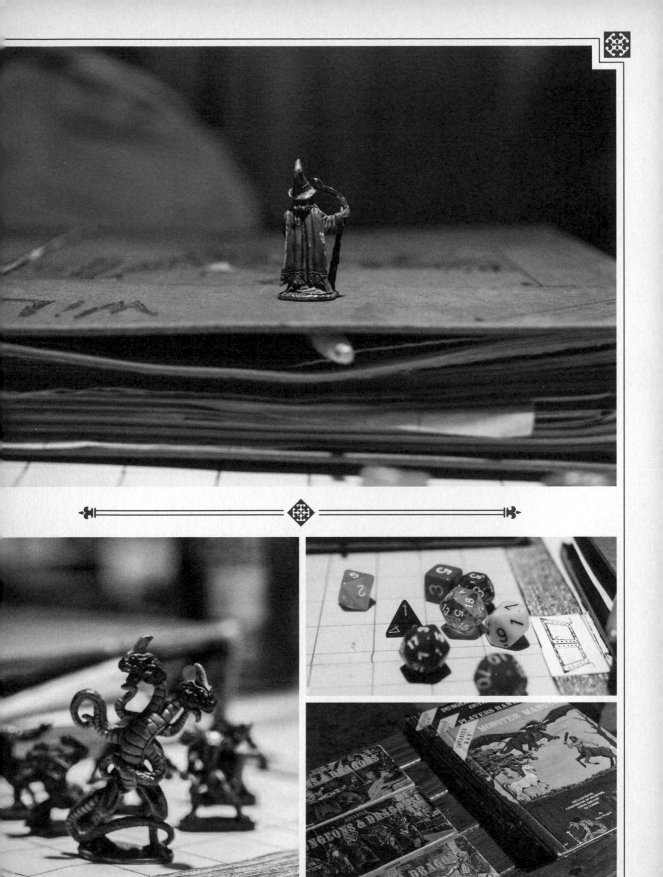

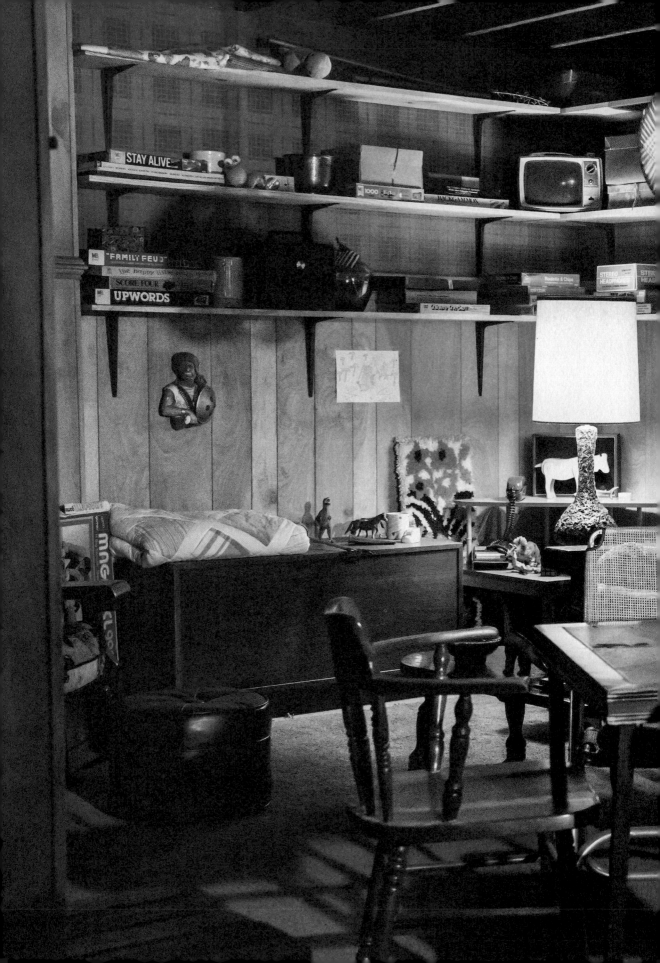

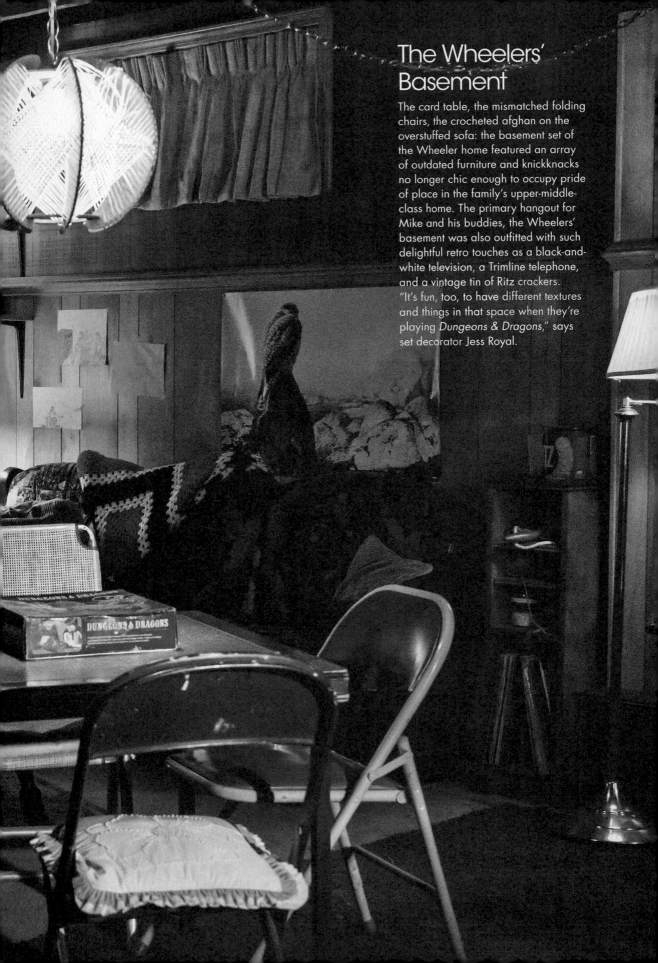

The Wheelers' Basement

The card table, the mismatched folding chairs, the crocheted afghan on the overstuffed sofa: the basement set of the Wheeler home featured an array of outdated furniture and knickknacks no longer chic enough to occupy pride of place in the family's upper-middle-class home. The primary hangout for Mike and his buddies, the Wheelers' basement was also outfitted with such delightful retro touches as a black-and-white television, a Trimline telephone, and a vintage tin of Ritz crackers. "It's fun, too, to have different textures and things in that space when they're playing *Dungeons & Dragons,*" says set decorator Jess Royal.

DUNGEONS & DRAGONS
PLAYER CHARACTER SHEET

Character's Name

MIKE WHEELER

Finn Wolfhard

Played by

Dungeon Master

Nomenclature

Level **3** Experience Points **6,500**

Cleric

Class

Alignment **Lawful Good**

FEATURES AND TRAITS

Identifiers

Rugby shirts, calculator watch

Abilities

Leadership, courage, determination, intelligence, loyalty

Weaknesses

Prone to emotional outbursts and mood swings, distrust of authority, overbearing mom

Armor Class **3**

Hit Points **15**

	ADJUSTMENT			ADJUSTMENT
S **16**	**+2**	D **9**	**+0**	
STRENGTH		DEXTERITY		
I **10**	**+0**	C **13**	**+1**	
INTELLIGENCE		CONSTITUTION		
W **13**	**+1**	Ch **17**	**+2**	
WISDOM		CHARISMA		

When Finn Wolfhard first spoke to Matt and Ross Duffer about the character of Mike Wheeler, the young Canadian actor and musician discovered he spoke the same language as the *Stranger Things* creators. Even though he was only twelve years old at the time, Wolfhard shared with the writer-directors a love for the cinema of the 1980s. "When I was really young—I mean, I still am really young, but when I was, like, really, really young—all I did was watch movies, every day," Wolfhard says. "Sometimes I just watch the same movie over and over again."

THE PENSIVE SKEPTIC

Wolfhard's passion for filmmaking initially brought him to acting: as a child, he began taking improv classes, thinking that performing might be one way to break into the business. Open casting calls soon followed. When he came across *Stranger Things*, Wolfhard had had small parts on such series as *The 100* and *Supernatural*. He immediately sparked to the project, rooted as it was in traditional Amblin-style storytelling. "I thought it was cool because some of my favorite movies have that charm to them, you know, from the 1980s, like *Gremlins* and *The Goonies* and *Stand by Me*," Wolfhard says. "It just hit something for me deeply."

Mike Wheeler could very well have been plucked from one of those beloved films. Mike is, in many ways, the average American boy on the cusp of adolescence, with a penchant for escapist

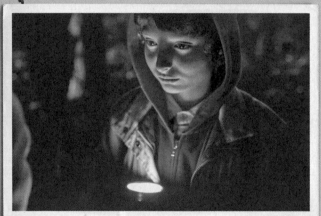

adventures like the ones he crafts for his friends—*Dungeons & Dragons* campaigns in which their heroic alteregos slay fantastical creatures, collect untold treasure, and become the subjects of legend. As the middle child in the Wheeler family, Mike lives a comfortable suburban life filled with comic books and collectibles and an annoying older sister, until his friend Will Byers goes missing.

Suddenly, Mike is confronted by the dangers that exist in the world around him, but he's also intrigued by the mystery that begins to unfold—especially once he encounters a girl with unusual abilities. "I like playing a leader," Wolfhard says. "It's fun to play a leader and to have kind of a key role in the story."

Wolfhard taped his *Stranger Things* audition from his sickbed, never expecting to hear back about the part. To his surprise, the Duffers scheduled a Skype chat with him and invited him to come to Los Angeles in the summer of 2015 for a screen test with future Dustin, Gaten Matarazzo, and future Lucas, Caleb McLaughlin. They became fast friends.

"Gaten came in the room, and we were just talking, and then he was talking about how he had no collarbones," says Wolfhard. (Matarazzo suffers from a rare condition known as cleidocranial dysplasia.) "And he's just making jokes about it, talking about how he's on Broadway and stuff. I thought he was a super funny kid. Then Caleb came in. It was kind of the same deal. He was supercool and really funny."

Four weeks later, Wolfhard had been cast as Mike, and the Duffers began adapting the role to suit the young actor. "They kind of formed the characters off of all of us," Wolfhard says. "My original character had a big birthmark on his face. That was a story point, but they ended up removing it because they thought that us being natural was [better]."

Instead of the birthmark, the Duffers sought to bring some of Wolfhard's own winning optimism and relentless determination to the young hero. "In the case of someone like Finn, the original Mike was much more of the straight man," Ross Duffer adds. "But Finn has a very specific kind of personality. He's fidgety. He talks fast, but we loved that he's so very authentic and real. Even though he wasn't exactly how we imagined Mike, he was less cliché. So we went back and adjusted Mike."

In the process, the character became much funnier, though Wolfhard says his screen alterego doesn't exactly realize the comedy inherent in some of the things he says. "I think he's clueless about everything," Wolfhard says. "He's kind of in his own head that way. Mike doesn't know that he's funny. Everything that comes out of his mouth is so ridiculous."

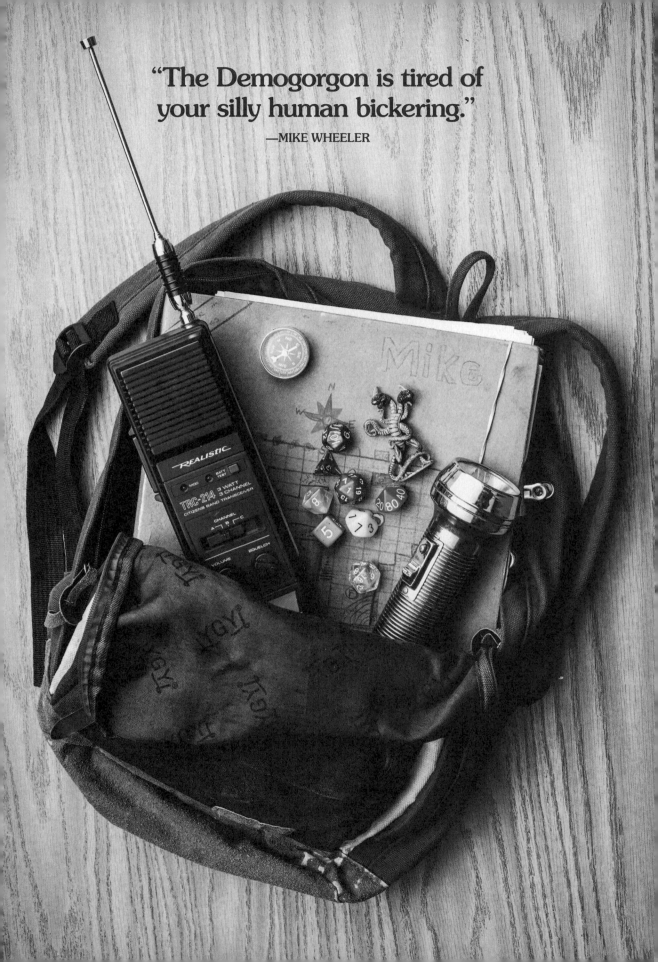

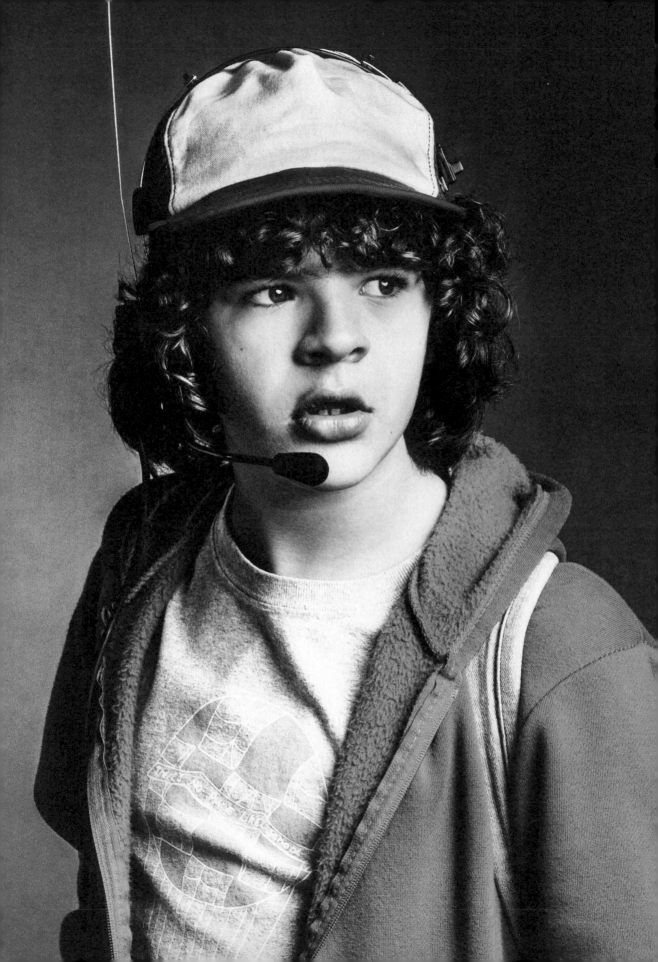

DUNGEONS & DRAGONS
PLAYER CHARACTER SHEET

Character's Name

DUSTIN HENDERSON

Gaten Matarazzo

Played by

Dusty, Compass Genius

Nomenclature

Level __3__

Experience Points __4,000__

Class __Thief__

Alignment __Neutral Good__

FEATURES AND TRAITS

Identifiers

red, white, and blue trucker hat, graphic tees, killer smile

Abilities

conflict resolution, diplomacy, resourcefulness, comic relief

Weaknesses

chocolate pudding, bad luck with pets

Armor Class
6

Hit Points
8

		ADJUSTMENT			ADJUSTMENT
S	(15)	+1	D	(15)	+1
	STRENGTH			DEXTERITY	
I	(13)	+1	C	(10)	+0
	INTELLIGENCE			CONSTITUTION	
W	(15)	+1	Ch	(15)	+1
	WISDOM			CHARISMA	

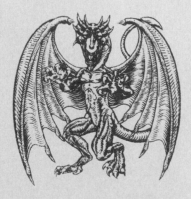

ustin Henderson didn't spring to life on the page with the buoyant geeky swagger that would come to define the chocolate-pudding connoisseur, graphic T-shirt aficionado, and consummate growler. In Matt and Ross Duffer's original script, the character was conceived as a heavyset boy with glasses who was frequently bullied at school. The quirky ebullience emerged once Broadway actor Gaten Matarazzo stepped into the role.

"From his very first audition, we knew we had to have him in this show," says casting director Carmen Cuba. "He was so

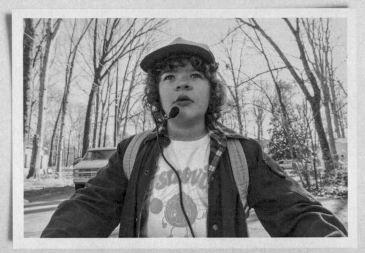

perfectly able to capture the spirit of Dustin and also was so connected to his own very unique self with such tenderness and humor and empathy that it was a big casting moment for us. When we met him in person, we nearly couldn't contain ourselves."

The middle child of a New Jersey family, Matarazzo was just beginning to build a reputation as a young talent in theater circles thanks to turns on stage in *Priscilla, Queen of the Desert* and as Gavroche in *Les Misérables* when he found his way to Hawkins, Indiana. (He and future *Stranger Things* costars Caleb McLaughlin and Sadie Sink used to hang out together in a Manhattan park where theater kids often spend time between shows.)

In Matarazzo's hands, Dustin became a staunchly optimistic presence, the pride and joy of a single mom who encourages his offbeat hobbies. Because he moved to town in the fourth grade, he's the most recent addition to the group of friends that revolves around Mike (Finn Wolfhard)— and he's nursing a major crush on Mike's big sister, Nancy (Natalia Dyer). The actor suffers from cleidocranial dysplasia, a rare genetic disorder than impacts the bones and teeth; after Matarazzo was cast, the Duffers gave Dustin the same condition.

"To the Duffers' credit, they're very strong in their opinions—but they adjust their creative strategy to what is fed to them," says producer Shawn Levy. "So many characters were rewritten and redefined as a result of what we saw [in] the actors…. Dustin got shaped as a result of casting Gaten."

Within his tight-knit circle, Dustin emerges as a kind of counterpoint to Lucas (McLaughlin)— he's able to negotiate conflict and defuse tensions, often with humor or a little bit of bracing honesty. "Dustin's a little more optimistic, a little bit more positive, and Lucas is very tough," Matarazzo says. "Lucas realizes that things are there, and you need to face them head-on, whereas Dustin has a little bit more of a passive approach."

Matarazzo believes positivity is a critical quality as Dustin makes his way through life. "I think that he's so overly optimistic because he's not at all optimistic on the inside," the actor says. "On the inside, he is scared. He's frightened. He doesn't know how to handle it, so he tries to make a positive spin and make everybody comfortable.

"I really do appreciate Dustin. I really feel like that's me as a person. I strive to be in a way how Dustin is. His outlook on life is kind of like how I want to have my outlook on life. Things are going to get better. Don't worry. It's going to be fine. If we could just work together, it will all be OK. Which isn't always true, but it's a nice attitude to have."

> "We never would have upset you if we knew you had superpowers."
>
> —DUSTIN HENDERSON

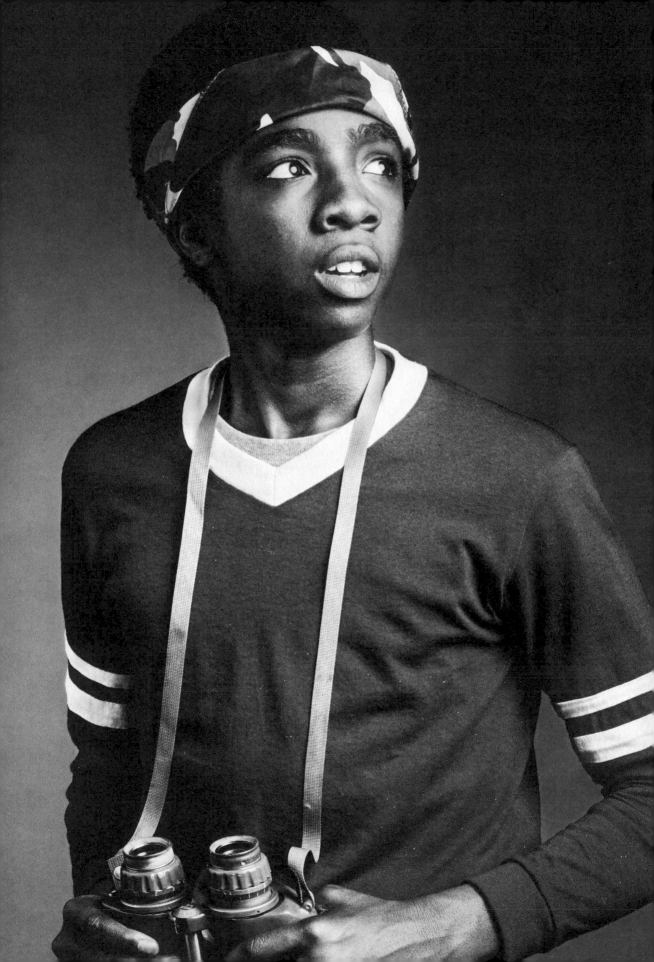

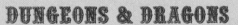

DUNGEONS & DRAGONS

PLAYER CHARACTER SHEET

Character's Name

Lucas Sinclair

Played by

Caleb McLaughlin

Nomenclature **Stalker**

Level **3**

Experience Points **7,200**

Class **Fighter**

Alignment **Lawful GOOD**

FEATURES AND TRAITS

Identifiers

Camouflage bandana, cartridge belt

Armor Class **3**

Hit Points **19**

Abilities

Intelligence, hunting and tracking, good shot

Weaknesses

highly skeptical, hot temper, meddling little sister

	ADJUSTMENT		ADJUSTMENT
S (14)	+1	D (10)	+0
STRENGTH		DEXTERITY	
I (13)	+1	C (14)	+1
INTELLIGENCE		CONSTITUTION	
W (14)	+1	Ch (8)	−1
WISDOM		CHARISMA	

You know that thing people do when they want to surprise someone with good news and they pretend instead that they have bad news to deliver? That's exactly how Caleb McLaughlin learned he'd landed the role of Lucas Sinclair on *Stranger Things*.

"The Duffers said they were going to call no matter what, to say you didn't get it or you did get it," McLaughlin says. "So when I got the call, I was nervous. They sounded super upset. I was like, 'Ah, hey guys.' They were like, 'Yeah, man—just wanted to tell you—you officially got Lucas!' I was like, 'Whoa!' My parents

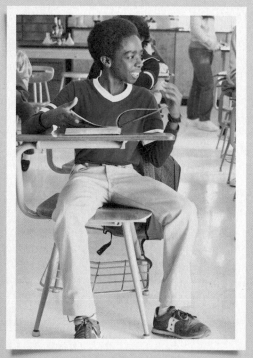

were like, 'What happened?' I didn't have it on speaker. And I said, 'I got it.' We were screaming and super excited."

It was unquestionably the biggest break of McLaughlin's career—though the talented young actor already had starred on Broadway in 2012 playing Young Simba in a production of *The Lion King*. Initially, McLaughlin was more interested in athletics than acting, but at his sister's urging, he began doing community theater with her and discovered he had a passion for performance. "I started to dance, and my sister and I would write plays and songs and choreograph dances," he says.

Small roles on such shows as *Blue Bloods* and *Law & Order: Special Victims Unit* followed, as did McLaughlin's winning turn on Broadway. Despite such early success, he calls starring in a Netflix series "another level."

McLaughlin immediately bonded with his actor peers and says that rapport helped them portray four devoted friends. "We hit it off right away," he says of castmates Finn Wolfhard, Noah Schnapp, and Gaten Matarazzo. "That's why the chemistry was so strong on film. The first day on set, we could not stop laughing. We could not keep it together."

For Lucas, though, Will's disappearance is no laughing matter. After Will goes missing and Eleven enters their lives, Lucas routinely objects to Mike's willingness to shelter the strange girl (or, as he often calls her, the "freak"). His reluctance to invite El into their party stems from jealousy—her arrival marks the first time Mike has truly prioritized an outsider over Lucas—but the boy's wariness isn't totally unwarranted. Eleven's presence does endanger the young friends.

"He's the grandpa in the situation," McLaughlin says. "Lucas knew that Eleven could survive on her own because she had all these powers, so he was like, 'Our friend's out there. No one's worried about him.' I believe in that. I feel like I would do the same thing. I know people said he was mean, but he wasn't."

Lucas eventually decides to strike out on his own, exploring the grounds of Hawkins Lab late at night and finding evidence of a troubling mystery. It's a side of the character McLaughlin would like to develop further—the fiercely independent "bad butt." "I want more of that," he says. "Wrist rocket and just going out on his own doing his thing and kind of getting into Rambo mode."

Sly Stallone had better watch out.

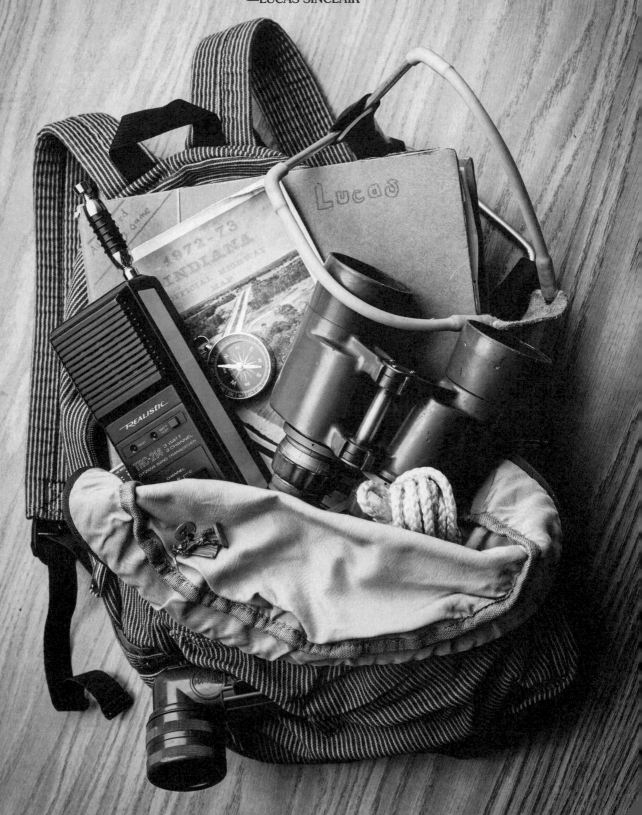

"We're going back to Plan A.
We're telling your mom."
—LUCAS SINCLAIR

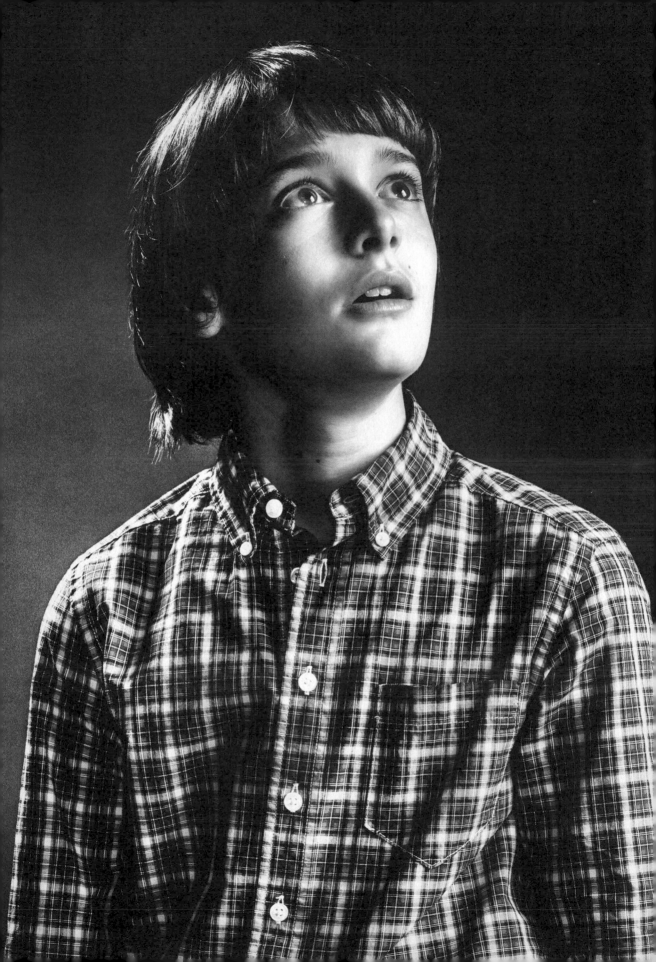

DUNGEONS & DRAGONS
PLAYER CHARACTER SHEET

Character's Name

WILL BYERS

Noah Schnapp

Played by

Will the wise, Zombie Boy, The Spy 3 7,400

Nomenclature Level Experience Points

Magic-User True Neutral

Class Alignment

FEATURES AND TRAITS

Identifiers

Ski vest, bowl haircut

Armor Class

7

Hit Points

9

Abilities

True sight, skilled artist, knows Morse code, good at hiding

	ADJUSTMENT		ADJUSTMENT
S (12)	+0	D (18)	+3
STRENGTH		DEXTERITY	

Weaknesses

Overprotective mom, small stature, sensitive to heat

I (15)	+1	C (12)	+0
INTELLIGENCE		CONSTITUTION	
W (10)	+0	Ch (13)	+1
WISDOM		CHARISMA	

In Hollywood, there are lucky breaks, and then there are life-changing lucky breaks. When Noah Schnapp was just nine years old, he was cast as Tom Hanks's son in Steven Spielberg's 2015 Cold War spy thriller *Bridge of Spies*. Only months later, he was back on screen again, voicing beloved sad-sack Charlie Brown in the animated family film *The Peanuts Movie*. Not a bad way to begin a career. Similarly, his first turn on television came as Will Byers on *Stranger Things*. Will is a sweet and sensitive kid who finds himself targeted by an otherworldly predator and whisked into a cold and distant place.

Character's Name

WILL BYERS

Despite his auspicious start in the industry, Schnapp was surprised to land the role of Will, as he had initially auditioned for the role of Mike. After a series of callbacks, he flew to Los Angeles from his home in New York to meet with Matt and Ross Duffer and to read with some of the other actors being considered for the show's core roles. Then weeks went by, and he heard nothing. Finally, when he was away at summer camp, his parents phoned him with the good news.

"My parents said, 'Oh, Noah, I have someone special on the line for you,'" Schnapp says. "Then the Duffers said, 'Hey, Noah, you got the role of Will.' I was so confused because I didn't know who they were. I forgot—it was from so long ago. I didn't even audition for Will. I auditioned for Mike."

Although Schnapp has only a limited amount of screen time in the first season of *Stranger Things*, he makes an indelible impression in the show's opening minutes. Will's not the kind of boy to get into trouble, yet trouble finds him as he rides his bike through the quiet streets of Hawkins and is confronted by a presence in the darkness. Fleeing on foot toward his house, he discovers no one else is home, and he runs to the woodshed out back, preparing to defend himself against the monster. Then, he vanishes.

Abducted into a nightmarish netherworld, Will clings to life, communicating any way he can with his mother, Joyce (Winona Ryder), his brother, Jonathan (Charlie Heaton), and Jim Hopper (David Harbour) as they desperately struggle to find him before it's too late.

Matt Duffer says he was never less than impressed by Schnapp's ability to capture the intensity of a moment, then immediately snap back to himself when cameras stopped rolling. "It's like he flips the switch on and off," Matt says. "He does this performance where he's traumatized and seems as though he's in severe pain, and then he's laughing five seconds later."

Projecting a near-constant state of fear without the benefit of dialogue was one of the greatest challenges for Schnapp, but mastering that skill would prove essential—especially considering where Will's story line would ultimately take him in the second season. "It's definitely harder—it's the same thing with Eleven in season one, where you have to speak through your eyes and not with words. That was definitely a lot more difficult because you really have to be in the character when you're doing that. But I think it's a lot more powerful."

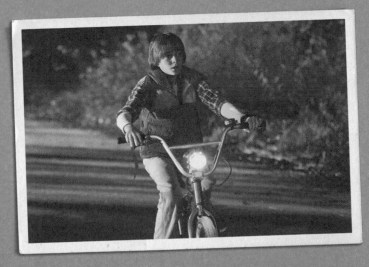

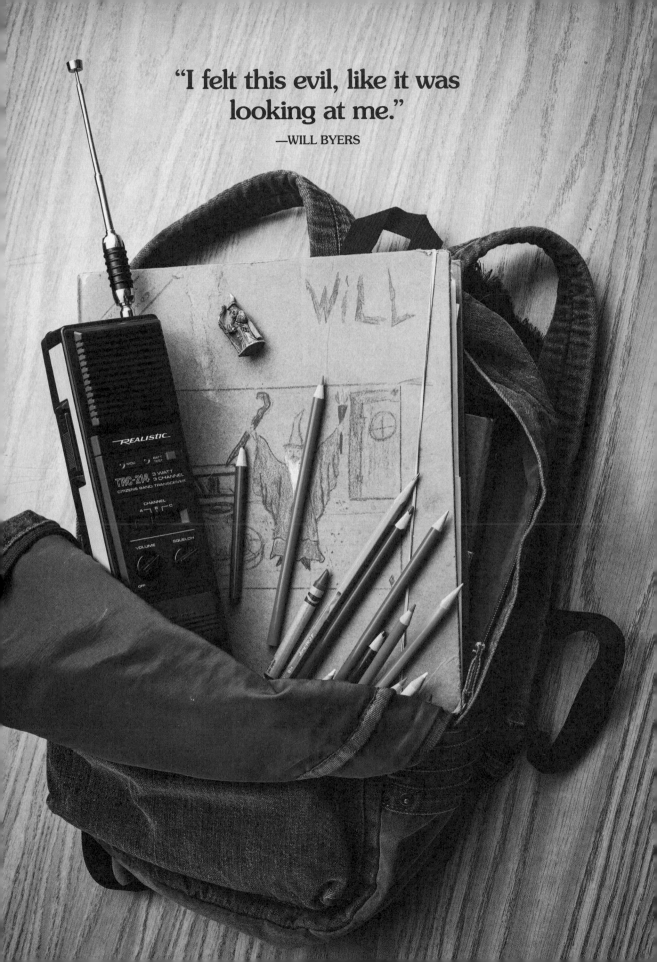

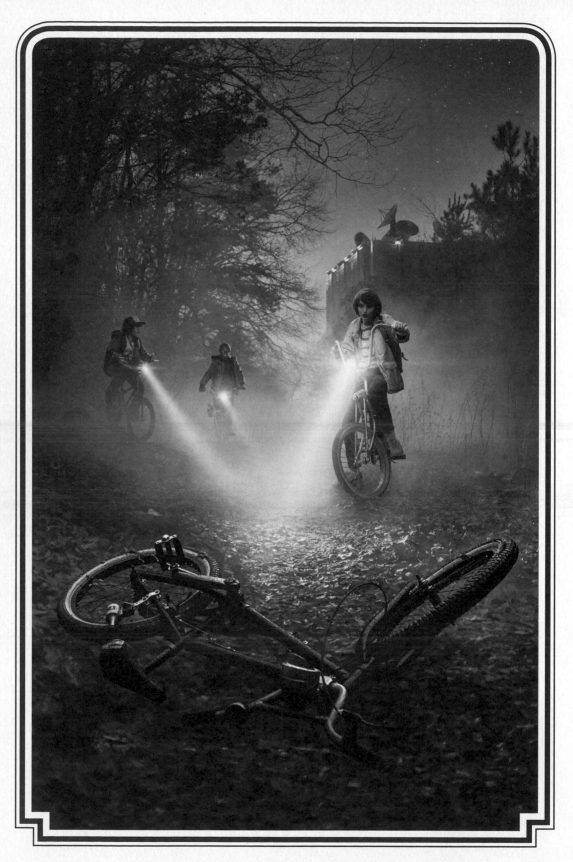

"Their lights revealed Will's red bike lying on its side amongst the leaves.
No other trace of Will could be found...."

2

WELCOME TO
HAWKINS, INDIANA

AFTER SEVERAL furious months of preparation, *Stranger Things* went before the cameras. The first scene filmed was the first that Matt and Ross Duffer had written: Finn Wolfhard, Gaten Matarazzo, Caleb McLaughlin, and Noah Schnapp as Mike, Dustin, Lucas, and Will are seated around a table in Mike's basement as he leads the party of *Dungeons & Dragons* adventurers into a high-stakes encounter with a Demogorgon.[1] The stakes were just as high for the writer-directors who were themselves venturing into the unknown.

Although the cast had undergone screen tests and chemistry reads, no one could have anticipated with absolute certainty how the group's dynamic might take shape once the boys arrived on set. There was never any doubt, however, that the production had found the right actors for the roles. "When we were casting the boys, we knew we wanted a really unique yet cohesive group," says casting director Carmen Cuba. "What was great was that we were able to find boys who had so much of their own individual traits and energy that they shaped their characters organically."

From the start, the Duffers understood it was important to forge close ties with the cast, and they wisely had scheduled time prior to the shoot to get to know the young

1 The Prince of Demons from *Dungeons & Dragons* (for a primer, see pages 26–27). But the creature's origins date back much further: the name *Demogorgon* appears in reference to a frightening demon in John Milton's *Paradise Lost* (1667) and in even earlier writings. A Georgia gaming enthusiast named Damon Paul painted the two-headed figure shown in the first episode.

actors through an extensive period of rehearsals. Those few days helped foster a feeling of familiarity that made everyone more comfortable and gave the brothers more insight into how best to guide their performances.

When that first scene played out with a loose, easy energy informed by the young stars' undeniable rapport, relief and excitement filled the air. "We had a bunch of eleven-year-olds and ten-year-olds," Matt Duffer says.[2] "The kids came in, and they crushed it. I just remember going in very nervous, coming out pretty exhilarated, and feeling really good about our kids. After that first day, everything got easier, because everyone was starting to get more confident about the show."

Finn Wolfhard remembers that first day of shooting: "The morning leading up to it, we were in the school trailer, and we were just super excited because we had never acted this whole scene out together. We had so much nervous energy. All that energy that you see on film, it's the energy that we had that day. It started us off with a bang."

2 The troupe of boys recalls the self-proclaimed "Goonies" of the 1985 film: Mikey (played by future *Stranger Things 2* star Sean Astin; nerdy Data (Ke Huy Quan); talkative Mouth (Corey Feldman); and chubby Chunk (Jeff Cohen). At the start of their last weekend together before Mikey moves away, the gang discovers a treasure map that leads them on a series of picaresque adventures involving pirates and a family of not-very-bright mobsters.

48

"There were a few takes where we just couldn't stop laughing for some reason. Gaten would make these faces before they'd start rolling, and we'd start laughing. He would do it just because he was a goofy dude and he loves making faces. And it was so much fun[3] from then on."

Co-executive producer Iain Paterson adds, "Matt and Ross have always had this relationship with the kids based on a child's view of the world, which they're able to summon quite easily. When we arrived on set, it was about the friendship of it all, the childlike imagination of going into this world."

The world around the young actors certainly gives them great fodder for their performances. Production designer Chris Trujillo crafted a vivid period aesthetic for the series. Although the show is set in 1983, Trujillo felt strongly that it should be grounded in an autumnal palette rather than the garish colors so often associated with the decade. "I see Indiana as being fall-colored—rusts and rich yellows and the oranges and red brick and the creamy whites," he says. "We wanted to feel the green of the

3 The set encouraged a spirit of play. Vintage board games line the shelves of the Wheeler basement, and in the corner sits a Rubik's cube. The goal of Erno Rubik's puzzle cube, invented in 1974, is to twist rows of smaller cubes until each side displays a solid-colored face. Obsession with the cube reached a fever pitch in the early 1980s, when children like Mike would devote hours to figuring out the puzzle.

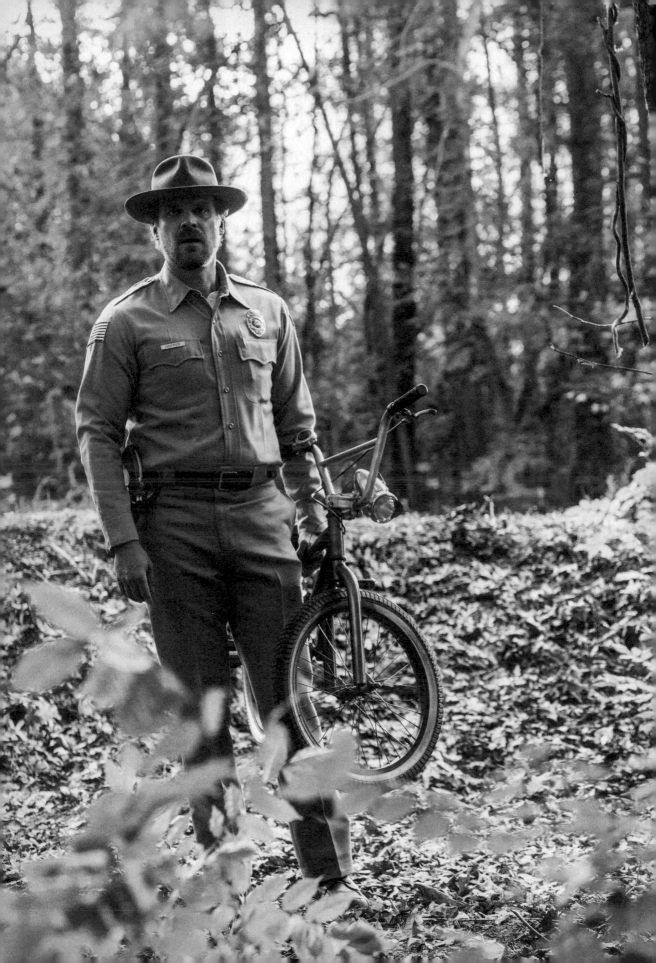

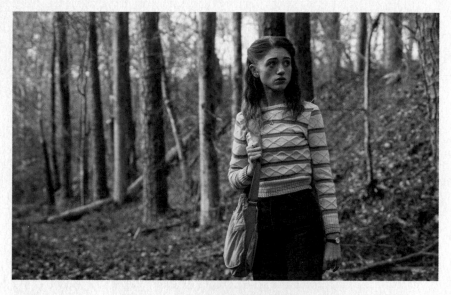

forest, your tree-trunk browns, and that [sense that the town is] all hemmed in by nature."[4]

Despite the Midwestern setting, locations in and around Atlanta provided the ideal backdrop. "There are so many pockets in Atlanta where time has stopped," Ross Duffer says, "where it feels like you just traveled back in time to the 1980s. These houses just haven't changed."[5]

Existing properties stood in for the exteriors of the boys' homes, but the interiors of the Wheeler and Byers residences, along with some portions of Hawkins National Laboratory, were constructed on a soundstage. Trujillo was careful to dig into the backstories of the characters when designing their environments. He believes that the circumstances of their lives should dictate the way the sets look. "A big part of the way I approach everything is trying to figure out who everyone is psychologically, their socioeconomic circumstances," Trujillo says. "That really sets the baseline of what these houses need to look like, and then from there, you build character onto them. It was important to us that we were able to show a cross section of American suburban life."

4 To find locations that felt appropriate for a small town not yet enveloped by suburban sprawl, the crew scouted woodland areas across the northern foothills region of Georgia, an environment in which pines often predominate on former farms.

5 The exterior location for the Wheelers' home is a private residence outside Atlanta, Georgia, originally constructed in 1963. The property is a common example of suburban architecture from the era, and it really is situated on a cul-de-sac.

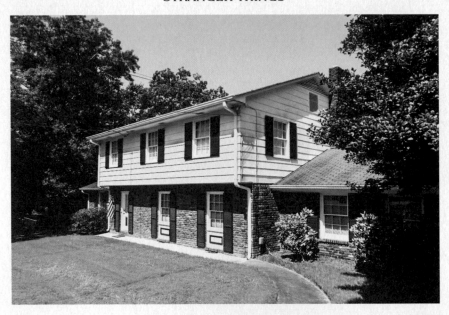

The Wheelers' home

For Mike's two-story traditional home, Trujillo imagined that matriarch Karen Wheeler (Cara Buono) would prefer an up-to-the-minute high-1980s style with wall-to-wall carpeting and an array of wallpapers—except for the basement, the domain where Mike and his friends spend nearly all their free time. "It's a mishmash of life and stages of progress and stalled progress," says set decorator Jess Royal. "There's wood paneling[6] in some parts of the basement where they started to finish it out. Obviously, they turned one area into the kids' corner. Because Karen is so neat and clean upstairs,[7] any clutter, any storage, all goes to the basement." Royal modeled the interior of the Wheeler family's space after her own childhood home, even unearthing

6 Upstairs, Mrs. Wheeler favored wallpaper in floral and chinoiserie patterns, though downstairs she left a mishmash of masculine plaid wallpaper and wood paneling. "We pored over dozens and dozens of huge books of wallpaper," says production designer Chris Trujillo. "In some cases, we would find something we liked as a reference point. Then, if we couldn't find something that we were happy with that existed, in a couple of instances, we had the paper made specially for us."

7 Karen's desire to keep the house just so extends to her children's bedrooms, which occupy the upper floor. Older daughter Nancy's room is decorated in pinks, while Mike's room is a traditional blue. It also contains a subtle homage to *E.T. the Extra-Terrestrial,* courtesy of set decorator Royal: "Growing up, I always remembered that the mini-blinds in Elliott's (Henry Thomas) bedroom were rainbow. I wanted to do a version of that in Mike's room."

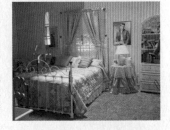

52

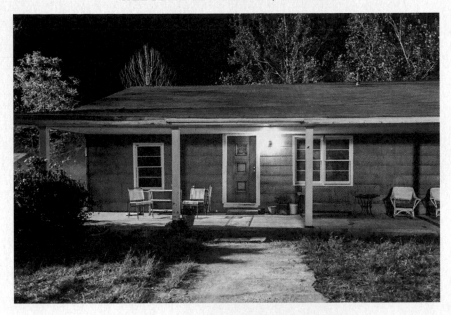

The Byerses' home.

artifacts from her parents' basement to add unique touches throughout. She gave Karen an affinity for the work of an artist named Wendy Wheeler, whose still lifes were popular in the 1970s. "She does all these botanicals, ferns, and macramé[8] hangers," Royal says. "It was mundane enough for a housewife, but it wasn't too common."

The homes were a study in contrasts: "Mike's mom keeps a very sort of *Better Homes and Gardens*–conscious, aspirational, keeping-up-with-the-Joneses house," Royal says. "Will's mom is struggling to make it as a single mom and just doesn't have the luxury of being so to the moment and house proud."[9]

8 Macramé is a craft similar to knitting, but rather than stitching yarn together, macramé artists tie knots in string to create patterns. Macramé may be decorative, or macramé textiles can be used as bedspreads or tablecloths. In the 1970s, macramé wall hangings and holders for hanging plants were very popular.

9 Joyce's home is strewn with vestiges of '70s design such as the crocheted throw often draped on her couch. Crochet is a yarn craft invented as a less expensive way to make lace-like fabrics. It comes from the French word *croche*, meaning hook, and is performed by knotting loops using a needle with a hook at one end. In the 1960s and 1970s, crocheting really took off. Stripes, chevrons, and "granny squares" were among the most popular patterns of the day.

The Wheelers' Living Room

The furnishings have a breezy Floridian feel with a tropical-inspired grass print on the sofa and love seat, a wicker rocker, and mauve carpeting. Set off by matching bookshelves (note the set of encyclopedias and the issues of *National Geographic*), the wet bar completes the look.

The Wheelers' Home

"On the surface, Karen is one of those I-have-it-all-together kind of housewives, just making things tidy and having her *Southern Living* or *House Beautiful* references that she obviously used to decorate her house," says set decorator Jess Royal. "It's all very put together."

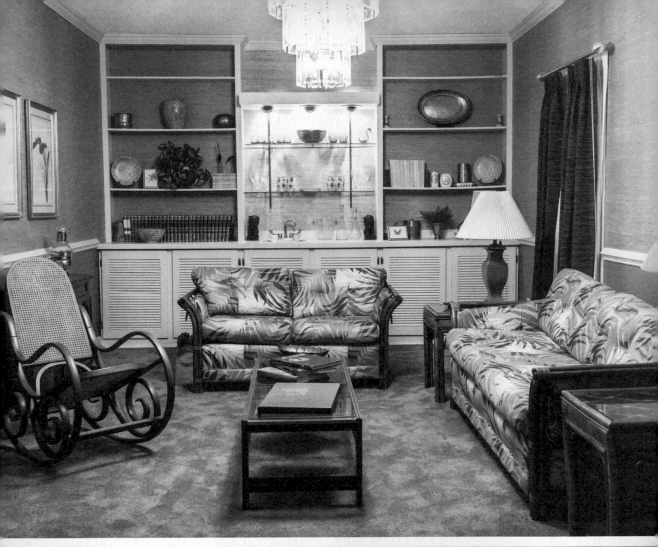

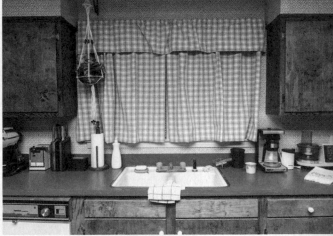

The Wheelers' Kitchen & Dining Room

Although the mauve carpeting extends into the dining room, tangerine orange and marigold yellow dominate in the cheery kitchen spaces.

Karen Wheeler

Karen keeps her leftovers organized with Tupperware. The popular plastic containers with tight-fitting lids were created by Earl Silas Tupper and launched in 1946. Two years later, the company introduced the idea of home parties where the products were sold.

Joyce Byers

The Byerses' home is far more dated than the Wheelers', a reflection of the disparity in the families' economic circumstances. "[Joyce is] a single mom and stressed out all the time, so she just hadn't done much since the '70s, and that's why it looks like the '70s in there," says Jess Royal.

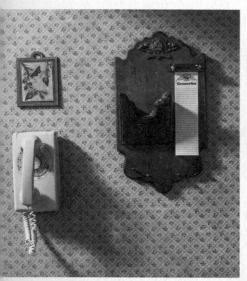

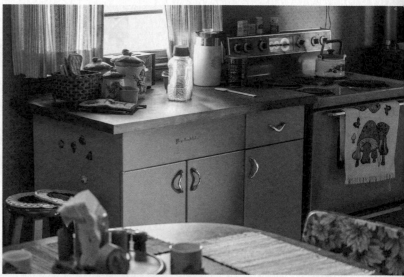

The Byerses' Home

The Byerses' home has a wood-and–earth tone palette and a shabbier, more rustic feel than the Wheelers' home. Instead of wall-to-wall carpeting, an oval-shaped area rug covers only a small portion of the exposed hardwood floors in the living room. The furniture is worn, with a new, smaller television stacked on top of the larger, older model; the kitchen is finished in shades of green.

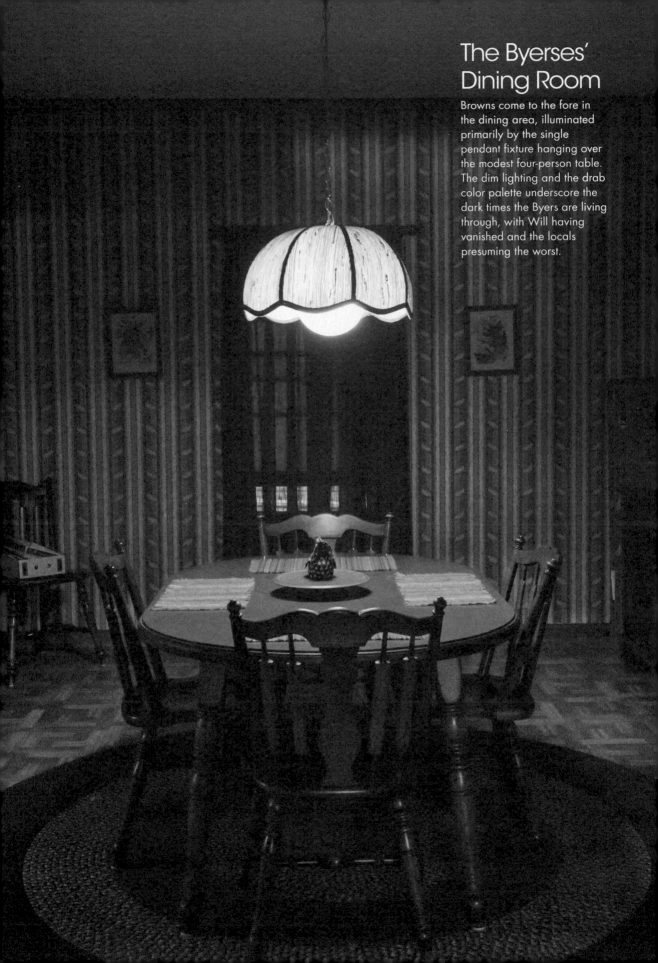

The Byerses' Dining Room

Browns come to the fore in the dining area, illuminated primarily by the single pendant fixture hanging over the modest four-person table. The dim lighting and the drab color palette underscore the dark times the Byers are living through, with Will having vanished and the locals presuming the worst.

NO PLACE LIKE HOME

WHILE BIKING back from Mike's, Will can't get back to his house fast enough after spying a menacing, vaguely humanoid figure lurking from the fog.[10] The being, of course, is the Demogorgon. Having escaped from Hawkins National Laboratory, it arrives in town to feed. It remains unseen even as it vanishes with Will into the night. "Not seeing the monster in season one was a big mantra for us," says cinematographer Tim Ives. "That we took from *Jaws*, where you didn't see the shark until the end.[11] And if we did see the monster in season one, it was always as a silhouette, hardly any detail."

Steven Spielberg's classic served as a reference point, too, for Mark Steger, the actor and movement specialist who played the Demogorgon in the show's first season. Steger says, "The Duffers were very succinct with their direction: that I was like the shark from *Jaws*, this creature that moves from one dimension to another to feed. I tried to make it as creepy as possible, just doing really subtle movements." The scene was set in the wooded location known to the party as Mirkwood, its name taken from the writings of *The Lord of the Rings* author J.R.R. Tolkien.[12]

The woods where Will first spies the creature also is the first place the boys encounter Eleven. The friends initially have no idea what to make of the girl with the shaved head, who's on the run, frightened, and alone. Her arrival helps bookend the episode with a second tantalizing mystery—one character has vanished from the boys' lives, another has appeared seemingly from nowhere.

10 This foreboding fog recalls John Carpenter's 1980 horror film *The Fog*, in which supernatural phenomena occur on the eve of a small town's centenary.

11 Only seen at the end of Steven Spielberg's film, the shark from *Jaws* (*right*) nevertheless remained an ominous threat. The Duffer brothers took a cue from the less-is-more approach in cultivating suspense, waiting until later episodes to reveal the Demogorgon in all his glory.

12 The English author is the most revered fantasy author of all time, having written *The Hobbit* and *The Lord of the Rings*, elaborate fictions set in a faraway land known as Middle-earth. Mike and the other boys would have known Tolkien's works backward and forward.

The rhyming of certain sequences and the overall pacing is as deliberate as every other creative choice the Duffers make. Early on, the brothers worked with the first season's editors Dean Zimmerman and Kevin D. Ross to build rhythm, alternately underlining the horror and the more comedic elements. "There were certain sequences when your heart is racing," Zimmerman says. "That's the way I wanted to cut it—that very fast, furious, heart-pounding pace." He adds, "When you have these moments of high tension, you need these moments of levity to get the audience back to ground zero, to get them sitting back in their seats so when you slap them again in the face with something super scary, they're not ready for it."

One of the series' most frightening environments was Hawkins National Laboratory—a warren of stark corridors, close cells, and cavernous spaces where Eleven was raised in seclusion and from which the Demogorgon escapes. Many of the scenes in the lab were shot at the former Georgia Mental Health Institute, once a psychiatric hospital that now is part of Emory

Millie Bobby Brown as Eleven is handled by Dr. Martin Brenner's orderlies.

University's Briarcliff campus.[13] Whereas the boys' homes are riots of texture and rich period detail, the facility where Eleven grows up is entirely clinical and devoid of personality.[14] Someone could spend a lifetime inside its walls without realizing how much the world outside was changing.

Trujillo made a point to strip the sets of anything that would make the lab feel warmer: "That was all about removing color and having it be this very kind of austere [place. We used] industrial colors, tans and whites and grays, sucking all the color out of that world and emphasizing the institutional coldness and making it feel forbidding."

13 The Atlanta building has a foreboding history well suited to the *Stranger Things* story line. From 1965 to 1997, the forty-two-acre campus was home to the Georgia Mental Health Institute, a 141-bed psychiatric hospital jointly operated by Emory and state authorities (it now houses the university's Continuing Education Department). The imposing structure has appeared in other productions as well, including the acclaimed 2016 NASA docudrama *Hidden Figures* about female mathematicians in the 1960s.

14 *Firestarter* is a 1980 book by Stephen King that follows Charlie McGee, a nine-year-old skilled at pyrokinesis—she can start fires with her mind—who's abducted by a secret government agency that wants to use her as a weapon for its own nefarious ends. As in *Stranger Things*, use of this special skill causes nosebleeds, but in *Firestarter,* it's the girl's psychic father who's afflicted with them. Drew Barrymore played Charlie in the 1984 film.

MKULTRA
THE REAL STORY

In *Stranger Things* lore, Eleven's incredible abilities are a direct result of her birth mother, Terry Ives, having participated in government mind-control experiments without realizing she was pregnant. That might sound like something straight out of a 1960s sci-fi film, but the U.S. government actually did run a covert program in which illicit psychotropic substances, like LSD, MDMA, methamphetamines, and psilocybin, were administered to U.S. citizens, often without their knowledge or permission. It was called Project MKUltra, and it was a multimillion-dollar initiative overseen by the Central Intelligence Agency.

Purportedly carried out as a defense against similar measures agents believed were being undertaken by regimes in Russia, China, and North Korea, the tests were conducted largely at colleges, hospitals, and prisons from 1953 to 1964. It's unclear exactly how many human subjects were involved in the studies, which grew to include behavior conditioning and sensory deprivation before officially being halted in 1973. Counterculture figure Ken Kesey volunteered for MKUltra during his student days at Stanford University, and his experiences influenced his work, including his landmark 1962 novel, *One Flew Over the Cuckoo's Nest.*

The Duffers did some preliminary research into the program as they were initially shaping the ideas for what became *Stranger Things.* "During the Cold War, our government was involved in some potentially shady experimentation," Ross Duffer says. "I wouldn't say [we had done] necessarily a deep dive into it. It was more a surface glance of seeing what they were up to and then using that as an excuse to have science-based horror in our narrative."

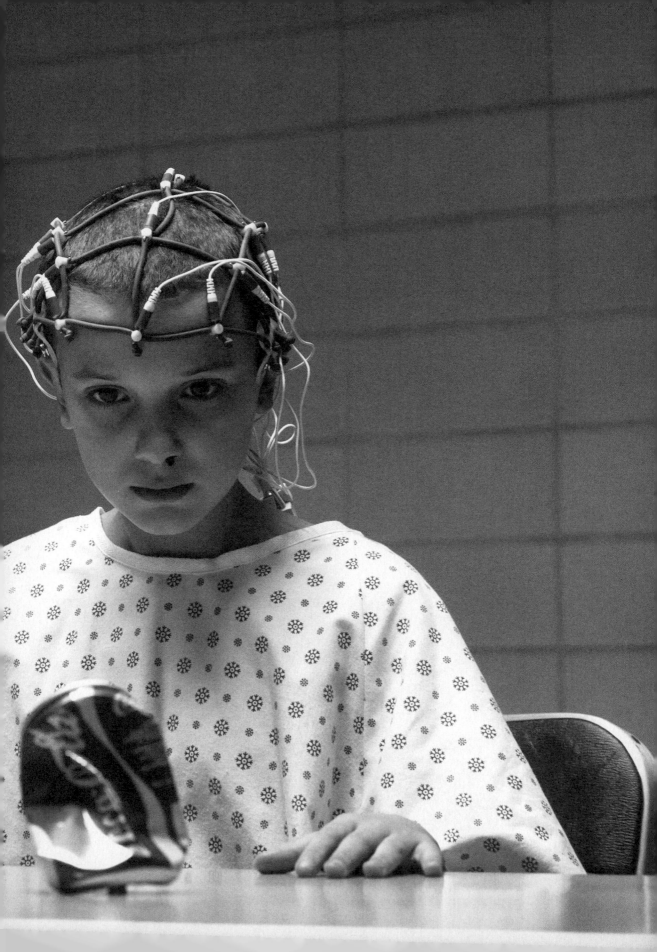

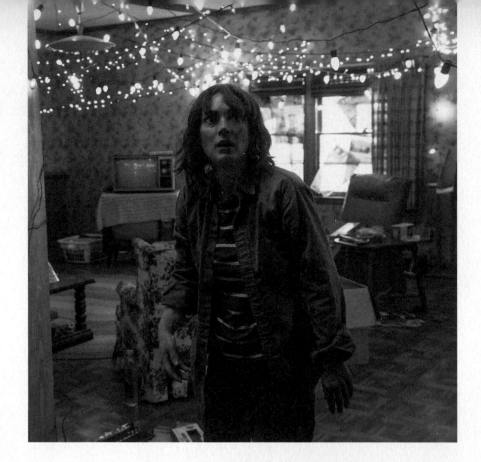

LIGHTS IN THE DARKNESS

INITIALLY, MATT and Ross Duffer had planned to direct all eight episodes of the first season of *Stranger Things*, but as the production got underway, they realized they still needed to devote time and attention to the scripts for the latter half of the season. So executive producer Shawn Levy stepped in, taking the reins of the third and fourth installments—each of which contains pivotal plot points and emotionally challenging scenes.

The third episode, "Holly, Jolly," begins with the Demogorgon dragging Barb to a watery demise.[15] Later, Joyce begins to string strand after strand of Christmas bulbs inside her house because she believes Will can communicate with her using electricity. Matt Duffer says that Joyce's obsession grew out of Winona Ryder's approach to the character. "She's this specific personality—it

15 Foreigner's power ballad "Waiting for a Girl Like You" (1981) plays as Nancy sleeps with Steve for the first time—completely unaware that her best friend is being sucked into a nightmare dimension only one floor below.

made us start to think about Richard Dreyfuss[16] in *Close Encounters of the Third Kind.*"

In Spielberg's 1977 science-fiction classic, Dreyfuss plays a blue-collar Indiana everyman whose behavior becomes increasingly erratic as his obsession with UFOs intensifies. Similarly, everyone around Joyce is unnerved by her certainty that Will is speaking to her through holiday decorations.[17] Set decorator Jess Royal strung the lights on the set and then worked closely with the show's electricians to develop a master control panel so that each bulb and overhead light could be turned on and off as needed for individual scenes. "I like tinkering and just the logistics of making stunts and effects like that work in the old-school way a show in the 1980s would have done it," Royal says. Levy remembers the lights as one of the most unexpected challenges of the inaugural season: "It turns out that Christmas lights don't normally blink in a sequence that communicates narrative." Programming them was not as easy as one might imagine, but "it led to one of the most iconic images of the show."

16 In the film, after Roy Neary (Richard Dreyfuss) spots a UFO, he can't shake the image of a mountain from his mind. Like Joyce Byers, his behavior appears to become increasingly neurotic. He even sculpts the peak out of the mashed potatoes his wife serves for dinner one night.

17 The mother in *Poltergeist* (1982) also uses a household electronic device to communicate with her child who is lost in a netherworld. The film (written and produced by Steven Spielberg, but directed by Tobe Hooper) is a prescient parable on the evils of too much screen time. In a planned community in Orange County, California, a young girl hears voices emanating from the family's TV set when programming is off the air. Her parents only hear static. Eventually, she is sucked into another dimension; she calls out for help through the television. In *Stranger Things,* Eleven becomes entranced by the TV screen in a similarly eerie way, and electric devices of all kinds offer conduits and signals of interference from the other side. Both productions could be read as allegories of the modern human struggle with technology that threatens to overpower us.

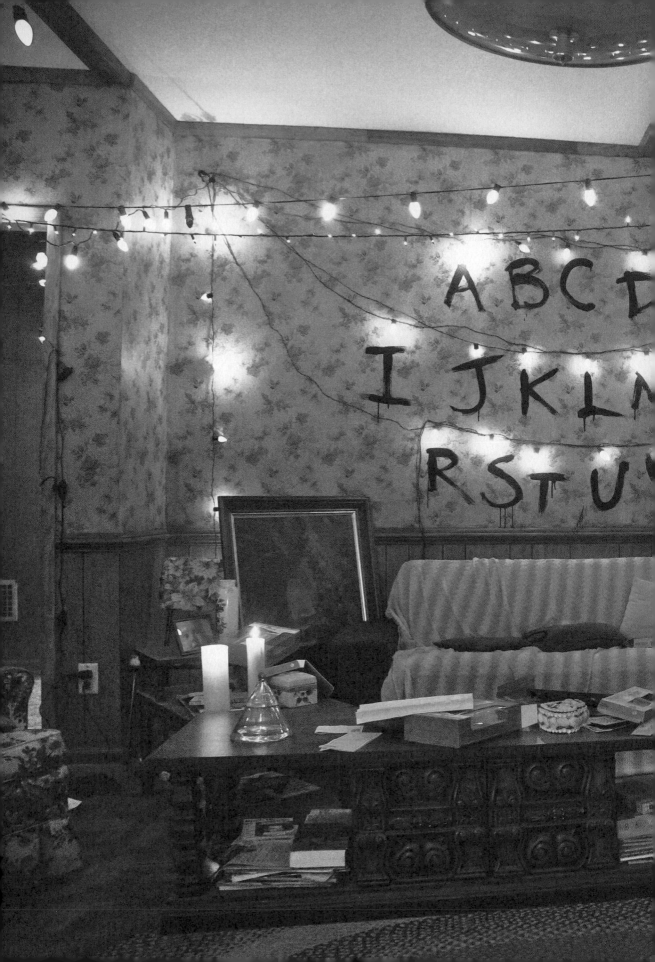

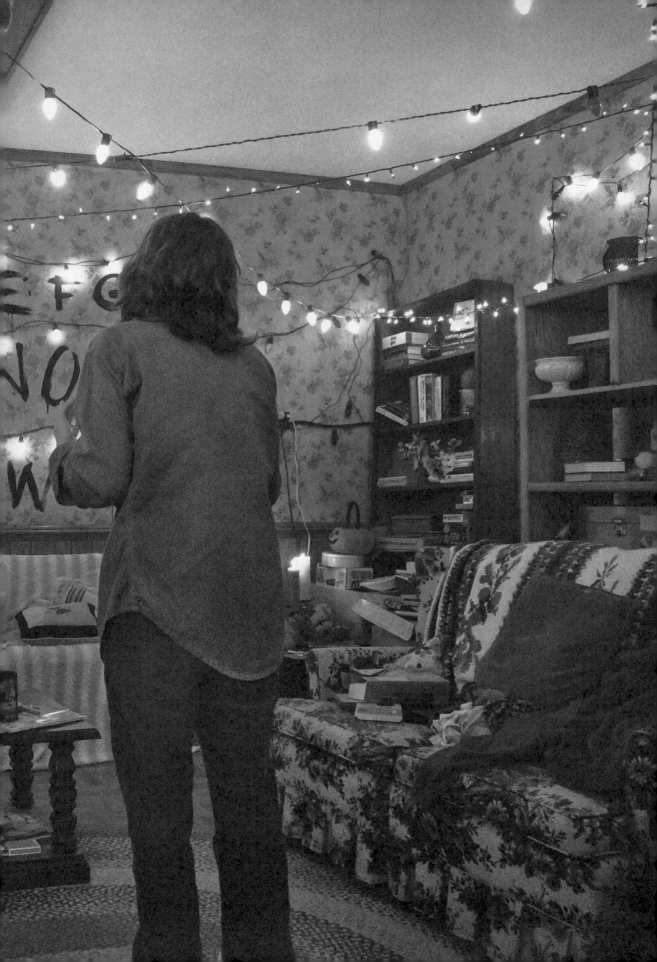

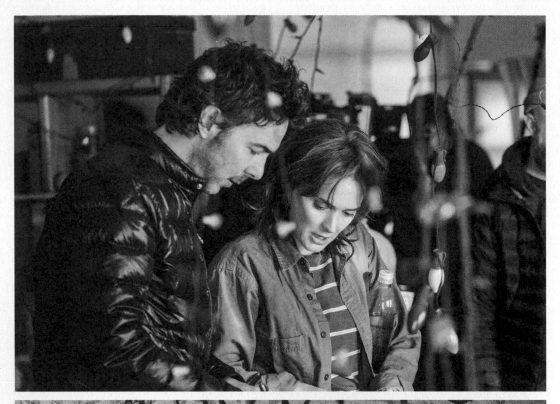

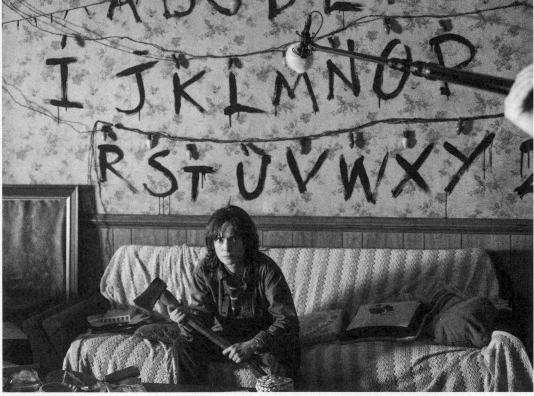

At top, executive producer Shawn Levy directs Winona Ryder through a difficult scene; below, Joyce Byers lies in wait for a supernatural threat.

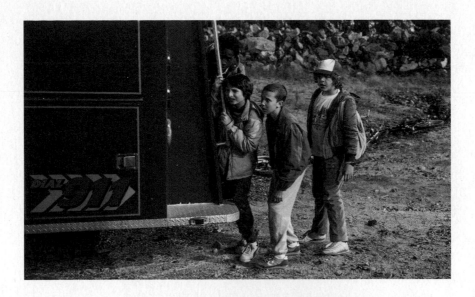

THE CHARACTERS EMERGE

WINONA RYDER came to *Stranger Things* as an acting veteran seasoned in her craft. The young cast members, by contrast, all had varying levels of experience, but none of them had ever had a lead role in a television series. The show's scripts routinely challenged them to bring more depth and nuance to their characters. For the sequence in which a body believed to be Will's is pulled from the lake at the bottom of the quarry, Finn Wolfhard (Mike Wheeler), Gaten Matarazzo (Dustin Henderson), and Caleb McLaughlin (Lucas Sinclair) needed to convey the shock and horror of realizing that their friend will never again be a part of their lives.[18]

"They wanted us to cry or whatever, and Caleb could get it super easy—just turn it on and turn it off super quick and be funny again," Wolfhard says. "I had never really cried before [on camera]...Gaten was trying to cry, and he couldn't. Gaten was laughing, I was laughing, and he couldn't do it. Then, all of a sudden, he just started crying. They were like, 'OK, start!'

18 Ryder's nuanced depiction of a mother moving through the stages of grief showcased not only Joyce's vulnerability and despair, but also her rage. Angry and frustrated by the idea that her son is trapped just beyond her reach, she takes an axe to the wall in her living room, determined to break through to her son. The moment is somewhat reminiscent of *The Shining* (1980), in which Jack Nicholson's character breaks down a bathroom door to reach his wife—though his motivations are more lethal.

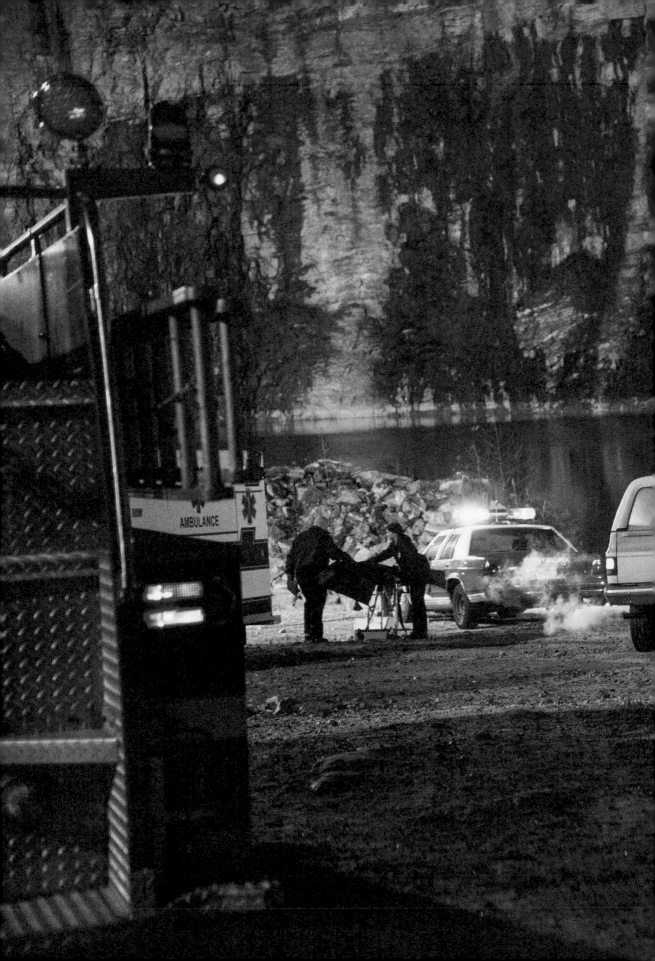

And he did it, and that was it after that and we were back to normal. It's kind of like an instantaneous thing."

While the moment was somber and deeply mournful, typically Levy says he likes to maintain a far more upbeat atmosphere during production, playing music on set to raise the actors' spirits. "I am not a director who likes a silent set," he says. "I like an energy and a dynamism on set, because I believe that's what ends up on screen. And in a show like this that has its share of creep factor, I knew we wanted the vitality of these young characters. You cannot fight the anarchy of youth, so you just better learn how to marshal it."

"It is an interesting show," Levy continues, "because you direct a David Harbour or a Matthew Modine very, very differently than you direct a Finn Wolfhard," Levy says. "Sometimes you need to use more words and be

"I like an energy and a dynamism on set, because I believe that's what ends up on screen."

— SHAWN LEVY —

hyper-articulate, and other times you need to say as little as possible but convey a feeling. The modalities of how these actors do their jobs differs immensely among our cast members."

Patrick Henry High School[19] in Stockbridge, Georgia, provided locations for Hawkins Middle School, where Mike and the boys bring Eleven when she insists that Will is still alive and that she may potentially find him with the right equipment. Hoping she'll be able to channel her powers through the new ham radio[20] science teacher Mr. Clarke (Randy Havens) has procured for the school's A.V. Club, they decide it's time to take her into the broader world of society. To disguise the girl as his cousin, Mike finds a blonde wig and an old dress that once belonged to his sister.

19 The school was named for the Founding Father who famously uttered, "Give me liberty, or give me death."
20 Amateur radio (colloquially known as ham radio) involves using a radio for communication for noncommercial purposes and/or to exchange messages. Science teacher Mr. Clarke obtained his setup from Heathkit, a company that makes kits for assembling electronic devices ranging from clocks to weather stations. A short-wave radio can be used to communicate across long distances.

THE
A.V. CLUB

FALLING IN LOVE WITH TECH

FOUNDED BY BOB NEWBY—remember that name, it'll become important later—the Hawkins Middle School Audiovisual Club, or A.V. Club, is the perfect place from which to launch a curiosity voyage. Members Mike, Dustin, Lucas, and Will meet regularly with science teacher Mr. Clarke (Randy Havens), the cheerful mustachioed genius who sometimes shares a little too much of his expertise with the gang. "Mr. Clarke is the science teacher I wish I had had, but I never did have,"

Matt Duffer says. "I didn't really get into science for the longest time because my science teachers weren't exactly inspirational. How do you make this stuff, which is so interesting, so dull? I found it all so boring, until I was in college and I was exposed to *Cosmos* and Carl Sagan. Mr. Clarke was really inspired by Carl Sagan, who seemed to me sort of like the ultimate science teacher." Like the Duffers, Mr. Clarke enjoys the early films of John Carpenter (as he's hanging with a lady friend one

ST-CA-4969 ST-WT-4971 ST-HK-5

evening, they're watching *The Thing* on TV). "We love Mr. Clarke," Ross Duffer says. "He's just pure nerd."

When the boys aren't together at school or in Mike's basement, their preferred mode of communication is via walkie-talkie. Many of the walkie-talkies used for filming were picked up by property master Lynda Reiss. "I actually got booked for the show two months before I started, and when I'm not working, I'm in California," Reiss says. "I was at the Long Beach flea market, and I saw two of the many walkie-talkies we ended up getting, and I bought them. I sent pictures to the Duffers, and they loved them. We wanted these big walkie-talkies next to the smaller kids' faces with the big antennas and everything."

Reiss also found Jonathan Byers's camera, which she selected based on a model she herself once owned. "I went to Hong Kong in 1979, I think, and I bought myself a thirty-five-millimeter camera. It wasn't high-end, but for me it was an expense at the time. So I picked a camera that I had used in that era. With Joyce working two jobs to pay the bills, there wouldn't have been money to buy that camera. But a couple of years prior, maybe before the father left, there might have been money, like at Christmas, to get the camera."

ST-VR-5014

ST-HS-4975

ST-RA-5041

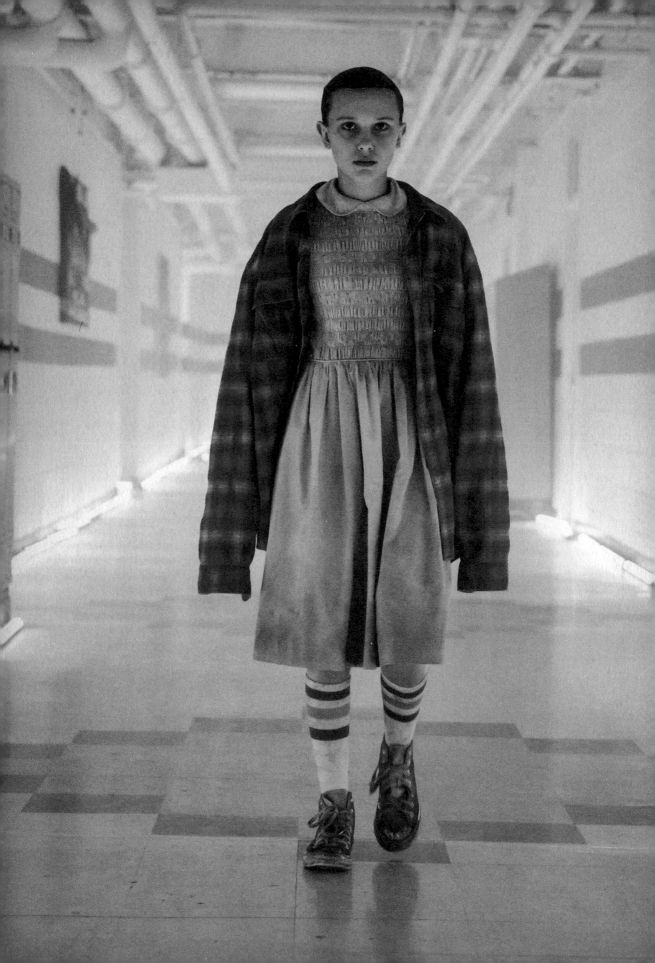

Costume designer Kimberly Adams designed the garment[21] based on the style of the Polly Flinders brand that was popular in the 1970s. Typically these dresses had elastic smocking across the chest, Peter Pan collars, and sleeves gathered with elastic at the wrists. "Every little girl had the Polly Flinders," Adams says. "We did many of those dresses. We found a fit that felt right for the character and then played with the wigs so we could marry the whole look. The embroidery was all hand-done.

"I went to the fabric store wanting to find [a fabric that] was not quite pink, not quite peach, not too hot pink, and settled on what was, to me, almost like in between peachy and pink. It just felt sweet enough. But then the twist with the Chucks[22] and the stripy socks helps make it more for Eleven."

21 The frocks that became ubiquitous among a generation of girls took their name from an old English nursery rhyme: "Little Polly Flinders/Sat among the cinders,/Warming her pretty little toes./Her Mother came and caught her,/And whipped her little daughter,/For spoiling her nice new clothes."

22 The first real athletic shoe was introduced to the public in 1923, when American basketball player Charles "Chuck" Taylor joined a team sponsored by the Converse Company called the Converse All Stars.

Eleven's trip to the middle school allowed the Duffers to introduce levity into a relatively intense episode. "We wanted that classic fish-out-of-water scene," Matt Duffer says. "Obviously, it led to the humor of them having to try to make her look a little more like a typical student, but also having the boys create what they think a typical female student looks like."

As filming progressed, the young actors flourished under the direction of Levy and the Duffers. Wolfhard and Brown found a way to convey the shared understanding between Mike and Eleven and their profound affection for one another. "I think what's cool is there's a story arc for Mike," Wolfhard says. "At first, he finds this girl and he treats it like, 'Oh, I discovered something really cool.' Then he kind of realizes halfway through the second episode [that] this is an actual girl. It's not E.T.[23] It's a person. He's never even really talked to a girl, and now he's teaching a girl to talk.

"I think he's just drawn to her because one, she's the first girl that's ever had interest in him, and two, he has crazy interest in her and what's going on

23 Seeing Eleven in Nancy's old dress and a long blonde wig evokes the moments in *E.T. the Extra-Terrestrial* in which Gertie (Drew Barrymore) initially treats the alien creature like a doll, adorning him in her favorite finery—blonde wig, floral frock, mink stole, rhinestones, and pearls. Her brother protests, "You should give him his dignity."

in her brain," Wolfhard continues. "He just feels bad for her, too, that she's gone through all this. It's very cathartic for both of them. They talk to each other and they vent because Mike and Eleven are sort of outsiders."

Offers Brown, "Mike doesn't really need anything from her. He just loves her for who she is."

The connection among the boys also developed in surprising, unexpected ways. "Some of the actors came with their roles and parts baked in, and some were totally a revelation," recalls co-executive producer Iain Paterson. "For instance, Finn had been written as kind of the leader of the group, and so that was baked into his character. Lucas was wonderful, too. He was really terrific bringing his brand of comedy, which is quite different from Gaten's, to the table. There's always that kind of Three Musketeers[24] weird comedy between the three kids. Finding that in the first season was one of the great joys."

24 The famed 1844 novel by French author Alexandre Dumas chronicled the 17th-century adventures of a young man named d'Artagnan who fell in with a trio of formidable swordsmen: Athos, Porthos, and Aramis. It's also the name of an excellent candy bar made from chocolate and whipped nougat. Both the book and the candy are referenced in *Stranger Things 2*.

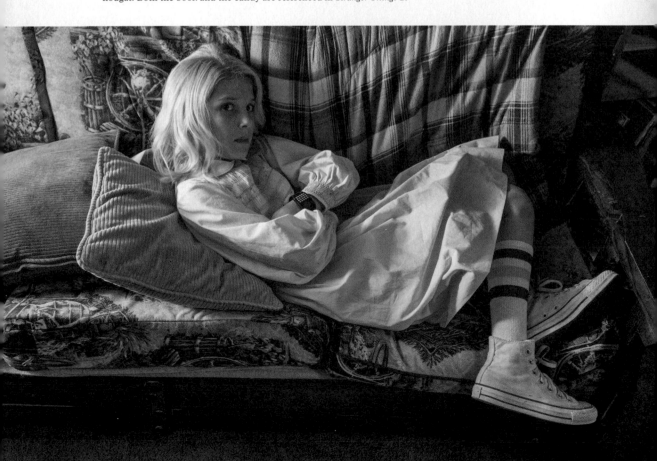

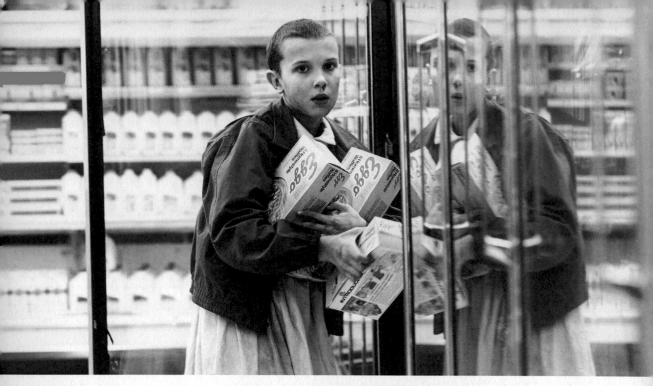

Eleven (Millie Bobby Brown) raids the local market for her favorite frozen waffles.

ELEVEN SHOWS HER POWER

BUT THERE'S conflict among the group, too. After Eleven sabotages the compasses[25] the boys are using to help locate the entry point to the alternate dimension that's been dubbed the "Upside Down," a heated argument breaks out among them. It ends with El—as the boys begin to call her—psychically throwing Lucas off of Mike and briefly knocking him unconscious. McLaughlin himself was excited to try the stunt, which basically involved his being yanked briskly into foam padding. "Caleb's very athletic," Matt Duffer says. It was filmed amidst an actual junkyard, which comes to serve as a sort of symbolic haven for this group of kids who don't quite fit in with the mainstream. (The defunct schoolbus reappears in season two.)

"That scene was so dope," says McLaughlin. "That was amazing because it was like six different shots where they dragged me. [At one point] I was on a harness flying through the air. It was so much fun."

25 Before the era of GPS and Google Maps, a simple compass was the easiest way to navigate. Compasses feature a freely rotating needle that interacts with the Earth's own magnetic field to determine in what direction north lies. However, the instrument is not infallible: disruptions in the Earth's magnetic field can alter its readings (a fact Eleven used to her advantage).

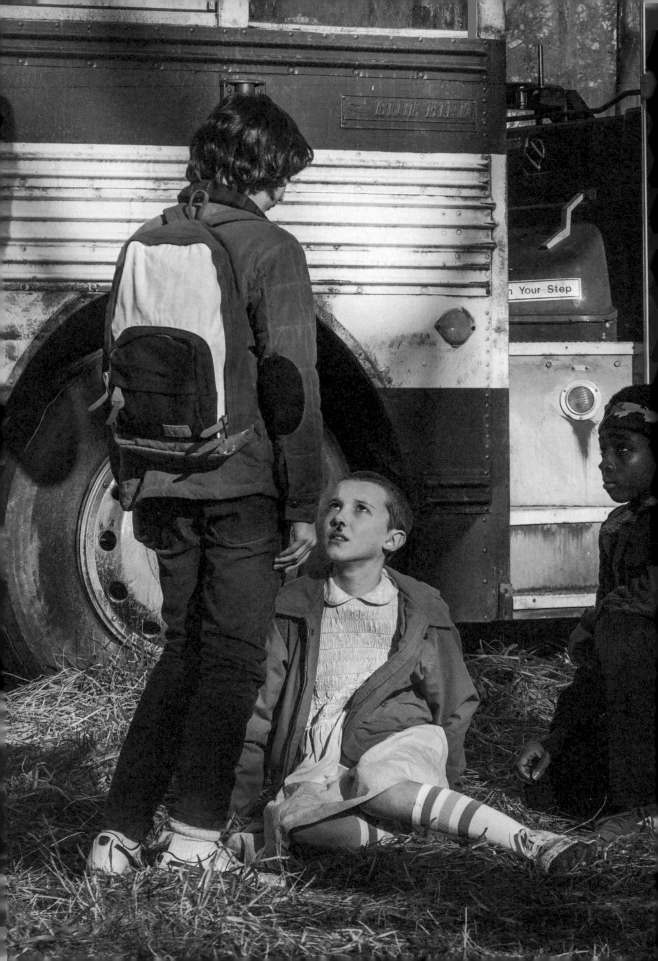

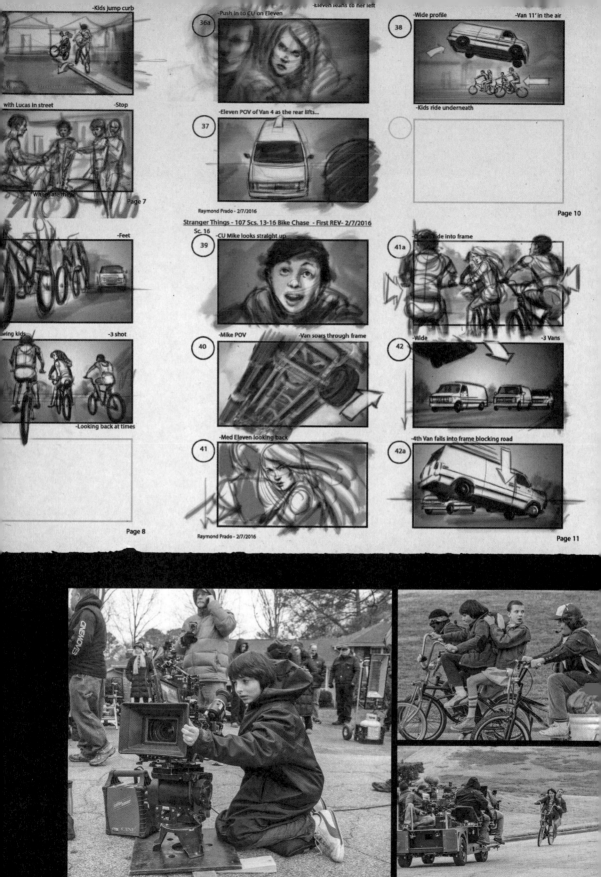

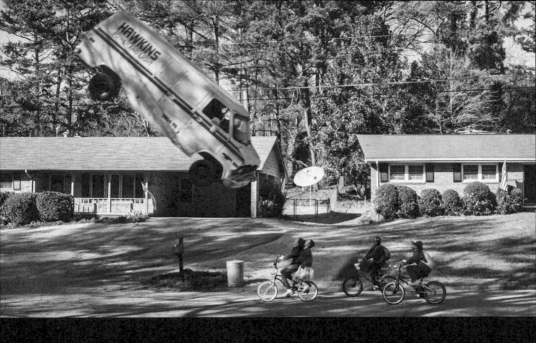

SCENE BREAKDOWN

UP IN THE AIR

It's one of the most eye-popping displays of Eleven's amazing powers: as the young heroes are pursued by Brenner and his "bad men" through the streets of Hawkins, the gifted girl stares down a white van coming straight toward Mike and her and sends it soaring overhead. The vehicle crashes to the street below, blocking the pursuers' path and allowing the kids to escape. Special effects coordinator Caius Man explains how he helped Eleven make the van fly:

"From our standpoint, it really wasn't that supremely complicated. A flying car is a flying car. There were some unusual aspects to that because of the unnatural way they wanted it to fly, where it lifted sort of straight up and then tipped forward, so it took a little engineering. But it worked when we did it.

"We actually physically fired a van. We towed one down the street, and the van had in it two nitrogen cannons, two nitrogen sleeves that fired a high-density plastic slug out of the bottom of them to push it up into the air. One was just hitting a little harder than the other, which is what resulted in it going end over end the way it was supposed to.

"We built a small test in our shop. Basically, we built a plywood van with a couple of pneumatic cylinders, and we hopped it around the shop a bunch of times and were satisfied that it was going to function. [The Duffers]

wanted to see a full-size version of it to make sure that we could get it sufficiently high [so that they] could composite the children on the bicycles underneath it. What we did is, we shot it in the air, and then we had the kids ride down the street with the camera in the same position. Then we just cropped the two images together. We didn't shoot the van over kids. That would be insane.

"We took it to a parking lot—a similar van, not exactly the same van—to a parking lot at Screen Gems, at our studio, and shot it. It launched, and everybody was excited. It landed exactly where I told them it was going to land, and pretty much everything was as it should be. On the day, we pointed three cameras at it, and we had a camera in the middle of the street that was aimed straight at it. It was the POV of the kids, and we fired it up over the camera. The first time we did it, we had a mechanical flaw. Instead of jumping up in the air, the front end jumped up and not the back, and it shark-attacked the camera in the middle of the street and destroyed it. So that didn't work as well as we would've liked.

"It turned out to be a mechanical failure in a part that we replaced. The body shop fixed up the bumper in a couple of days, and we shot it again two weeks later. It was flawless and beautiful. As Shawn [Levy] described it, the gag's so nice, we did it twice."

The fight among the boys triggers a painful flashback for Eleven in which she recalls being submerged in an isolation tank[26] to help locate a Russian agent. The scene required Brown herself to remain underwater, and to underscore her terror in those moments, cinematographer Tim Ives employed theatrical lighting. "We used haze and smoke in order to catch light, which is something that was done a lot back in the 1980s. I wanted the water tank to pop," he says. "We had underwater lighting in there—that's the main source of light. Sterile environments tend to be sometimes very bright, but I definitely wanted to keep it mysterious and dark in there, too."

The scene in the sensory-deprivation tank was particularly challenging for Brown because, once submerged, she couldn't fully communicate with her directors. "She had an earpiece on, and the guys—because there's no dialogue in that moment—the guys were talking to her while she was underwater, directing her and saying, 'Give us a sign if you need to come up or anything,'" says executive producer Dan Cohen. "It was a very unique way of capturing that moment, and that set was so cool. That was a moment that

26 The isolation-tank scenes have drawn some comparisons to the film *Altered States*, which stars William Hurt as a professor who experiments with psychedelic drugs while inside a sensory-deprivation tank. The movie served as a key reference point for *Stranger Things* production designer Chris Trujillo as he was early in the process of conceptualizing sets for the series.

Millie Bobby Brown as Eleven on the set of *Stranger Things*.[27]

I really remember fondly because if you step back and look at it, this is a really wild scene that we're shooting. This kid who was born out of a lab basically is in the water with a helmet on, and yet it was so magical."

The junkyard altercation prompts Eleven to leave the boys behind, but she stages a triumphant return when Mike and Dustin need her most. Bullies James (Cade Jones) and Troy (Peyton Wich) chase the boys down to the quarry and threaten to cut out Dustin's teeth unless Mike leaps into the waters below. He jumps, knowing he's unlikely to survive the fall, but Eleven lifts him back onto the lip of the quarry and turns her fury on the cruel tormenters.

For the Duffers, the visual-effects-intensive sequence, shot at Atlanta's Bellwood Quarry, proved to be one of the season's most challenging. "It was really difficult to move around there," Matt Duffer says. "It was really hard to get equipment there. By the time we got all set up, I think we may have had five hours with our kids. We didn't really know what we were doing as far as digital effects were concerned. I remember feeling very lost when we were shooting this."

"We had to make it look like Mike was really teetering on the edge there, and then we had him falling as well," adds cinematographer Ives. The

27 The black room with the black-water floor is reminiscent of the "black room" in *Under the Skin*, in which Scarlett Johansson plays an alien who lures men into her lair who get absorbed into the black water and digested.

crew had been striving to reveal elements of the story with extensive camera work in earlier scenes such as the 360-degree turn inside Hopper's trailer. But the quarry offered a chance to go even further technically. A fifty-foot techno crane was set up to capture the most arresting angles. "There were green-screen elements where we had Finn Wolfhard in a harness on green-screen falling toward camera, falling laterally, going back up. And then we had to fly him over our camera. The rock that he steps off of was at that location, but it was off to the side with a pad underneath. We were just underneath looking up at him."

"Our friend has superpowers, and she squeezed your tiny bladder with her mind."
— DUSTIN HENDERSON

Ultimately, though, the camaraderie among the cast came through on screen. "The group hug at the end, that's what people remember," Matt Duffer says. "Not the shaky-looking green screen. Even though it still bothers me."

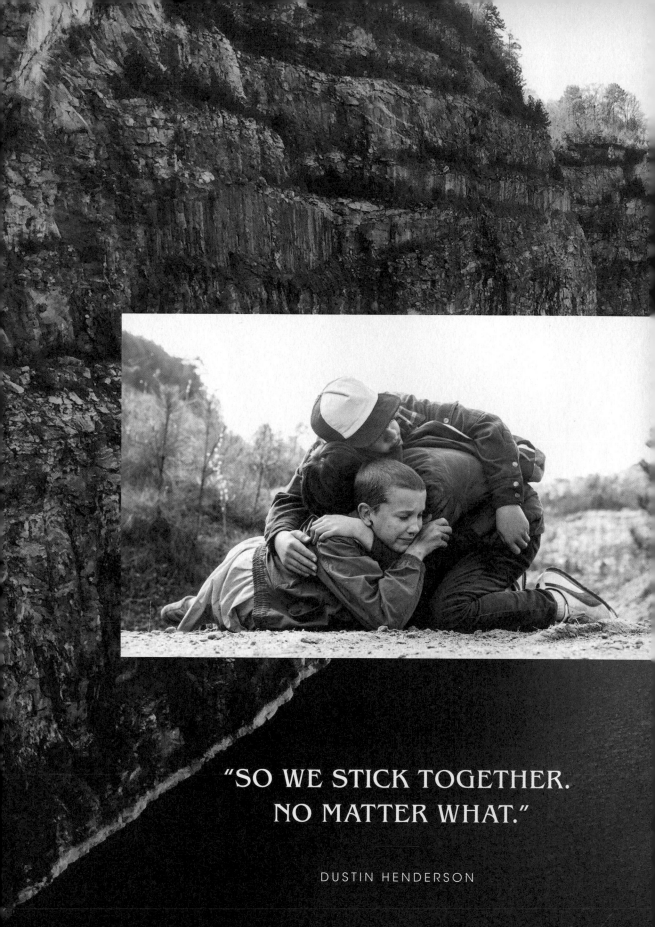

"SO WE STICK TOGETHER.
NO MATTER WHAT."

DUSTIN HENDERSON

The Not-So-Good Girl

NANCY WHEELER

Played by: Natalia Dyer

Year: Sophomore **Sports:** Varsity Volleyball, Cheer Squad **Clubs:** National Honor Society, Student Council, French Club, Model UN **After-School Activities:** Meals on Wheels, Hawkins Presbyterian Youth Fellowship, writing tutor

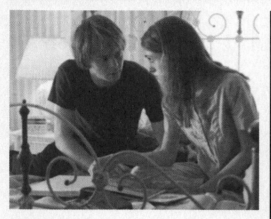

Above: Late-night study buddies.

"Don't you think it's weird how we only seem to hang out when the world's about to end?"

—Nancy Wheeler

Below: Nancy steals a moment with boyfriend Steve Harrington—plotting prom plans perhaps?

I magine making one mistake that will haunt you for the rest of your life. Nancy Wheeler's days as the straight-A student who is always home by curfew abruptly end after she falls for the ultra-popular Steve Harrington (Joe Keery) and falls in with his fast crowd of friends. Nancy chooses to ditch her closest pal, Barb Holland (Shannon Purser), at a party at Steve's house. But she doesn't realize that when she leaves Barb alone and vulnerable, her friend will become prey for the hungry Demogorgon lurking nearby.

"Nobody knew that there was some kind of supernatural creature running around," says Natalia Dyer, the actress who plays Nancy. "Everyone's put in a situation where they make the wrong decision, putting romantic interests over their friends. And that goes both ways. I think both men and women do that. It's just a time in your life when your social world is so important and where you fit in is so important."

Dyer was in her late teens when she was cast as Mike's seemingly perfect older sister in *Stranger Things*. It was a breakthrough role for the young actress, who got her start in 2009's *Hannah Montana: The Movie* opposite Miley Cyrus. To prepare, the Duffer brothers referred her to another famous Nancy—Nancy Thompson, the resourceful high-school student portrayed by Heather Langenkamp in the 1984 horror film *A Nightmare on Elm Street*, who has a fondness for sweater sets and a way with booby traps.

If Nancy Wheeler begins *Stranger Things* as the stereotypically perfect girl next door enduring the trials that typically come along with coming of age, she doesn't stay that way for long. Determined to solve the mystery of what happened to her friend, the oldest Wheeler child finds her life taking off in unexpected directions—most of which she's not entirely equipped to navigate. Instead of worrying about crushing on the cool guy, or dealing with her annoying little brother and his weird friends, she's tromping through the woods and learning how to fire guns to become a better monster hunter.

For Dyer, it was thrilling to play a multifaceted, imperfect heroine who is attempting to deal with impossibly difficult circumstances. "OK, how does it feel to lose your best friend to an inter-dimensional monster? That's not something I've experienced in my life personally," Dyer says. "Losing anybody that close is hard, and losing them in such a traumatic way, as much as you can imagine, is incredibly hard. And to feel responsible for that on top of everything— Nancy can't talk about it to anybody, and that's all she wants to do. She's really grieving on her own, in a way."

Nancy finds a kindred spirit in Jonathan Byers (Charlie Heaton), who is dealing with his own feelings of loss over his brother's disappearance. As the characters learn more about the creature threatening their hometown, they are pulled toward one another, putting them both at odds with Steve. But Nancy's season-one story line is about much more than who she's dating: it's about her personal growth.

"The more you get to know Nancy, the more you realize she does mess up a lot," Dyer says. "I love that she's still figuring herself out, dealing with all the high-school dynamics of life and boys and friends in that weird transition period between being a young girl and becoming a young woman. I think she's developing a strong moral compass."

She's also learning how to kick some ass. "Those are probably my favorite scenes," Dyer says of the moments when Nancy takes charge. "I honestly don't know how to shoot a gun in real life, but when Nancy gets to be a bad-ass, those are some of the most fun, really cool scenes." ▼

Top: *Nancy chats with bestie Barb Holland before heading to class. Trading last-minute study tips for Kaminsky's chem test, ladies?*

Middle: *Uh-oh. Mom and the cops? That's never a good sign. Better fess up, Wheeler, while you still can.*

"Let's burn that lab to the ground."

—Nancy Wheeler

Bottom: *No one said sophomore year was easy, but you're looking awfully worried, Nancy Wheeler.*

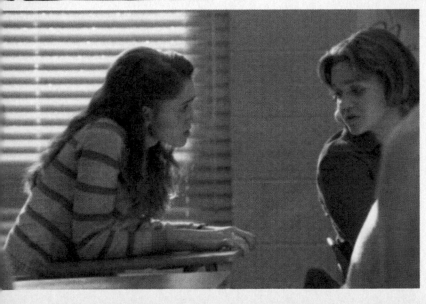

THE NOT-SO-GOOD GIRL: NANCY WHEELER

The Wallflower

BARB HOLLAND

Played by: Shannon Purser

Year: Sophomore **Sports:** Varsity Softball **Clubs:**
Class Treasurer, Marching Band (first clarinet),
National Honor Society, Key Club, Mathletes
After-School Activities: Rotary Youth Exchange,
Hawkins Community Library volunteer, babysitting

> "Nancy, seriously, you're gonna be so cool now, it's ridiculous."
>
> —Barbara Holland

Poor Barbara Holland might not have enjoyed much popularity during her short life, but in death, she found immortality. Shannon Purser was just eighteen when she was cast as the famously ill-fated wallflower on *Stranger Things*, the girl who meets a gruesome end after being left alone at a party by her best friend, Nancy Wheeler (Natalia Dyer). It was the first screen role ever for the Atlanta native, who subsequently landed parts in the high school–set series *Riverdale* as Ethel Muggs and the limited-run musical *Rise* as Annabelle. "I got very lucky," she says.

Purser taped her first *Stranger Things* audition in her parents' basement, reading two scenes between Barb and Nancy opposite her real-life best friend. Later, she got the phone call to schedule an in-person meeting: "'Hey, the Duffer brothers want to meet you and want to see you audition.' I was just horrified and excited all at the same time," Purser says. "I just remember driving up to the audition in my mom's minivan—it was the first time I'd ever been on a soundstage—just being so nervous and so overwhelmed, but it went well."

During the meeting, Matt and Ross Duffer asked Purser to perform Barb's death scene—in which the Demogorgon drags her into its world through the swimming pool at Steve Harrington's house. "We'd never met before, and we're in a tiny room," Purser says. "And so I'm like, 'Am I really about to scream bloody murder in front of these two men that I've never met?' I just went for it, and I think that's sort of my approach on the day, too. Acting is so weird, because you have to be both very self-aware and also able to just completely let go."

"The Duffers had a very specific idea for [Barb]—as they do for every single role, even one-line roles," says casting director Carmen Cuba. "But once we saw Shannon, it was pretty clear she was our girl. She was singular and strong yet still so young—she was still in high school!—and really seemed to connect with the material. She didn't feel like a

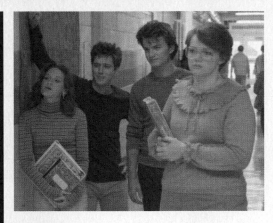

Above: *Barb is hanging with the in crowd (but no one looks too pleased). From left, Carol, Tommy H., Steve Harrington, and Ms. Holland herself.*

Below: Striking a Halloween pose; Nancy + Barb, BFFS 4 Ever.

Hollywood version of Barb. She felt like every Barb from our childhoods."

Despite Purser's youth, she says she was up to speed with the pop culture of the 1980s, so the show's setting didn't feel especially alien to her. "I grew up watching '80s movies," she says. "I was very familiar with Michael Jackson. Even though I am a '90s baby—it felt weirdly familiar."

Although Barb has only a few scenes, she struck a powerful chord with viewers. After *Stranger Things* debuted, the hashtag #JusticeForBarb began trending, and there was even speculation that the Duffers might find a way to rescue her from the Upside Down. While that was not to be, the character did continue as a palpable presence long past her last living moments on-screen.

"There is just something so relatable about this girl who is uncomfortable and trying to figure out who she is and wants to be popular but kind of resents the popular kids because she feels left out," Purser says. "I think more of us than not were not the really cool, hot, popular kids in high school. We were just kind of trying to get by without being too embarrassed." ▼

Above: *Looking cool! Love the shades.*

The Lone Wolf

JONATHAN BYERS

Played by: Charlie Heaton

Year: Junior **Sports:** Cross-Country **Clubs:** Photography Club, Newspaper, Yearbook **After-School Activities:** Photography, target shooting, making mixtapes

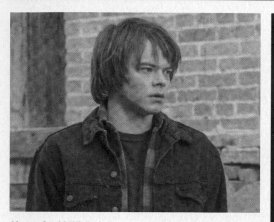

Above: Ouch! What drew you into that back-alley?

> ## "You shouldn't like things because people tell you you're supposed to."
> —Jonathan Byers

Below: Look out, Peter Frampton—Jonathan Byers comes alive. Love a fella with an acoustic guitar.

For English actor Charlie Heaton, the role of shy and sensitive adolescent Jonathan Byers felt strikingly familiar. "I remember coming across it—I'd been reading a lot of material—and I was like, 'Wow, I really kind of understand this guy,'" Heaton says. "I come from a music background. I used to play in bands. My upbringing was very similar to Jonathan's. I grew up in a working-class family. I grew up with a single mother, so there were a lot of relations that I saw within myself and Jonathan."

Heaton's personal touch helped develop the broodiest adolescent in Hawkins beyond the simple outsider he might have been. With a passion for post-punk music and an interest in photography, Jonathan longs to leave Hawkins behind to study art and photography at New York University. But he isn't suffering from typical teenage ennui—his angst grows out of genuine concern for his little brother, Will (Noah Schnapp), and his mother, Joyce (Winona Ryder), whose theories about her son's disappearance are growing increasingly far-fetched. Jonathan is left to try to hold things together.

Before Heaton arrived on the *Stranger Things* set, he had appeared in several roles in film and on television, but working through the dramatic moments with Ryder provided an invaluable education for the young actor. "It was an amazing lesson to be able to share that experience with Winona," he says. "You're trying to be very vulnerable, and she helps you with that. When you're both very emotional together, you literally do takes and then afterward, you'd be checking up on each other, just very supportive."

Jonathan finds a truly unlikely ally in Nancy Wheeler (Natalia Dyer), and as the pair spend time together hunting monsters, he develops serious feelings for her—which present something of a problem, given that she's mostly still seeing popular party boy Steve Harrington (Joe Keery). "They're kind of put together by fate," Heaton says of Jonathan and Nancy. "They each have a part that the other person doesn't. Jonathan is always someone who is who he is. He has a lot of responsibility. He's not going to change the way he is for anybody. He's very strong. I think for Nancy, meeting Jonathan, she gets to be herself in a way.

"Sometimes, it's kind of hard to say in words. I feel like when you fall in love with someone or you're attracted to someone, you don't necessarily choose who that person is. It just happens."

For starters, Heaton might have chosen a girl with a different name for his *Stranger Things* character. "This is my first major role with an American accent, and it went pretty smoothly," Heaton says. "Funnily enough, there was one word during the first season that I couldn't say in an American accent, which was *Nancy*. It ended up being a joke with the crew. The forest scene where Jonathan is running around the woods screaming, *Nancy*—I couldn't say it." It was a night shoot that ran into the early hours of the morning, and to try to help him, the whole crew was chanting back "Nancy" in an emphatic American accent. "I couldn't get it, which was hilarious." ▼

> ## "Nobody normal ever accomplished anything meaningful in this world."
> —Jonathan Byers

Left: *Jonathan Byers and Nancy Wheeler share a moment in the hallway.*

Below: *Together again? Better be careful, guys. People are starting to talk.*

> "Sometimes, people don't really say what they're really thinking. When you capture the right moment, it says more."
>
> —Jonathan Byers

Left: *Say cheese! Hawkins's resident photographer captured in action.*

THE LONE WOLF: JONATHAN BYERS

The King Bee

STEVE HARRINGTON

Played by: Joe Keery

Year: Senior **Sports:** Varsity basketball, Varsity baseball **Clubs:** Student Council, Key Club, Future Business Leaders of America, Prom Committee **After-School Activities:** hanging out with my girlfriend, partying (keg stand champion)

THE KING BEE: STEVE HARRINGTON

Right: *Steve takes a moment to tie his Nikes. Who says jocks aren't smart enough to tie their own shoes?*

Middle left: *Steve's face has seen better days. What happened, Steve?*

"I may be a pretty shitty boyfriend, but turns out I'm actually a pretty damn good babysitter."

—Steve Harrington

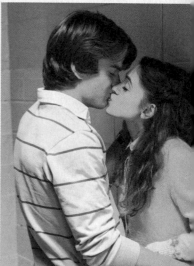

Middle right: *Class couple Steve Harrington and Nancy Wheeler caught in the hallway catching some face time between classes. Get a room, guys!*

Right: *Steve and Nancy chow down on Hawkins High's famously grody cafeteria food. Gag me with a spoon!*

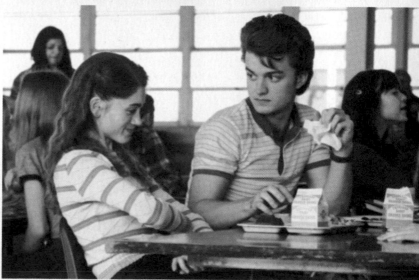

E very 1980s high-school movie has a Steve Harrington: the popular preppy jock from the wealthy family who inspires more crushes than any other boy but maybe isn't the nicest guy. So when Matt and Ross Duffer were populating Hawkins High, Steve became an almost obligatory sort of presence—one never intended to make it out of the first season alive. "This Steve character," Ross Duffer says, "he was just supposed to be this giant douchebag." Then Joe Keery came along.

The young actor brought a certain easy charm to Steve, giving the character real heart and a conscience. He began to feel like an essential part of the *Stranger Things* ensemble—which meant that killing him off was no longer a viable option. "We fell in love with Joe," Ross Duffer says.

After graduating from Chicago's DePaul University, where he studied theater, Massachusetts native Keery began pursuing a career in acting as well as music, appearing in TV series such as *Chicago Fire* and *Empire* and playing in the psychedelic rock band Post Animal. His first feature-film role came courtesy of Windy City indie auteur Stephen Cone's coming-of-age story *Henry Gamble's Birthday Party*.

Keery auditioned for the role of Jonathan Byers as part of a nationwide casting call. Two months later, he had a quick Skype conversation with Matt and Ross Duffer, and just one week later, he got good, if somewhat surprising, news. He'd been cast—as Steve. It was at that point that he decided to shape the character as something other than a straightforward antagonist.

"I wanted to justify the character's actions, so he wasn't doing terrible things for no reason," Keery says. "That was my goal going into it. Then as the process went along and the scripts came out, I worked with the brothers to create this sort of tightrope between doing the right thing and doing the wrong thing, just trying to make sure that every single choice that he made, whether it was good or bad, was justified."

Keery adds, "I don't think he's necessarily turned out to be a villain, but I do think he was the opposite to Jonathan. He's pretty affluent and maybe doesn't understand things the way a character like Jonathan, who has been through struggles, [does] just because of his upbringing."

Given Steve's social standing, it comes as a bit of a shock to him when he finds himself vying with the elder Byers brother for the affections of Nancy (Natalia Dyer), and his jealousy turns ugly fast. But his relationship with Nancy ultimately becomes a catalyst for personal growth. "Looking back now, it's like he lived his life a certain way prior to meeting Nancy," Keery says. "Sometimes you meet people in your life that change the trajectory of the things that you think are important."

Behind the scenes, Keery enjoyed spending time with his more youthful costars—watching them work together serves as a powerful reminder to approach acting with a sense of curiosity and play. Good thing, considering where the Duffer brothers would ultimately take Steve's story line in the second season of *Stranger Things*.

"You learn a lot from working with new people, and especially from a totally new age group," Keery says. "Having a lighthearted playfulness on set is very important. It's something that I like to bring, but I often forget. It was a constant reminder each day just to listen to each other, relax, and have fun." ▼

Above: *The King Bee surveys the halls of his kingdom.*

"It's Fabergé Organics. Use the shampoo and the conditioner, and when your hair is damp . . . you do four puffs of the Farrah Fawcett spray." [1]

—Steve Harrington

Below: *Not many guys can rock a Christmas sweater. However, this preening peacock has no qualms about outshining his girlfriend. Lookin' good, Steve, but have you no shame!*

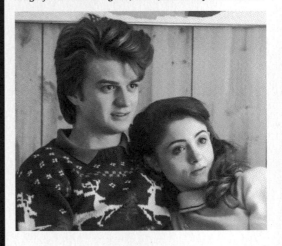

1 1980s men's mullets came in numerous variations: the Country mullet (think Billy Ray Cyrus), the Heavy Metal mullet (à la Whitesnake), the Wet-Gel mullet (Lionel Ritchie). Steve's version is most reminiscent of the meticulously coiffed New Wave mullet made popular by stars like John Taylor of Duran Duran, though Steve doesn't have the frosted bangs . . . yet.

FACING DOWN THE DEMOGORGON

WHILE THE boys have been searching for Will, Nancy and Jonathan have been hunting the monster who took him (and Barb), and the unlikely allies team up to lure the creature to Jonathan's home, which has been rigged with a bear trap.[28] The sequence was filmed over the course of one very long day, with Charlie Heaton (Jonathan Byers), Natalia Dyer (Nancy Wheeler), and Joe Keery (Steve Harrington) channeling their inner action heroes.

"I loved the showdown inside Joyce's house with the teenagers," says Demogorgon actor Mark Steger. "We spent some time with the stunt coordinator—there are certain things [you have to determine], like how do you sell me hitting one of the kids, for instance. It has to be done a certain way from certain angles. When Steve hits me with the baseball bat with the spikes, it was a heavy rubber bat.[29] It was solid. I told Joe just to hit me as hard as he could, because I had so much padding from the suit that he couldn't really do much damage."

"There were definitely a couple times where I gave him a good hit in the stomach, because you want to sell it, but you don't want to hurt the guy," says Keery. "He's neck-deep in rubber, breathing through a hose, sweating his brains out, so you have to give him some serious credit."

To avoid damaging the set, a replica of the hallway in the Byerses' home was constructed at the studios and then set on fire. For that scene, the Duffers opted for a computer-graphics version of the creature. "We were really committed to only using the actor in the suit," Ross Duffer says. "But over the course of this, we realized there were limitations to it. Once he got burned, that was our first time committing to a full computer-graphics character. That whole sequence was a learning experience. We did light the hallway on fire for real, and then they [digitally] added the monster in the middle."

28 A bear trap has spring-powered steel jaws that are prompted to close tightly around an animal's leg when triggered.
29 The spiked bat Steve Harrington uses against the Demogorgon might be seen as a real-life incarnation of one of the weapons in the *Dungeons & Dragons* arsenal, the club.

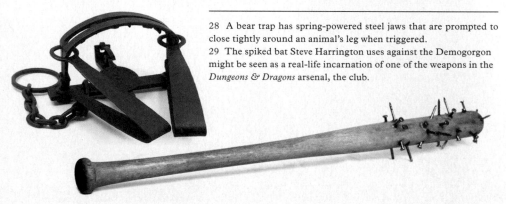

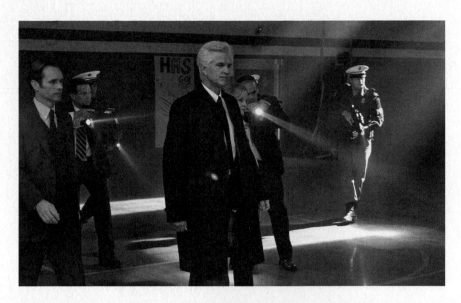

The CG Demogorgon also emerged in the final showdown with the monster that takes place at Hawkins Middle School in Mr. Clarke's classroom. Eleven confronts the creature beneath the school's flickering fluorescent lights. "We had to do a different thing to those overhead lights so we could get them to flicker like that," says cinematographer Tim Ives. "We found this pattern that we loved, that made it feel like it was an event, versus earlier scenes where it was just a little flicker here and there. This was the time that it was meant to signify that it's really hitting the fan, and the monster is right there."

"I just remember when we dollied back with her, and Millie has that look on her face of just pure determination," Ross Duffer adds. "I remember being so blown away by the intensity she brought."

The classroom sequence was shot in a single day, and while some of the scenes were filmed with Steger wearing the Demogorgon costume, mostly the cast was working purely from imagination, with the monster digitally added during postproduction. "We had a practical monster there, and we ended up just getting rid of it because it was proving too time-consuming and the burned version didn't look that great on camera," says Matt Duffer. "Millie was really acting against nothing at that point."

"I just remember those takes when the boys are slingshotting and screaming," Ross Duffer adds. "We would just run it again and again, saying, 'Keep shouting.' And a lot of that was improv from the boys. It's not scripted."

The Duffers did manage to surprise the cast at least once during the sequence. "When we were in the classroom, there was a speaker behind us,

111

and we did not know that was there," McLaughlin recalls. "Usually [when we were acting], the Duffers would do the Demogorgon voice with screams or just make, like, a bad, cheesy sound or something. Once, for a certain part in the scene, they turned on the speaker. It was like, 'Aargh!' We were like, 'Oh, shoot!' Millie was super scared. She was supposed to be kind of knocked out, so they couldn't really use that take. We were actually scared."

Initially, the Duffer brothers hadn't planned for Eleven to survive the confrontation. But long before it came time to shoot the final scenes, the writer-directors underwent a change of heart. "Eleven was going to sacrifice herself to save the day," Ross Duffer says. "That was always the end game. But once we realized that the show was potentially going to go on longer than one season, we needed to leave it more up in the air, because deep down we knew the show just wouldn't really work without Eleven. And at that point we knew how special Millie was. If there were going to be more Stranger Things, Eleven had to come back."

But the sequence does see the Demogorgon appear to claim one victim, the cruel Dr. Brenner. Ross Duffer cautions, however, that the character might not necessarily have met his demise. "What we always say about that is that if we wanted to really kill Brenner, we would have shown it on screen," Ross says. "Based on what he's done, the audience deserves to actually see it. That's where I want to leave it for now."

WILL'S RESCUE

AS ELEVEN and the boys are battling the Demogorgon at the school, Joyce and Hopper are traveling together through the terrain of the Upside Down to rescue Will. For the sequence, Ryder and Harbour wore customized hazmat suits[30] made from Cordura nylon that were dyed a "mustard sort of ocher color," according to costume designer Adams. The suits were also fitted with lights inside them to help

30 Haunting figures in hazmat suits, like those Hopper and Joyce don in this sequence, cast a long shadow over the cinema of the 1970s and '80s, cropping up in films such as Steven Spielberg's *Close Encounters of the Third Kind* and George Romero's *The Crazies*.

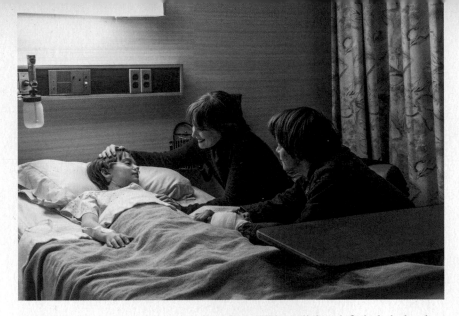

illuminate the actors on-screen. Says Ives, "Those lights definitely helped us a lot with Hopper and Joyce coming into the Upside Down out of the lab."

Although Joyce and Hopper's rescue efforts succeed, not all is well when *Stranger Things* concludes. At the end of the first season, the Duffers reveal that Will might be home, but he's not the same boy as when he vanished.[31] "You don't want everything tied up in too neat of a little bow," Matt Duffer says. "The idea always was: If there was going to be a season two, it would focus on Will—specifically on the effects that being in the Upside Down had on him. We wanted to introduce that idea, there being something wrong with Will. We thought that would be a haunting end to this first chapter."

31 This sense of foreboding that accompanies the otherwise joyous moment of a lost child's return may again recall *Poltergeist* or the *Twilight Zone* episode "Little Girl Lost" (1962).

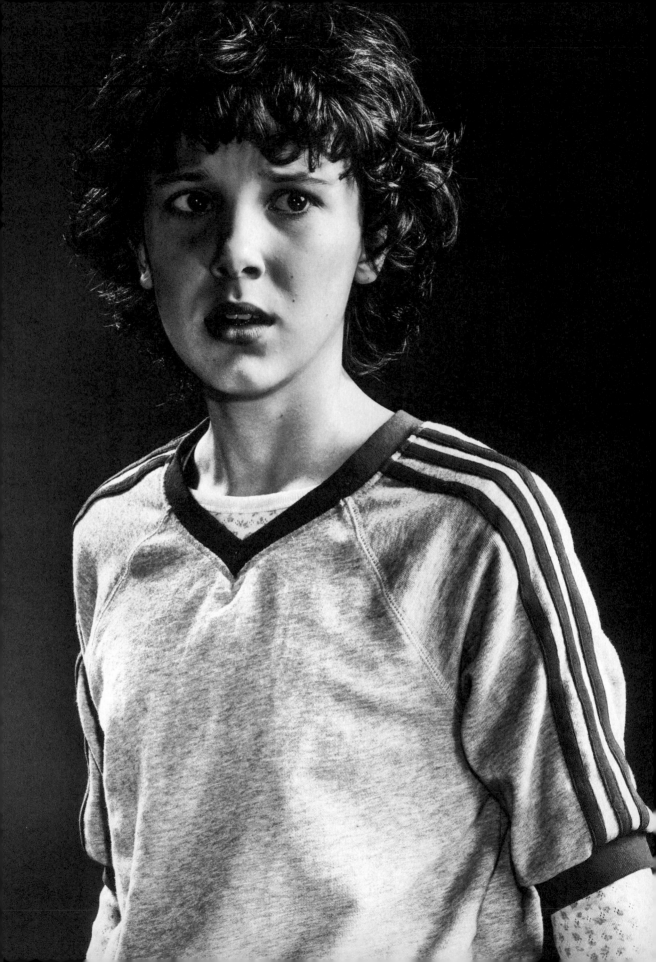

CENTRAL INTELLIGENCE
AGENCY

EYES ONLY
TOP SECRET

DR. M. BRENNER

RK	T.D.	03.13.83
A.K.W.	FM	
SfrW	AB	
F.S.P.C		
SS		

FOR OFFICIAL USE

HAWKINS NATIONAL LABORATORY
U.S. Department of Energy

SUBJECT

ELEVEN (née Jane Ives)
Played by Millie Bobby Brown

THE GIFTED ONE

CONFIDENTIAL

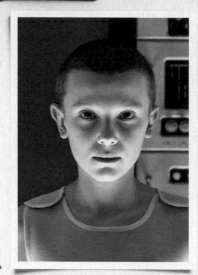

ABILITIES:
Telekinesis, extrasensory perception,
psychometry, technopathy,
teleportation, biokinesis

WEAKNESSES:
Minimal spoken language, occasional
episodes of opposition/defiance,
prone to nosebleeds

* *

Two hundred forty-six. That's how many young actresses were seen
for the role of Eleven, the mysterious girl at the center of all
the strange things transpiring in Hawkins, Indiana. But even
early on, Millie Bobby Brown stood out from all the rest.

"Millie was an incredible find," Ross Duffer says. "That honestly
was one of the harder roles to audition for because that's a
character who rarely speaks. We did a scene with her where she
tried on this wig for the first time and was looking
in the mirror, and we filmed it in close-up. The number of
emotions she went through in just a few minutes—she just felt
like this alien creature coming to Earth for the first time."

Brown's gifts as an actress might seem as preternatural as the
abilities belonging to her screen counterpart—a child raised
entirely apart from society inside the corridors of Hawkins
National Laboratory, where she was subject to bizarre experiments
at the hands of her "Papa," Dr. Martin Brenner (Matthew Modine)
that left her with unique abilities. Eleven's psychic wanderings
take her into the orbit of a monstrous creature from another
dimension, the Demogorgon—Eleven is frightened of the beast,
but it's drawn to her power.

The role was a breakthrough for
the star, who made her screen debut
as a young Alice in Wonderland on
the series Once Upon a Time in
Wonderland. Turns in series
including Intruders, NCIS, Modern
Family, and Grey's Anatomy followed,
but from the start, Brown says she
was excited about the idea of
playing Eleven—a character far

outside the realm of parts normally available to pre-teen actors. "I think her ability to be vulnerable and her ability to be badass all at the same time, that's what really attracted me," Brown says.

Casting director Carmen Cuba says Brown appeared to understand intuitively what Eleven required. "She had an adult quality of stillness and intelligence, but a slight turn of her head or a certain look toward something off-camera would instantly remind you she's just a child," Cuba says. "And her crying on command is pretty nuts."

Brown felt no apprehension about shaving her head for the role— in fact, she says she found the entire experience liberating. "It was very empowering," she says. "You can be cool with or without hair, with or without make-up."

The far bigger challenge, she says, was conveying Eleven's reactions as she escapes from Brenner and his "bad men" and makes her way into the wider world, finding friends and a chance at freedom. "When you have words on the page, you can just say that," Brown says. "But with Eleven, she doesn't say it. She uses her emotion to do it. The true definition of an actor is acting with your face, acting with your expressions, your emotions, your feelings."

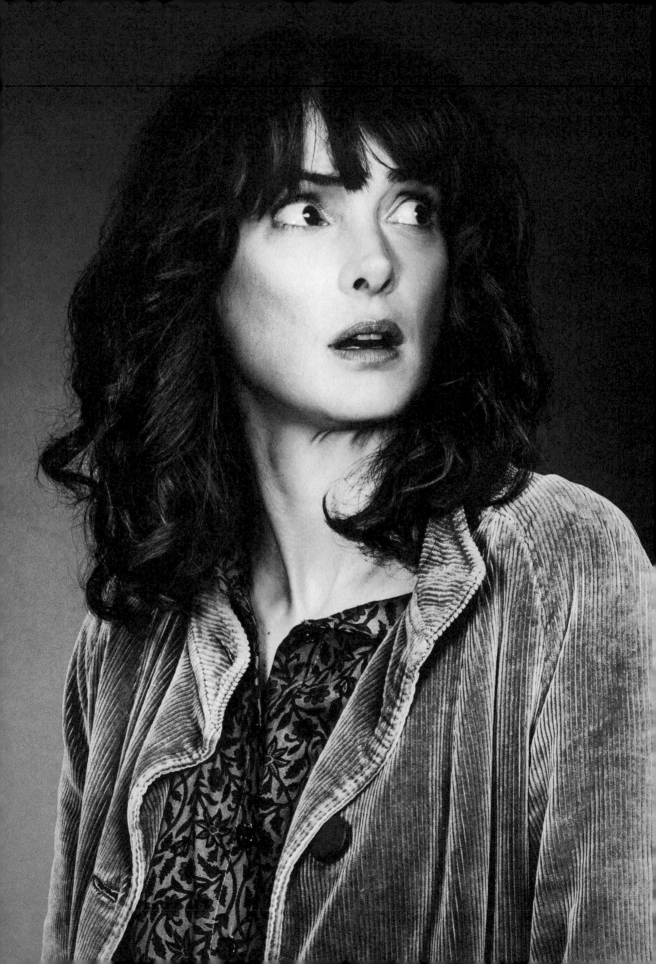

HAWKINS NATIONAL LABORATORY
U.S. Department of Energy

KEEPER OF THE FAITH

SUBJECT

CASE #257 (Joyce Byers)
Played by Winona Ryder

CONFIDENTIAL

OCCUPATION:
Salesclerk, Melvald's General Store

ABILITIES:
Strong intuition, dogged determination,
fiercely protective

WEAKNESSES:
Prone to bouts of high anxiety,
no paternal support system, chain-smoker

* *

Even before her youngest son disappears, Joyce Byers gives the
impression of a woman barely holding on. Raising two boys as a
single parent means that money is tight, and what little she
makes working at the general store barely covers the bills. Joyce
is messy and scattered, dwarfed in clothes far too ample for her
slight frame. There's a quiver in her voice when she speaks. But
Joyce has surprising reserves of courage that carry her through,
especially after young Will vanishes. In the face of overwhelming
odds, she knows in her core that she'll be reunited with her boy
if only she continues to search for him.

"She's certainly not perfect in any way," says two-time Academy
Award-nominated actress Winona Ryder (Little Women, The Age of
Innocence) of her Stranger Things character. "I think she
carries a lot of guilt around. There's a lot of people out there
struggling, a lot of single parents. She works Christmases. She
works Thanksgiving. . . . Her husband left when Will was about
five—just took off and never paid any child support."

When thinking about actors who could embody Joyce, casting
director Carmen Cuba immediately suggested Ryder—not only because
of her strong connection to films from the era that inspired the
series, but also because of her incredible talent. She's someone
who can easily project strength and vulnerability simultaneously.

"Winona was a perfect fit," Cuba says. "People have a strong
connection to [her] from her very magical early work, but I
especially loved that this would highlight her as a grown-up mother
to children as complex as the ones she herself once played."

Ryder says she was excited by the opportunity to explore genre
storytelling that eschewed the more gruesome conventions favored
by some directors. "I was really interested in the whole

government-conspiracy aspect," she says. "I've always been fascinated by that kind of stuff. I liked that while it was every parent's worst nightmare, it didn't get into territory that was incredibly upsetting. It's got a human thread throughout: friendship and family and community."

In shaping Joyce, Ryder looked to real life and to cinema history, putting together "a little collage of inspirations" that included Marsha Mason's work in 1983's <u>Max</u> <u>Dugan</u> <u>Returns</u> and the 1977 film <u>Audrey</u> <u>Rose</u>. She also drew from Ellen Burstyn's Oscar-winning performance in the 1974 release <u>Alice</u> <u>Doesn't</u> <u>Live</u> <u>Here</u> <u>Anymore</u>. She was looking to portray "the sort of real desperation to just put food on the table and to just get by."

According to the Duffer brothers, Ryder's approach fundamentally changed Joyce from a "tough, hard-ass Long Island mom" to a character who was "so much more fun." Matt Duffer says, "It could have been such a sad, depressing role of a mother whose child has gone missing. There's a fun, quirky quality to her performance that makes it a lot more fun to write—and watch."

Before they arrived on set, Matt Duffer says he and his brother were perhaps most intimidated by the idea of directing Ryder. "Winona is an actress who I really look up to, who we grew up with and was in so many movies that meant so much to me," he says. "I was nervous about looking like a fool in front of her. She's worked with some of the great directors of all time, Tim Burton and [Martin] Scorsese. How do you live up to that? But I realized that when you get an actor at that caliber, you actually don't have to do very much. Winona brought it, every day. We just hit record."

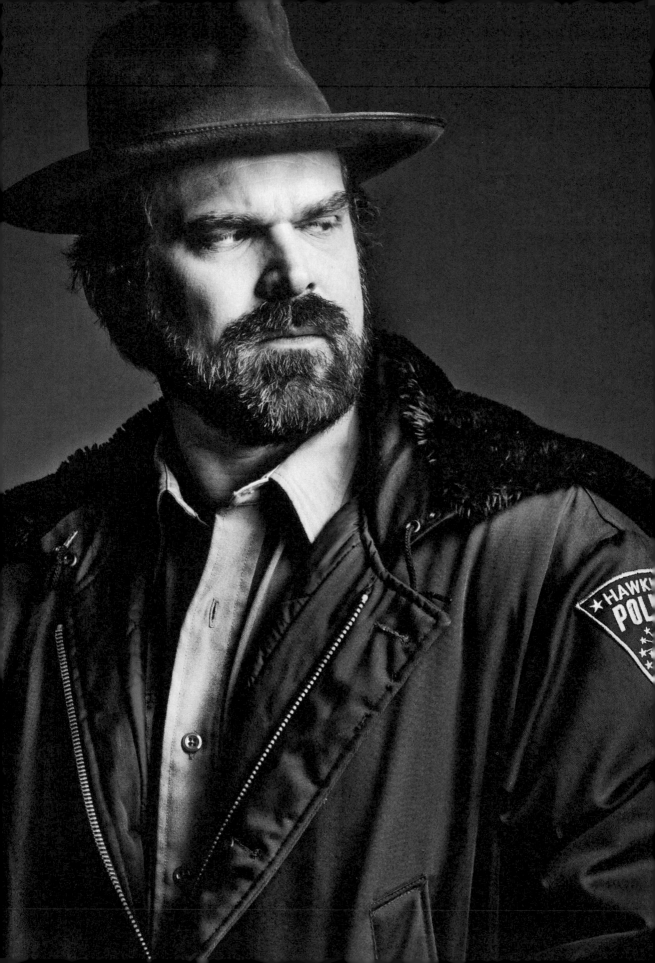

CAUTION

HAWKINS NATIONAL LABORATORY
U.S. Department of Energy

SUBJECT

CASE #243 (Jim Hopper)
Played by David Harbour

THE HARDENED CYNIC

CONFIDENTIAL

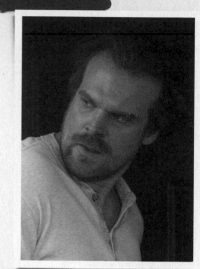

OCCUPATION:
Chief of Police, Hawkins, IN

ABILITIES:
Vietnam Veteran, skilled with firearms,
strong survival and fighting skills

WEAKNESSES:
Prone to violent outbursts, haunted by the death
of his only child, heavy drinker and smoker,
possible addiction to antianxiety medications

* *

When David Harbour read the script for the pilot episode of
<u>Stranger</u> <u>Things</u>, he was already a well-respected actor whose
impressive, decades-long career included roles in such acclaimed
films as <u>Brokeback</u> <u>Mountain</u>, <u>Revolutionary</u> <u>Road</u>, <u>End</u> <u>of</u> <u>Watch</u>,
and <u>Black</u> <u>Mass</u>, television series <u>The</u> <u>Newsroom</u>, <u>State</u> <u>of</u>
<u>Affairs</u>, and <u>Pan</u> <u>Am</u>, and a Tony-nominated turn in <u>Who's</u> <u>Afraid</u>
<u>of</u> <u>Virginia</u> <u>Woolf?</u> on Broadway.

Still, the role of Hawkins chief of police Jim Hopper was
"certainly the most interesting character that had ever been sent
my way," Harbour says. "I love very flawed individuals as well, and
I love very messy individuals who in turn discover who they are
through the course of a few series of events, which forces them
to either grow up or die."

In his auditions for Hopper, Harbour captured the character's
loose, rough-and-tumble masculinity and hinted at the police
chief's broken heart. "When I read the first draft of the script,
I immediately thought of my grandfather John Ashe, who was a
lieutenant in the NYPD motorcycle division when I was a kid," says
casting director Carmen Cuba. "He was the most iconic American
man I knew, slightly terrifying and incredibly loyal and loving.
He was also six feet, three. David Harbour embodied all of that
in this character without ever having been given that direction."

"I grew up watching those movies that this series is an homage to,
and the leading guys, even a little bit before that time, were all
the dudes who taught me how to become a man, what it is to be a
man," offers Harbour. "These were guys like Harrison Ford, or Jack
Nicholson, Gene Hackman, Roy Scheider, Nick Nolte. I was looking
at movies about cops that are a little bit messed up and have to
go into a situation that makes them face their biggest flaw."

Scheider was an important reference, in terms of not just his inner life but also his overall look. "Roy Scheider's character [from Jaws] was a big influence with his uniform look," says costume designer Kimberly Adams. "What was great about how that movie was done was that the chief

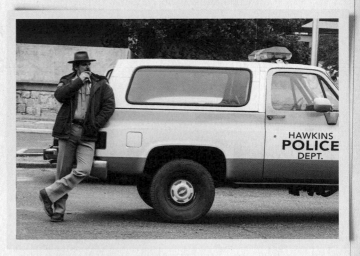

had a different uniform than his guys. That felt right for Hopper to not be the same as his guys, to make it more small-town, not so perfect. The hat—we wanted it to seem like something that had been on [Hopper's] head for a while." Even the way Hopper's clothes hang on his body indicate that something's amiss in his life. Adams says, "David didn't want to slim down for the character. [Hopper] drinks a lot of beer, and he's not taking care of his body like he should. So we played into that with the way that his jeans fit, the way his clothes fit. He's let himself go a little bit."

Harbour had other insights into Hopper's demeanor and his behavior that he eagerly shared with the Duffer brothers. "One of the things was I wanted him to be very emotionally unavailable and have problems with intimacy," Harbour says. "So there's this stuff with sleeping around. In the first season he sleeps with the librarian and with some random girl who he talks about being cursed. All that stuff was my contribution because I wanted to see more of the degradation of this guy in terms of intimacy."

Hopper's cowboy persona quickly turned him into the show's resident sex symbol—despite his inner turmoil, he moves through the world with confidence. He's hot-tempered and brave. "He is still and simple in a show that is often loud and busy, and yet even with that simplicity, he conveys such damage, such wounds," executive producer Shawn Levy says.

"His backstory with his daughter has so much complexity," Harbour adds. "There's a lot of secrets there that the Duffers and I have talked about, in terms of his own guilt around his daughter and the way that all particularly went down. Never have I worked on something where I wanted to come back to it so much because I feel like the fabric is so dense and you can really take the story anywhere."

A SYNTH SCORE

When Matt and Ross Duffer began to consider what sort of score their series would need, they first wondered whether it should be a John Williams–style orchestral score. "But," Matt Duffer says, "we just thought it would end up sounding like a knockoff. We wouldn't have the kind of money to do a proper orchestral score. It was just never going to live up to that."

So they began to imagine what the show might sound like against the backdrop of a synthesizer-driven, electronic score like the one Cliff Martinez had provided for the 2011 film *Drive*, or like the ones director John Carpenter had written for some of his own features. Their search led them to a track called "Dirge" from the experimental Austin outfit Survive, which they used for the "sizzle reel" they'd created to help sell *Stranger Things*. "Once the show got green-lit, they were one of the first calls we made," says Matt Duffer.

Survive's Kyle Dixon and Michael Stein were longtime friends who first bonded over a love of electronic music—Aphex Twin, Boards of Canada, and other featured artists on the Warp Records roster—but neither had any experience composing music for film or television. Still, they were excited by the brothers' shared interest in synth music. "When you're making instrumental electronic music, there are no vocals for anyone to latch onto, or listen to, so you have to do a lot more to keep things interesting," Dixon says. "So the pictures are kind of like the vocals in a song."

"A lot of the stuff does come from an older sound palette," adds Stein. "Especially the main theme, that's 95 percent stuff from the '70s and early '80s. There's a few modern sounds, but for the most part, it's very vintage on that piece of music."

Matt Duffer believes the music is huge in terms of helping create the atmosphere of the show: "The reason I know it's huge is because I see these cuts without it. It's maybe 30, 40 percent of what it is at the end of the day. Kyle and Michael elevate it in a major way. I can't overstate their impact on the show."

"IF A PLACE LIKE THAT
DID EXIST,
THE VALE OF SHADOWS,
HOW WOULD WE
TRAVEL THERE?"

MIKE WHEELER

THE UPSIDE DOWN

their approach to the production— they wanted to use a minimum of visual effects, instead building a physical world with texture and depth that would feel foreboding yet real. Inspiration came in part from the 1999 survival horror video game *Silent Hill*, in which players set out to solve a mystery in a remote town that was home to a terrible darkness.

"Our concern was how do we create an alternate dimension in a way that doesn't look cheesy," Matt Duffer says. "It couldn't become a CG fest. We wanted to do it in a very simple, effective way, and it did lead us, of course, to talking about [the approach used in] *Silent Hill*, which is basically color correction, ash, and deteriorating buildings. We were also inspired by the planet in Ridley Scott's *Alien*, where he's got these particles always dancing about in the air. So we added what we called spores, most of which were achieved practically, and all

NOW ENTERING

The Upside Down is a region that exists outside of space and time—a terrifying, colorless underworld overrun by death and decay and populated by faceless monsters. The Upside Down was always central to the *Stranger Things* story line, but initially Matt and Ross Duffer planned for the supernatural plane, which was originally dubbed the Nether, to remain offscreen. "We were never going to go into the Nether," Matt Duffer says. "We were only planning to hear this other dimension over radios and walkie-talkies. We thought that'd be scarier. What we don't see is often scarier than what we do. And that worked for a while. But once we got five hours in, we felt the show really needed to open up, expand. It just became increasingly obvious: we had to go into the Upside Down."

Creating the look of the Upside Down became a central challenge. The Duffer brothers wanted the dimension to remain in keeping with

these vines and weird organic growths. It was all based in real locations. We wanted the Upside Down to be as practical as possible, and so we always shot actors in the actual locations, which were then enhanced with set dressings and just a little bit of [visual] effects."

Production designer Chris Trujillo collaborated closely with cinematographer Tim Ives and special-effects coordinator Caius Man to determine how to achieve the desired look.

"Initially, it all was this very abstract conversation about what do we want it to feel like," Trujillo says. "The idea is it's a shadow world, this murky, dark reflection of reality that feels infected in a way. There's something infiltrating it and sucking the life from it. That's when we came up with this idea of having the vines, as though there's this spreading disease that's overtaking everything. That floating dustiness in the air is meant to feel like spores."

The behind-the-scenes team scoured a range of films for ideas. While the initial inspiration came from Alien and Silent Hill, they were also inspired by the early work of body-horror auteur David Cronenberg. Andrei Tarkovsky's 1979 film Stalker—about a journey to a mysterious area called the

Zone—also proved useful, as did John Hillcoat's 2009 feature adaptation of Cormac McCarthy's Pulitzer Prize–winning novel The Road. "The Road, obviously, has that sort of post-apocalyptic vibe—there's just this inexplicable ash covering everything and floating in the air," Trujillo says.

To fabricate vines and tendrils, the art department and the special-effects team experimented with various materials, including bubble Wrap and sheet plastics, that were heated until they melted and then painted. Clear latex was also stretched and treated to craft netting and webbing for the netherworld. "We spent three months, closer to four, probably, fooling around with every chemical and flexible stretchy thing and meltable thing we could possibly lay our hands on," says Man. "Everything from laying out latexes and using chemicals to rapidly harden them or drizzling latex into trays of the chemical to make webs."

Stranger Things sound designer Craig Henighan developed the atmospheric sonic environment for the otherworldly plane. "A couple of the sequences were out in the forest, so [the sound design includes] a lot of trees, there's a lot of moisture," Henighan says. "It sounds wet. It's got dripping, and it's got tree creaks, movements of bark, and general wetness. I used a little bit of my own breathing that's pitched down low. I'd layer a few things and add delay sounds to tree creaks and any other sort of weird creaking stuff I could come up with."

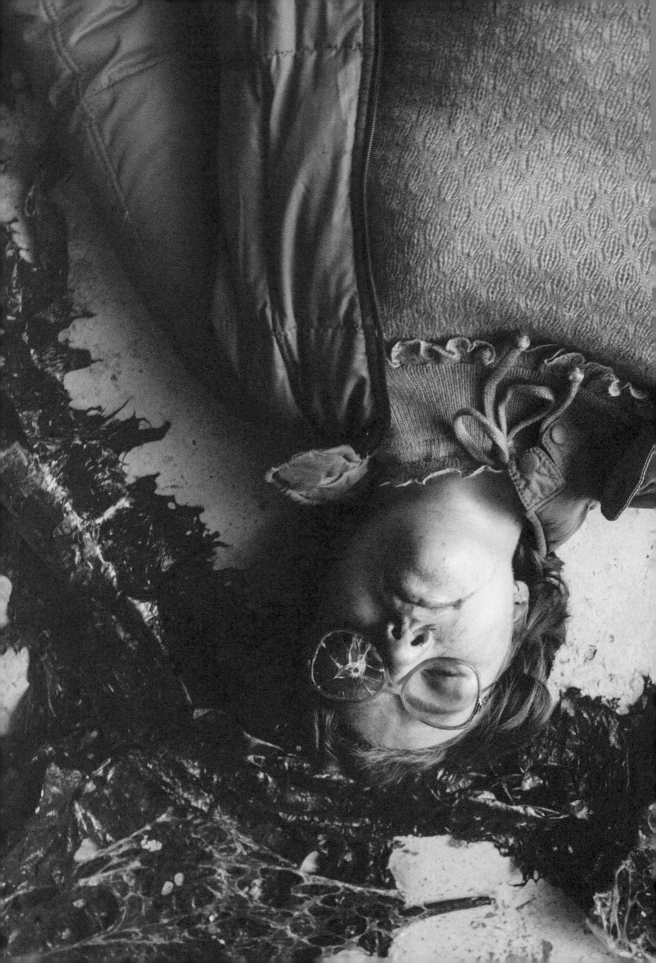

TOP Barb prepares to meet her grim fate: Actress Shannon Purser awaits direction from Shawn Levy (second from left). "It actually went very smoothly," says Purser of Barb's death scene. "The stunt team was so helpful. I wanted to do everything myself, but it was a lot of being dragged around and falling onto mattresses." Purser's stunt double stands in the bottom of the pool in the photo above.

BOTTOM "The whole set was created for that scene," Purser continues. "It was half of a hollowed-out pool. Everything was covered in vines and slime, and they had little spore things blowing into the air. We shot a lot of it in the pool, and then there was a ledge where we shot the part of me being dragged down into the pool after [Barb] tried to climb out."

THE DEMOGORGON

Lurking inside the shadowy netherworld is a monstrous predator drawn to the smell of blood. The Demogorgon appears in *Dungeons & Dragons* as a towering, two-headed demon prince, but for *Stranger Things*, the Duffer brothers wanted to design a creature that could be played on set by an actor wearing prosthetic makeup and a costume made from foam rubber.

"All these monster movies we grew up loving, *Aliens* being the biggest, [the creature] was a stunt guy in a suit, or a movement artist in a suit", Ross Duffer says. "We wanted something that, if you're a kid and you're in school and you're doodling, you could just sort of sketch this monster out. I think there's a danger sometimes now—because you can do anything you want with computer graphics—that you can overcomplicate things. There's an elegant simplicity to the Xenomorph's design. I think that makes it much more iconic."

Veteran concept artist Aaron Sims (*Maleficent, Wayward Pines*) designed a powerful beast with a vaguely humanoid body—it could walk on two legs, though it more often crouched low like an animal, and it had the torso of a man with impossibly elongated arms. Its featureless face was reminiscent of a Venus flytrap with flaps of flesh that opened to expose hundreds of sharp teeth.

"I started doing a lot of research on other creatures in nature that actually have weird, bizarre layers of teeth inside their mouths," Sims says. "One is a snapping turtle, and so the snapping turtle is used as kind of the foundation—even though in snapping turtles, those aren't really teeth. They're these almost cartilage-like mandibles inside the mouth to kind of push food down."

Working from the resulting designs by Sims, Mike Elizalde's Glendale, California-based company, Spectral Motion, built a foam latex creature suit that was worn by performer and choreographer Mark Steger (*I Am Legend, World War Z*), who played the Demogorgon. The costume covered almost all of Steger's body; for some sequences, the suit was augmented with stilts on which the performer stood nearly seven feet tall.

For the creature's face, Steger wore one of two masks that were designed by Spectral's Mark Setrakian and, like the suit, were made primarily from foam latex. The open version of the Demogorgon's face showcased rows of sharp teeth made from rigid silicone that had to be glued on individually.

"When the face opens, it's like this orchid's flower that opens up with all the teeth and the gullet in the center," Setrakian says. "But then when it closes, it looks like this meat wad. I had to come up with the mechanism that would take the open version and scrunch it down into the closed version."

DESIGNING

In the Duffers' earliest conversations with Henighan, the writer-directors referred to the creature not as the Demogorgon but as "the entity," which sent the sound designer in a slightly supernatural direction. "I had to come up with something that was animalistic but sort of human-esque," he says. "I found a couple of vocal ideas from baby seals. I basically took these seal sounds and manipulated them a certain way so that they would do a certain thing every time the Demogorgon was about to attack somebody, or he was kind of creeping around, or he was thinking."

Henighan combined the baby-seal sounds with altered snippets of his own breathing and squeals and "roars" created by scraping sheet metal with dry ice. He would mix the same sounds together in different ways to convey the actions of the creature. "You look for combinations," he says. "You

"One of the great tricks of sound design is trying to figure out how to use repetition in sounds. And if you think about music; a verse, chorus, verse, verse, chorus, there's a lot of repetition out there in audio worlds and in language of music and language of sound."

He adds, "Your monster has a voice. You could say the same thing about the queen alien with Ripley [the character played by Sigourney Weaver in the Alien films]. Every time that Ripley would fight that queen, there was a certain [sound]—I think it's a cappuccino sound or a goose sound, something in there. You have to listen for it."

The Demogorgon appears to feed on an egg in the instant before Eleven initially makes contact with the creature. Like the monster itself, the egg was designed by Aaron Sims Creative.

would be in white sleeves. Sometimes he'd be in green-screen green. Sometimes he'd be in black."

Visual effects were also used to erase Steger's feet, which protruded just below the creature's knees. "Mark was able to stand flat-footed," Viniello says. "His foot actually extended out through the shin of the creature, and he had little green booties on that they would just digitally clean up and erase. It was as comfortable as he could be given the situation, but he still had to be careful on uneven ground. Your center of gravity is off just being in this costume."

"The stilts are probably the one element that doesn't help with performance, simply because Mark has to work on uneven terrain, outdoors," Elizalde adds. "But it did certainly help with the height, the impressiveness of the creature."

What does a Demogorgon sound like? To answer that question, Henighan drew inspiration from some of the same films that had inspired the creature's unique physiology. "I wanted to do a set of snarls," he says. "I knew from the script that he kind of creeps around. I was trying to do something that would work with the Duffer brothers' touchstone ideas from Alien and The Thing and then create something unique out of that."

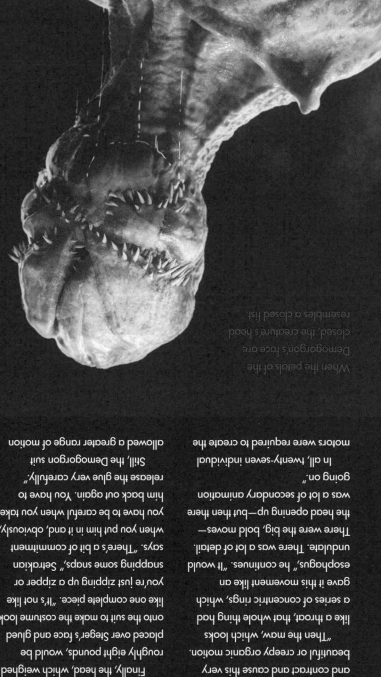

When the petals of the Demogorgon's face are closed, the creature's head resembles a closed fist.

Setrakian's design consisted of five "petals," each of which opened and closed; additionally, the bases of the two largest petals could move independently." "Each petal also [has] this kind of fleshy thing . . . I call them drawstrings," Setrakian says. "They're basically like mechanical muscles embedded in the foam latex that . . . can expand and contract and cause this very beautiful or creepy organic motion.

"Then the maw, which looks like a throat, that whole thing had a series of concentric rings, which gave it this movement like an esophagus," he continues. "It would undulate. There was a lot of detail. There were the big, bold moves— the head opening up—but then there was a lot of secondary animation going on.

In all, twenty-seven individual motors were required to create the effect of the face opening and closing. The mechanism controlling the face was housed inside a small backpack that was concealed by the suit itself. For the Demogorgon scenes, Steger wore bicycle shorts and tight-fitting athletic apparel; he then would have the backpack put into place and the suit glued on over his body up to the neck.

Finally, the head, which weighed roughly eight pounds, would be placed over Steger's face and glued onto the suit to make the costume look like one complete piece. "It's not like you're just zipping up a zipper or snapping some snaps," Setrakian says. "There's a bit of commitment when you put him in it and, obviously, you have to be careful when you take him back out again. You have to release the glue very carefully."

Still, the Demogorgon suit allowed a greater range of motion than most. "Since most of the motors are in the backpack, the head wasn't all that heavy, and it was nicely balanced, too," Setrakian says. "Because the face would open up and Mark's actual face was exposed, he had good access to air. It's not unusual for a creature-suit performer to have to work in a very claustrophobic environment. In the case of the Demogorgon, it was not too bad. He was able to be quite dynamic in the suit."

It helped, too, that Steger's own arms remained outside the suit. The Demogorgon's long, narrow limbs hung down close to the creature's knees, and it would have been impossible for the performer to slip into that portion of the suit. So Steger, wearing sleeves that would blend into the background of a given shot, manipulated the monster's arms using carefully concealed handles; those were later erased by the show's visual-effects technicians during postproduction.

"We always knew [his arms] were going to be digitally removed," says Spectral Motion project supervisor Mark Viniello. "We talked to the VFX team, and they said, 'If his arms could be white if he's in kind of a white background [that would make things easier].' Sometimes he

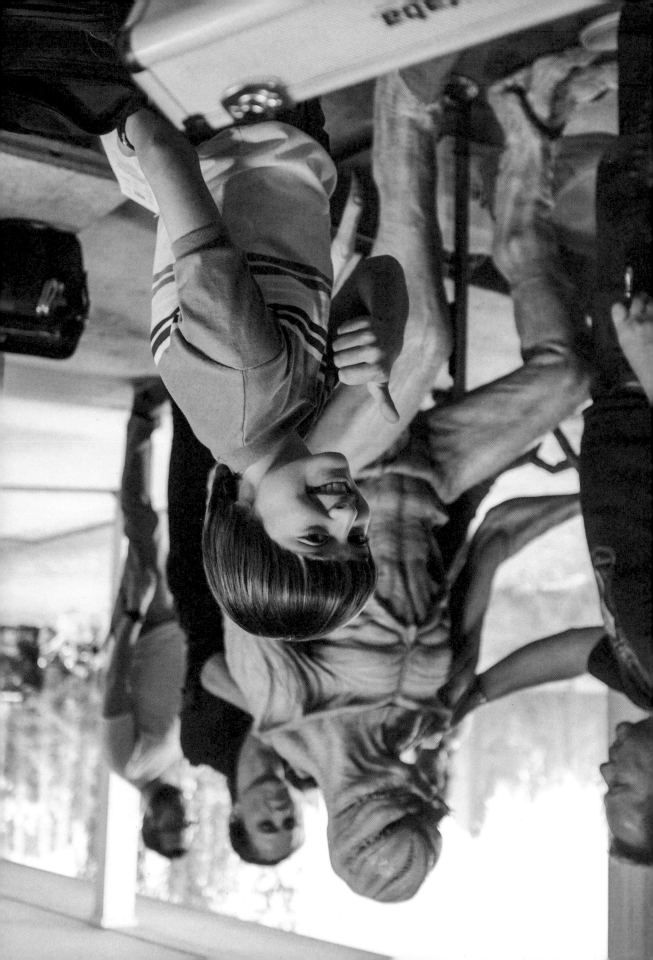

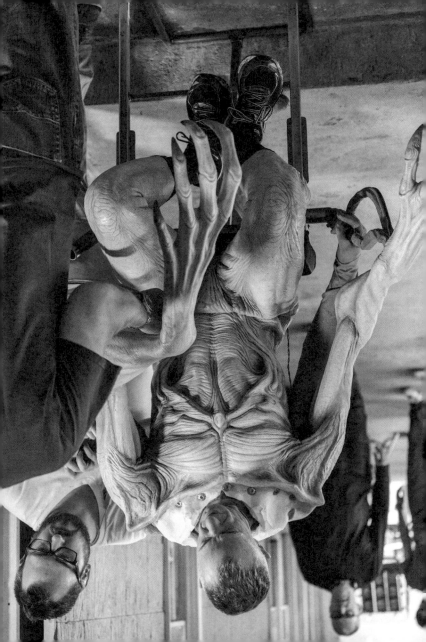

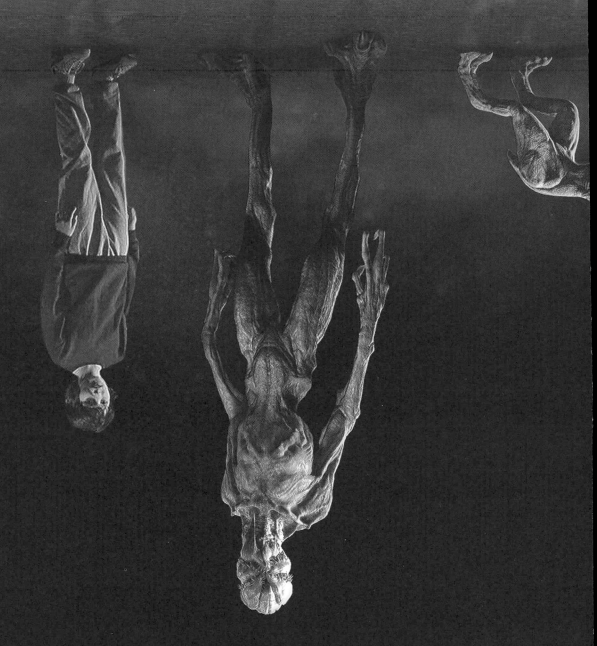

CATOGORGON

As the creature moves into its adolescence, it once again grows larger and its diet evolves. In its third stage of development, it was referred to by Graff as a "Catogorgon," not only because Dart is roughly the size of a house cat, but also because it is in that stage that Dart devours Dustin's pet cat, Mews (RIP Mews). It's here that the creature's signature petal mouth is first on full display.

DEMODOG

In the penultimate stage of the beast's life, it grows to the size of a large dog and adopts certain canine behaviors—traveling in packs as wild dogs do, for example. The sound of the Demodog was created by pairing recordings of howler monkeys with Henighan's own voice, roaring. "By the time you got to Demodog, [Dart sounds much closer to] the Demogorgon than the original pollywog sounds."

DEMOGORGON

The last of the five stages sees the beast reach full maturity, though Dart's life comes to an end before he's fully grown. At least he and Dustin are afforded a tender moment together in the tunnels to say their goodbyes.

When Dustin discovers an unusual critter in the garbage can outside his home on Halloween night, his first inclination is to determine what, exactly, it is. But when his new pet proves difficult to classify, the boy begins to think he's stumbled across an entirely new species—and possibly a cool way to impress girls. Unfortunately, the little critter he names Dart (short for D'Artagnan) turns out to be an all-too-familiar beastie, the Demogorgon.

As the episodes progress, Dart grows in size and ferocity. Here's how the life cycle of a Demogorgon breaks down.

POLLYWOG

Aaron Sims Creative, the designers of season one's full-grown Demogorgon, sketched out ideas for the youthful stages of the creature. It begins life looking something like a tadpole with front legs and no real bone structure. Its skin has a translucent quality—the creature's internal organs, including the throat, can be seen under direct light. Dart also has one distinguishing characteristic. "Dart has this kind of yellowish birthmark over his kind of leg—that's sort of how you can tell

it's Dart, because he has always the same pattern, no matter what his body looks like," says senior visual-effects supervisor Paul Graff.

Dart's voice came courtesy of sound designer Craig Henighan.

"I just didn't want Dart to come out of animals or a library or something," he says. "I really wanted to try to come up with something that was performance-based. And the best way to do that is either to find someone who can perform vocals for you, or a lot of times, sound designers like me, we do a road map with our own voice first. I used a little bit of water—I would gargle a little bit. The trick was to get it to be small and cute and cuddly to a degree, and then slowly get more aggressive."

FROGOGORGON

In the second stage of the creature's life cycle, it has four legs and is roughly the size of a toad. Dart also moves a little differently. "The larger Demogorgons, they trot," Graff says. "The Frogogorgon was trotting forward, and for some render-error reason, it had a limp. We thought the limp was really cool. That's what makes it come alive."

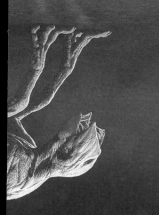

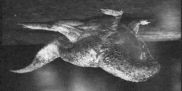

"THE GATE . . . I OPENED IT . . ."

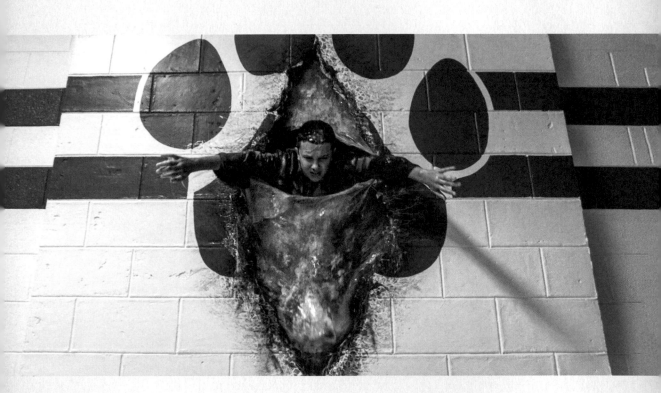

"I'M THE MONSTER."

—

ELEVEN

3

THE PHENOMENON

LIKE THE Demogorgon or a frightened telekinetic prodigy, *Stranger Things* arrived with little warning and landed with tremendous impact. All eight installments of the Duffer brothers' carefully crafted supernatural mystery debuted on Netflix on July 15, 2016, and almost immediately the series became a creepy summer sensation. By the close of the weekend, both Stephen King and Guillermo del Toro had publicly endorsed the show on Twitter. King tweeted, "STRANGER THINGS is pure fun. A+. Don't miss it. Winona Ryder shines." Del Toro wrote, "Stranger Things may be a lot of things: King, Spielberg, 80's, myself (Duffers pointed that to me) but what it is, above all, is good!!" At that point, executive producer Shawn Levy knew it was a hit. "By Saturday, I was seeing so much social-media traffic, and we'd already gotten some good reviews," Levy says. "We'd gotten some incredible tweets from, most notably, Stephen King. But when I started getting praise from J.J. [Abrams], and Steven [Spielberg], and del Toro, I realized, 'Oh, the people we respect are respecting the work we are doing.' It was...euphoric."

Critics were almost universally positive. Writing in *The New Yorker*, Emily Nussbaum praised the series as a "cool summer treat." She wrote, "It's spooky but not scary, escapist but not empty. It's a genre throwback to simpler times, with heroes, villains, and monsters. Yet it's also haunting, and has a rare respect for both adult grief and childhood suffering. It's an original. [...]The main plot is a swift-moving caper with jokes and jolts. The flashbacks are about vulnerability, how people are bruised in places that no one can see. The combination of those two tones is almost musical, with a sincerity that feels liberating."

In *Time*, Daniel D'Addario offered a similar appraisal: "The show's tone, giddily indulgent of both small-town cliché and monster-serial oddity, is so backward-looking that, on first blush, it's hard to imagine how the show could succeed, artistically or commercially, in our more ironic age. And yet *Stranger Things* is an unqualified success—a show whose fondness for its own source material makes its nostalgia warm and inclusive. It isn't using familiar tropes to demand your money or your attention. It's welcoming you into a fan club."

The reception *Stranger Things* received was beyond what the Duffers might have imagined—the idea that the series would immediately catch fire in the way that it did had never occurred to them. "I don't even know how to put it," Matt Duffer says. "It felt great that we had made something that people had actually liked. We had seen it through from beginning to end, and it had worked from beginning to end. On every other thing we had worked on, something had fallen apart somewhere along the way. We felt enormous relief more than anything."

Levy says he had an inkling that the show might provoke an impassioned response. The producer is the father to four daughters, ranging in age from eighteen to seven, the eldest of whom had been hooked after seeing the season finale ahead of the show's debut. "At the final playback of the finale, I remember saying to my daughter, who was with me, 'It's very good, isn't it?'" Levy recalls. "She was like, 'No, I'm obsessed with it, and I've seen one episode.' That was my first clue that there's something in the DNA of the show, beyond its quality, that makes people love it with an irrational fervor."

That fervor spread quickly. "It was a word-of-mouth show," Netflix executive Matt Thunell says. "It was a show that people discovered on their own and felt some ownership over because they came to it kind of organically. That word of mouth built over the course of months."

Much of the promotion around the show wisely tapped into its under-the-radar vibe—for many fans, the series felt like a unique discovery rather than must-see summer event programming, adding to its air of mystery and unquantifiable cool. The 2016 edition of Comic-Con International, the massive pop-culture expo that takes over downtown San Diego every July, was held the week following the *Stranger Things* debut. Eagle-eyed attendees

took note of flyers posted around the city's Gaslamp Quarter reading, "Have You Seen This Child?" accompanied by a photograph of Noah Schnapp in character as Will Byers. Their #strangehunt search led to prizes that tied into the show's vintage themes.

The fanfare continued to build as weeks went by and growing numbers of viewers sought out the series. The more creatively inclined began sending artwork to Levy and to the Duffers to show their appreciation for the drama. The young actors rocketed to stardom, and Harbour's rugged demeanor and easy charm transformed him into a shambolic sex symbol.

Perhaps the most surprising turn of events saw Shannon Purser's ill-fated Barb become an Internet cause célèbre. Think pieces that paid tribute to the character turned up on taste-making sites like *Vulture* and *The Ringer,* and there was an outpouring of interest on Twitter. "I remember John Stamos tweeted, 'Justice for Barb,' and I'm like, Uncle Jesse knows who I am? This is crazy!" says Purser. "It was so surreal."

There was a general feeling that the likable everygirl had been deeply wronged and deserved a far happier fate than the one she'd been dealt. Barb was even the subject of her own Reddit thread. "The Barb thing, that was something," Matt Duffer says. "She had around twenty-three lines. We loved Shannon and loved that character, but to see that explode, to see her become a viral phenomenon, was wild."

"The Duffers were channeling some stories that don't get told enough on television," adds *Stranger Things* staff writer Paul Dichter. "I think that there's a strand of melancholy about what it's like to be a big dork in high school, what it's like to be bullied and picked on, that came from a very real place. That strand of sadness and reality underpins a lot of *Stranger Things*."

As summer turned to fall, the passion for the show showed no signs of diminishing. With *Stranger Things* dominating the cultural conversation, all manner of tributes emerged. David and Henry Dutton of the YouTube channel CineFix re-created the Duffers' hit as an eight-bit-style video game, complete with a tiny reproduction of Mike's *Millennium Falcon* toy in the Wheelers' basement, which Eleven levitates before Mike gifts her with a pink dress and a wig.

Even President Barack Obama took notice. The Duffers and the young stars, along with Shawn Levy and Dan Cohen were invited to attend the

South by South Lawn event at the White House on October 3, 2016. "He said, 'Millie, I'm scared of you, girl. Don't use your powers on me.' That was funny. It was really cool," reports Caleb McLaughlin.

Later that same week, *Saturday Night Live* delivered a send-up on the show with a sketch that saw the Duffer brothers (played by Mikey Day and Alex Moffat) offering a "sneak peek" of the show's second season and host Lin-Manuel Miranda stepping in as Dustin. On Halloween, swarms of Elevens and Barbs of all ages and genders were spotted across the country.

In the span of only a few months, *Stranger Things* had become a cultural touchstone that reached beyond any single demographic. Younger viewers related to the show's winning protagonists; older viewers could connect to Joyce Byers's plight and Jim Hopper's heartbreak; children of the 1980s could watch the series and experience a profound nostalgia for a bygone era.

Even audiences far too young to have watched movies like *E.T. the Extra-Terrestrial* and *Stand by Me* in theaters were drawn to the show for its time-capsule quality. Levy says, "I think that the 1980s setting is its own form of wish fulfillment. Increasingly there is a collective yearning across borders for a time that felt ironically less scary. It's a show with inter-dimensional monsters, but it's a time with fewer monsters. I believe. There is an innocence, pre–cell phone, pre–pervasive terrorism, pre–pervasive gun violence, pre–horrific leaders, that even my teenagers yearn for. I know this because I live with the focus group."

In the peak TV era, when brooding antiheroes and elaborate dark mythologies fuel so many series, the Duffers' brainchild also became the rare drama that a family could watch together. "People talk a lot about how there is no 'everybody' show, other than reality TV like *The Voice* or *American Idol*," Levy says. "There are very few things that parents can watch with their kids. *Stranger Things* has weirdly spanned this wide horizon line."

Hollywood rushed to pay tribute to the series, which became a fixture at every major awards show. Winona Ryder was nominated for a Golden Globe for best actress in a drama for her work on the first season; the American Film Institute named the show one of the year's best. *Stranger Things* won top honors at the Producers Guild of America Awards and at the Screen Actors Guild awards in the drama series category—after which David Harbour's impassioned acceptance speech went viral.

"The speech was taken in a political vein, and that was not really my intention—my intention was more a cultural aim, which was speaking to my fellow artists about what, culturally, I feel like we should be doing in society," Harbour says. "I think culturally we have a responsibility that affects policy on a political level, but it also affects daily life. In a sense, I want to see America great again, too, but in a different way, where we are more compassionate and more generous and more accepting of humanity and of human beings, and people being flawed and weird and strange."

"I think one of the beautiful things about *Stranger Things* is that we are trying to create a show where people don't have perfect bodies, they don't have perfect characters, they aren't very capable all the time. In a way, [we're trying] to be more inclusive of ordinary, but to be able to let people know that even if you're ordinary you can do extraordinary things."

As time passed, kudos continued to pile up. *Stranger Things* won five Emmy Awards and was nominated for thirteen others (at the ceremony, Brown, McLaughlin, and Matarazzo entertained the audience with a rendition of Mark Ronson and Bruno Mars's "Uptown Funk"). "I would always watch the award shows at night with my mom," Schnapp says. He remembers thinking, "'Oh, I wish I could go there. It looks so exciting.' I always dreamed of going to one of those events. Then it's all happening to me, and I wasn't watching TV. I was there in it, and it was so different and so cool."

Stranger Things resulted in an explosion of artwork from fans around the globe.

Opposite, clockwise from top left: British designer Matt Needle used an iconic D&D polyhedral die as the centerpiece of his poster design; Brazilian designer Butcher Billy created nine images like this one for each episode of season two, taking inspiration from vintage 1980s video game cartridges; Italian designer Federico Mauro put the walkie-talkie in the spotlight in his poster design; and French illustrator Thomas Humeau was inspired by fan favorite Barb when creating this illustration that alludes to her tragic fate.

"Chief Hopper cast a lonely look around the infected pumpkin patch"

4

MAZES AND MONSTERS

W HEN THE Duffer brothers created *Stranger Things*, they conceived of the project as an eight-hour movie, a tightly contained mystery told cinematically. So naturally, they approached the follow-up not as a second season of television but as a sequel: *Stranger Things 2*, which would be set one year after the original season.

"We wanted it to feel like it was growing and evolving as opposed to the same show, part two," Matt Duffer says. "Our kids are naturally growing and maturing—they look different. It just felt like the show needed to change in some way. If you look at the *Harry Potter* films, as the kids grow, the series becomes a little bit more adult, a little bit more mature. That was something we wanted to do. We wanted to give it a little bit more scope. We wanted some big shots and big sequences in there."

Going big meant not only introducing a slate of new characters to Hawkins, but also sending Mike into a depression, giving Dustin a surprising pet from another dimension, having Lucas meet his first love, and delivering Will into the clutches of a Lovecraftian[1] big bad. "You want to shake things up," Matt Duffer says. "You want to take the characters that you have, and you want to throw some stuff in there that's going to mess with all of the dynamics in an interesting way."

It also meant finding a way to bring back Eleven from wherever her showdown with the Demogorgon had taken her and then crafting a

1 Howard Phillips Lovecraft (1890–1937) was a prolific and influential horror author whose primary contribution to fantastic literature involved stories about the old cosmic entity known as Cthulhu. Many of the ancient malevolent (and often tentacled) beings in his writings defied human understanding.

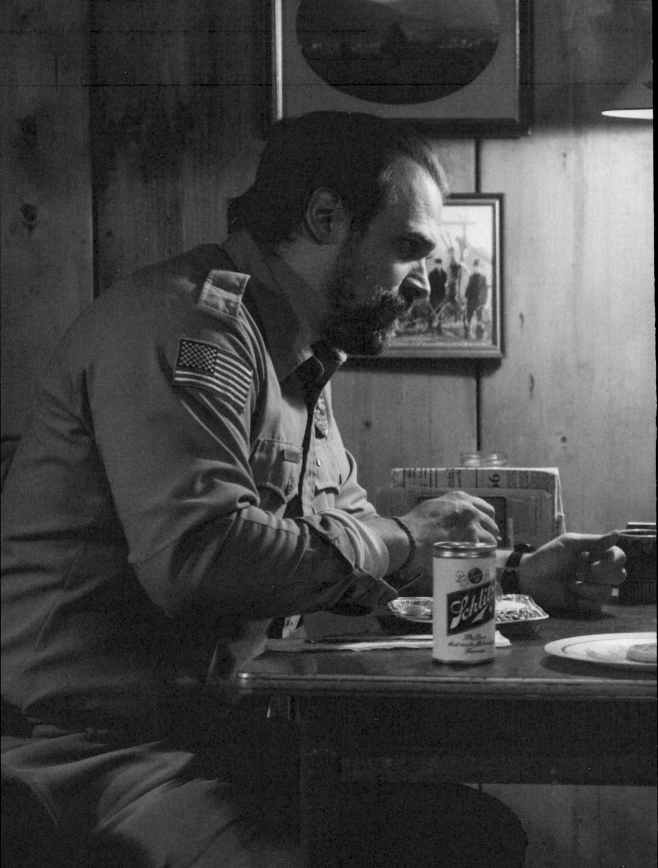

"Dinner first, then dessert. Always."
HOPPER

compelling arc for the character worthy of Millie Bobby Brown's extraordinary gifts as an actress. The Duffers decided to send the character on a personal quest, searching for the truth about her own history and coming to terms with the idea of Hawkins as a place she could truly call home. They paired Eleven with Jim Hopper and watched them try to establish a father-daughter rapport.[2]

"We knew what Millie was capable of, and we just wanted to push her," Ross Duffer says. "We knew she wasn't going to be with the boys, and we weren't going to be playing with that fish-out-of-water comedy, because we had played those notes and wanted to try something different. We did want to give Millie an extremely emotional season where she goes on this big overall journey and arc that is really very specific to just her."

"That's what makes the character so cool— he's always growing and always changing."

— FINN WOLFHARD —

At the outset of *Stranger Things 2*, Eleven's absence looms large for Mike (Finn Wolfhard), who marks the days since her departure and tries to contact her from his basement on his walkie-talkie, though he hardly expects a response. (Eleven tries unsuccessfully to reach him as well.) For Wolfhard, it was difficult to access Mike's emo side, though he understood that after the events of the first season, the boy would be moody and withdrawn.

"My character was just kind of a downer," Wolfhard says. "You can tell that Mike's still there. You can tell that his leader is still inside of him, but he just can't get it out. It was a challenge for me to do that, to play the opposite of what he was before. You

2 Reading a bedtime story to Eleven, Hopper shares a heartbreaking passage from the book *Anne of Green Gables*: "She died of a fever when I was just three months old. I do wish she'd lived long enough for me to remember calling her mother. I think it would be so sweet to say 'mother,' don't you?" This scene calls up a poignant corollary from season one, when Hopper reads from the same book to his daughter, Sara, as she lies in her hospital bed. We learn that the death of his only child led to the dissolution of his marriage and is the main source of his profound loneliness. Reading from the book allows the normally taciturn Hopper a way to comunicate his tender feelings to Eleven, but also perhaps a way to work through some of his grief for his daughter.

Mike tries in vain to make contact with Eleven, sitting in the tent fort that was her haven.

have less to play with. But that's what makes the character so cool—he's always growing and always changing."

Dustin and Lucas, meanwhile, are distracted by the arrival of California skater girl Max Mayfield (Sadie Sink)—but the Palace Arcade's new high-scorer brings with her an older stepbrother whose tightly coiled rage explodes in ugly, violent outbursts. Dr. Brenner might have functioned as the human monster in the first season, but Billy Hargrove (Dacre Montgomery) was designed to be someone potentially even more dangerous to the young heroes.

"Initially, we wanted Steve to be the classic human villain who's so common in Stephen King's books," Matt Duffer says. "It's kind of a King trope that he has these human bullies[3] that are as bad or worse than the supernatural villains. Once we cast Joe, it became clear that wasn't going to be Steve. He was so much more likable than we had originally intended Steve to be. So we wanted a really nasty human antagonist who's also hopefully—like all great villains—wildly charismatic, the kind of villain you love to hate."

3 King's fiction contains a host of human villains (from *Carrie*'s Margaret White to *Misery*'s Annie Wilkes), but sadistic teenage bullies "Ace" Merrill from the short story "The Body" and Henry Bowers from *It* perhaps had the most direct influence on the Duffers when they sat down to write *Stranger Things 2*.

The Bad Seed

BILLY HARGROVE

Played by Dacre Montgomery

In *Stranger Things 2*, a different sort of monster comes to Hawkins. Billy Hargrove is a violent, abusive teen with an explosive temper who seems to hold the world around him in great contempt. A California transplant in a bitchin' black Camaro, Billy is the baddest of bad boys, all anger and aggression and rage; the embodiment of an untamable teenage id who terrorizes his younger stepsister, Maxine (Sadie Sink).

"Looks like you got some fire in you after all, huh?"

To play Billy, the Duffer brothers cast Australian actor Dacre Montgomery (*Power Rangers*, 2017) on the strength of a now-infamous audition tape that involved a Duran Duran soundtrack and a G-string. "I felt like I needed to stand out from the rest, I suppose," Montgomery says. "But I always kind of do that with my [audition] tapes. When I find something that I'm really passionate about, I make them into a little bit more of a short film and make pretty bold choices."

Executive producer Shawn Levy says the tape caught everyone off guard, and they knew immediately they had found the right actor for the role. Levy

says, "His charisma was astonishing. His instincts for Billy's quiet menace were so compelling."

The character is one familiar to readers steeped in Stephen King's classic fiction. It's easy to draw a link from John "Ace" Merrill in King's novella *The Body* to Billy Hargrove. Both derive perverse pleasure from terrorizing a group of younger protagonists. Montgomery says, "I tried to home in on what characteristics people who are considered bullies in school might possess. He has tons of insecurities, and he's letting out those insecurities on his sister and his sister's friends."

Costume designer Kim Wilcox selected all the hallmarks of 1984 tough-guy fashion for Billy's look—topped off with a mullet wig. "The hair and the costume, as with any role, help you feel like the character," Montgomery says. "There's a little bit of myself in there. I kind of wear my collar popped up and a few buttons undone. I had a few big nights out in the leather jacket he wears. But the mullet made him feel completely different from me, and the earring."

Montgomery didn't meet the Duffer brothers in person until he arrived on the *Stranger Things 2* set from Perth, and he remembers feeling nervous his first day. But he quickly found his way into the character, and he fell into a solid rapport with Max actress Sadie Sink, which was helpful for the intense scenes they had together. "All I wanted to do was to make her feel safe because she is younger than I am, and she didn't know me from a bar of soap before we started shooting," he says.

Similarly, he felt it was important for the audience to understand Billy as a multidimensional character whose actions were motivated by his own inner turmoil. A sequence near the end of the season in which Billy's dad, Neil Hargrove (Will Chase), is revealed to be physically abusive went a long way toward humanizing the antagonist. "He's just kind of this confused teenager, as we all are with all those chemicals running through our bodies at that age," Montgomery says. "Certainly his home life isn't helping."

The California Girl

MAX MAYFIELD

Played by Sadie Sink

Sadie Sink does not like horror movies. At all. So when the young actress was presented with the mask she'd wear for one of her early scenes in *Stranger Things 2*, she didn't immediately recognize the costume: Michael Myers, the silent, imposing Shape from John Carpenter's 1978 landmark *Halloween*.

"The Duffer brothers were like, 'Hey, have you seen *Halloween*?'" recalls Sink, who plays tomboy skateboarder Max Mayfield. They explained it was a scary movie. "I'm like, 'No, I'm not watching it. I'm sorry.' I hate watching scary movies. I'm able to watch the show just because I know what's going to happen. I still will get a little bit anxious, but for the most part, I'm OK."

Sink had just finished watching the first season of the Duffers' brainchild when she heard about the role of Max and decided to audition. She was intrigued by the character's pluck and excited by the chance to work with Gaten Matarazzo and Caleb McLaughlin, both of whom she knew from the time she'd spent performing on Broadway. In the 2012 revival of the hit musical *Annie*, Sink, then 11, alternately played the title role and the orphan Duffy, sharing the parts with actress Taylor Richardson.

She was pleased to discover she enjoyed an instant kinship with the boys. "That was one of the best auditions I've ever had," Sink says. "Then to find out that I got it the next day—that was even better."

Netflix executive Carolina Garcia says, "There was just this ease with Sadie and the rest of the kids. She kind of walked right in and fit in with everybody, and so to us, that just felt very organic and very natural and it paid off."

By contrast, Max's initiation into Hawkins society is a little more fraught. The West Coast transplant immediately makes her mark at the Palace Arcade, unseating Dustin as reigning *Dig Dug* champion. Max is sharp and smart and resourceful but relentlessly bullied by her abusive older step brother, Billy (Dacre Montgomery). Although Dustin and Lucas develop instant crushes on the California native, she's initially reluctant to join up with their party. Eventually, though, she develops a fondness for both, especially McLaughlin's Lucas.

As soon as she was cast, Sink—who had never set foot on a skateboard in her life—had to learn quickly in order to look like a pro by the time she left her home in New Jersey to begin work on *Stranger Things 2* in Atlanta. "They sent me a skateboard, and they sent me a helmet, shoulder pads, elbow pads, kneepads, and all this material," she says. "Then, they set up an instructor, and they told me to start practicing skateboarding because that was really important."

"Nobody calls me Maxine."

"It was a process. I fell, I think, it was my first lesson. I was so frustrated. I was like, I'm never going to get this. It's going to be a disaster. It was pretty hard in the beginning, but I had some really great instructors. It all worked out in the end."

Since the pale redhead also needed a little help approximating Max's sun-kissed features, she wore tanner in many of her scenes. She was surprised by the difference a little bronzer could make. Sink says, "Max is from California. She skateboarded a lot. It made sense that she'd have a bit of a tan—which is a little unrealistic for me, personally, because I don't tan. I burn. I've never seen myself with tanned skin. I thought it was funny. The first time my mom saw me, she was like, 'Wow.'"

GAMER'S
DELIGHT

FOR A MIDDLE-SCHOOL STUDENT in 1984, there was no place cooler than the local arcade.

So when discussing ways to open up the world of the show for *Stranger Things 2*, Matt and Ross Duffer knew immediately that Mike Wheeler and his friends would hang out in an arcade in Hawkins. Production designer Chris Trujillo and his team found a derelict Laundromat in Douglasville, Georgia, that they gutted and transformed into the gleaming Palace Arcade—the name was inspired by the arcade featured in the 1983 film *WarGames.*

"The owner of the property was storing literally just junk in it," Trujillo says. "It looked like you walked into an episode of *Hoarders,* but we could see the potential. We were able to really take a blank canvas and just go for it without feeling restrained."

"The roof was caving in," adds set decorator Jess Royal. "It was so much work to even get it cleared out and structurally sound. But there were subtle things about it that made it what we wanted it to be. The awning on the outside was original, the metal building—everything about it was really great."

Construction was completed in a matter of weeks. The behind-the-scenes team then painted the set in bold, vibrant colors before stocking the location with fourteen vintage games, including *Missile Command, Pole Position, Ms. Pac-Man,* and, of course, *Dig Dug* and *Dragon's Lair.* "I love primary colors, so it's all yellow, blue, and red," says Royal.

"It's so whimsical just being able to pick all of these wild colors and do these sort of zigzagging data stripes," adds Trujillo. "That's the place where we really let the color palette just get totally nuts and mid-1980s."

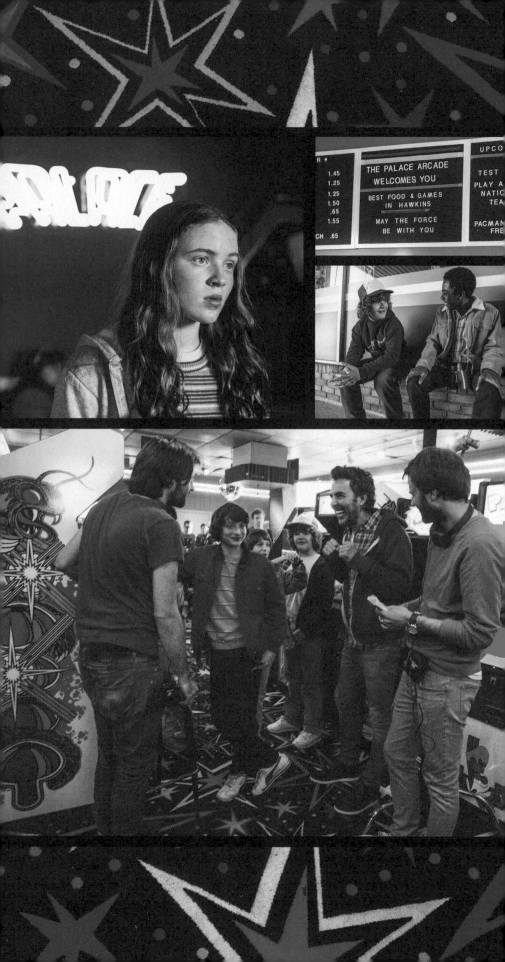

The BMX Files

"A bike like this is like a Cadillac to these kids."

– JIM HOPPER, CHIEF OF POLICE

WHEN POLICE CHIEF Jim Hopper discovers Will Byers's bike lying discarded in the woods, he instantly realizes something has gone wrong: "Bike like this is like a Cadillac to these kids," he tells his deputies, indicating there's no way the Byers boy would have abandoned his most treasured possession.

It was the job of *Stranger Things* season one property master Lynda Reiss to track down the bikes that the four boys ride. Reiss didn't need just four individual bikes for the kids—she needed a primary and three duplicates for each. One replica served as a backup in case the original was damaged during production; the other two were for stunts.

"I would have loved to have bought restored period bicycles, but trying to find four different bicycles I could get four matching [copies of], it was almost impossible," she says. Instead, Reiss improvised. She started with vintage bikes from the early 1980s and then changed out parts to make them into what she needed. "You can get BMX bikes that have the same frame," she says. "Then we bought on eBay period handlebar grips. We added in what we call the 'life layer.' The old vinyl seats would split, so you'd wrap them in duct tape. The kids would wrap foam around the handlebars. I found vintage lights that went on the front of the bicycle because, of course, kids were out biking in the dark back in 1980."

Each bike was tailored to each character. "Mike's bike is slightly newer, because Mike's family seemed, of any of them, to be the ones that have more money," Reiss says. "Dustin's always tinkering with things and making things, so I wanted Dustin's bike to have a halfway-finished repaint job on it, which is why it has that sort of white-to-black fade going on. And I wanted to throw a green one with a sparkly seat in just because I loved them, so I gave that one to Lucas. We didn't really see Will's bike apart from in the woods in a big heap."

Don't forget the extras! Your BMX is fully customizable, ready to adapt to suit your needs. Stay connected with your friends on the move by strapping on a walkie-talkie, and ride safely past sundown with the mounted headlight.

The Strangest Name in BMX

11 Sattler Place • Hawkins, IN

INQUIRE FOR STICKER PACK AND CATALOG

TRICK OR TREAT, FREAK

FOR WILL—AND for the town of Hawkins—the greatest danger remains supernatural. After being brought back from the Upside Down, the boy is haunted by waking flashbacks to the alternate dimension and stalked by a giant, long-limbed creature clouded in electric storms that comes to be known as the Shadow Monster, or the Mind Flayer. "We liked the idea of a very sentient being that's able to basically possess and puppeteer other creatures, other human beings," Matt Duffer says. "Once you introduce a concept like that, the possibilities are pretty endless."

Will's first encounters with the being come in the first hour of *Stranger Things 2*, but the creature has a larger presence in the second episode, which unfolds on Halloween night. Will inadvertently captures a brief image of the Shadow Monster after the video camera his brother, Jonathan, has loaned him (on loan, in turn, from Bob Newby) drops to the ground as he is transported into the Upside Down for a brief moment. "Halloween was one of the big ideas that we wanted to hang the season on," Ross Duffer says. "Once we started thinking about Halloween, one of the first big ideas that we fell in love with was this image of all of our kids in *Ghostbusters*[4] outfits."

4 *Ghostbusters* follows a team of paranormal experts out to save New York: Bill Murray as Peter Venkman, Dan Aykroyd as Raymond Stantz, Harold Ramis as Egon Spengler, and Ernie Hudson as Winston Zeddmore (Mike and Lucas argue over who gets to be Venkman). It opened on the same date as another classic that influenced *Stranger Things 2*: *Gremlins*. Photo © 1984 Columbia Pictures Industries, Inc. All Rights Reserved. Licensed courtesy of Columbia Pictures. Inc.

168

"One of the big images we had was Will in his *Ghostbusters* outfit standing on this neighborhood street and having a giant Shadow Monster rise up over him—we called it Trick-or-Treat Street," adds Matt Duffer. "Then we had to pray that we were going to get the rights to use *Ghostbusters* costumes."

Trouble was, they didn't get the rights. At least not initially. After the rejection came back, executive producer Levy sprang into action, contacting *Ghostbusters* filmmaker Ivan Reitman to plead their case: "I knew it was a make-or-break Halloween costume, so I spent weeks tracking down Ivan

"We liked the idea of a very sentient being that's able to basically possess and puppeteer other creatures, other human beings."

—— MATT DUFFER ——

Reitman," Levy says. "We ultimately had a personal conversation—the Duffers, me, and Ivan—in which we laid out why we loved his film and why those costumes were so perfect for our own franchise. Ivan agreed and gave us the go-ahead."

The Halloween scenes were shot over two nights and featured 150 to 200 extras, all sporting masks sourced by property master Lynda Reiss. (For practical reasons, she largely used reproductions of masks that were popular in 1984: "The real things, because of what they're made of and because they were meant to be disposable at the time, literally are disintegrating.") The

scenes were the first in which Max joins the crew, sporting a costume from John Carpenter's film *Halloween*.[5] Against Mike's wishes, Max tags along for trick-or-treating.[6]

5 Killer Michael Myers stalks his Illinois hometown on the scariest night of the year in John Carpenter's 1978 classic. Max, wearing a replica of Myers's mask, emerges from behind a row of shrubs to frighten her new friends; the staging of the scene recalls a moment from the film.

6 The Halloween scenes take place just days before the 1984 presidential election: in the upscale housing development where the group goes to trick-or-treat, signs for Ronald Reagan dot the manicured lawns. Back at Dustin's more modest home, the lawn boasts a sign supporting Walter Mondale. (Reagan won his second term by a landslide.)

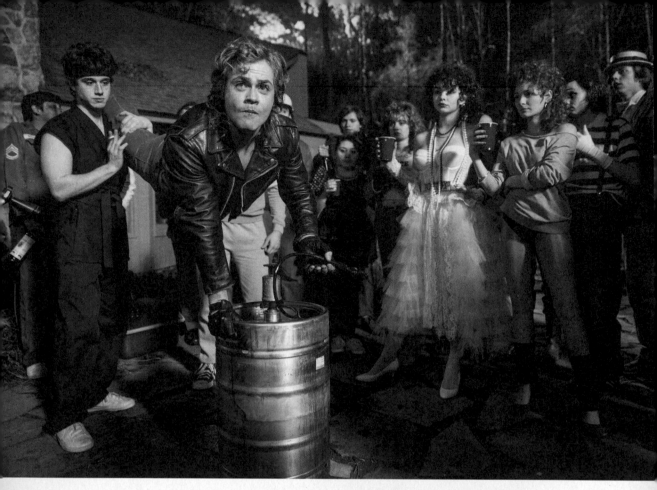

Billy becomes the keg master at the massive Halloween party, where he's surrounded by costumed students paying tribute to such movies as *The Karate Kid* and *Flashdance*.[7]

"She was so scary," says Matt Duffer. "She was waiting for the boys while we were shooting that, hiding behind a bush just as Michael Myers does in the movie. She was absolutely terrifying. We had a lot of fun shooting that sequence. For all the video-camera stuff, we just had the kids run around with the video camera and film footage that we were able to splice into the show."

7 Turns out the older Byers boy isn't the only Hawkins teen up on his counterculture. At the party, Jonathan runs into a classmate dressed as Siouxsie Sioux, the lead singer for a classic post-punk English band, Siouxsie and the Banshees. Sioux's distinct style formed the template for post-punks and goths from the 1980s onward (the tarantula hair of The Cure's Robert Smith and the torn-fishnet stockings and crucifixes favored by early-'80s Madonna among them). Her dark visage looms large over the stylings of Kali and her punk cronies (see pages 182–185), who give Eleven her own alt-girl makeover.

At the end of the evening, Dustin has a close encounter of his own, discovering an unusual creature lurking outside his house—which he traps and deposits in the aquarium in his room for further study. What he doesn't realize is that he's decided to nurture a baby Demogorgon. "This was something we talked about for season one but just didn't have room for," Ross Duffer says. "We were taking our cue from *Gremlins*[8], which was a staple of our childhood. You get this creature that seems cute and seems like it's your friend. Then, of course, things take a wild turn and become quite dangerous. We wanted to see Dustin have a bond with this thing and then also have to deal with something that was very, very scary."

The creature he names Dart becomes a huge focus for the character, and Gaten Matarazzo credits director Shawn Levy with helping him find his way through his early scenes with baby Dart. Matarazzo was most often working with nothing but his imagination, or, in some cases, a small mirrored ball that was intended to represent the tiny creature.

"To help me get in-depth with the character and to be emotionally connected with the character, he would make noises when directing because there wasn't anything there to work off of," Matarazzo explains. "He would make a noise that we both imagined that Dart would make, and he would use that type of voice to direct me and keep me on the edge emotionally. He was playing Dart."

By the time Dustin realizes exactly what sort of creature he's been nurturing with nougat, the family cat is dead (RIP Mews), and he's forced to turn to an unlikely source for help: Steve Harrington, who has had his heart broken by girlfriend Nancy. The idea for the pairing emerged as writing for *Stranger Things 2* was well underway.

"Dustin and Steve, honestly, that's sort of one of those things you stumble into. We simply didn't know what to do with Steve," Ross Duffer says. "He was originally in a plotline with Billy that we didn't end up having room for, so Steve was sort of sitting there, broken up with Nancy, depressed. At the same time, we had Dustin, who was

8 Joe Dante's film centers on a mogwai called Gizmo, an adorable creature who requires very specific care. The most important rule is never to feed him after midnight, lest he transform into a tiny, scaly monster (like his kin Stripe). Dustin's own pet, of course, turns out to be a dangerous predator in disguise.

isolated from all of his friends. I don't even remember who came up with the idea—what if we put these two together? We saw this bromance develop from there."[9]

"Steve is really like a father figure to him because Dustin doesn't have his father," Matarazzo adds. "His father's not living at home anymore for reasons we don't know. And he doesn't have any male siblings—or any siblings. He has his mom, and he loves his mom, and his mom teaches him so many things. There are some things that parents can't teach you. So when he gets [advice] coming from someone that he can relate to, a friend, someone who is close in his life, that doesn't feel awkward."

Stranger Things 2 uses unique pairings of characters to push the storytelling in unexpected ways. It isn't just Dustin and Steve who team up: Joyce embarks on a romance with sweet-natured Bob Newby (Sean Astin); Lucas and Max develop feelings for one another; Nancy and Jonathan hatch a plan to gain #JusticeForBarb. But the most explosive match up might be the one between Hopper and Eleven in the fourth episode, "Will the Wise," directed by Levy.

9 In 1986's *Stand by Me* (based on a Stephen King novella and directed by Rob Reiner), four twelve-year-old boys in 1959 Oregon set out on foot to locate a dead body, often walking along railroad tracks on their journey. A profound influence on the Duffers, the film even inspired them to stage certain scenes as overt homages to the emotional, coming-of-age tale.

Nancy and Jonathan find common cause in their quest for truth.

The psychic tantrum—as it came to be known—is one of the season's most unforgettable moments. Hopper's temper boils over when he learns that Eleven has left their cabin sanctuary. In a burst of anger, he desperately tries to stress to her the degree to which she's endangered them both by venturing out to see Mike.

"I think it was a lot of fun for us all to think about, what if you did have superpowers and you were a tween girl and you were really upset?" says staff writer Paul Dichter. "You can't help but kind of grin at the possibilities. And we obviously love the idea of Hopper being in way over his head as a sort of relatively unenlightened 1980s stereotype[10] and challenging him with this really tough, strong girl who also could kill him with the twist of her head."

But Harbour says Hopper has a bit of a mental roadblock when it comes to realizing just how dangerous Eleven can be. "He can't really fathom that she has these powers," Harbour says. "You can't actually yell at a kid if you can see that they could snap your neck with their mind, right?"

10 Movie and TV cops were often portrayed in the decade as hyper masculine holdovers from an earlier era who frequently displayed chauvinistic or sexist attitudes. They were usually quick-tempered and prone to violence and uncomfortable with displays of emotion.

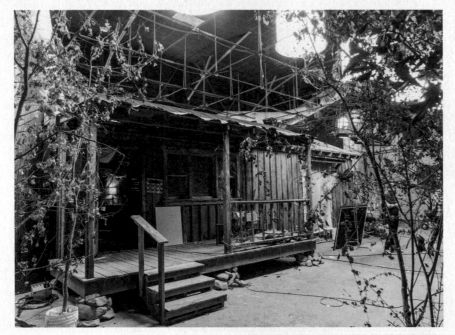

The exterior of Hopper's cabin in the EUE/Screen Gems Studios, Atlanta.

Harbour described the actual filming of the sequence as incredibly intense, with both he and Brown acutely feeling their characters' emotions. "It was a very difficult day, because there's a lot of difficult feelings to have to go through," he says. "Acting work is best when it's very personal, and I think that Millie and I both were a bit bruised as we were shooting that scene and afterward. We had to come to reconciliation through the rest of the season because it did get very personal—she's a very open instrument, and I am as well. She calls him psychotic and controlling; he calls her a brat. The lines get a little blurry in those scenes, and it gets very real, which I think is why it resonates so well. Your job as an artist is to bleed a little bit so that maybe other people don't have to."

Adds Levy, "That was an example where you start the day, you stage the scene, and then with those two, you get out of the way. Actors like Millie and David feed on each other's energy. Every time you say 'Cut,' it's a deflation. We did long takes, and I let their anger and frustrations build up, and we captured a lot of it on film. I gave a few notes here and there about the pain that is underneath both of their anger, but they're so good, and they just delivered."

Millie Bobby Brown prepares to film an emotional scene.

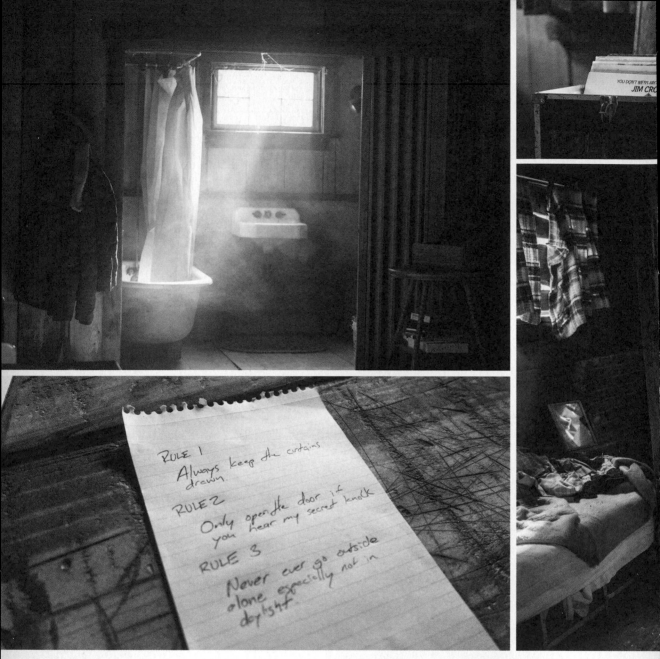

RULE 1
Always keep the curtains
drawn.

RULE 2
Only open the door if
you hear my secret knock

RULE 3
Never ever go outside
alone especially not in
daylight.

INSIDE HOPPER'S CABIN

It's perhaps the biggest revelation in the first hour of *Stranger Things 2*: Eleven hasn't vanished with the Demogorgon into the Upside Down—she's living with Hopper in a remote cabin in the woods that's been in his family for generations.

Production designer Chris Trujillo's team built the exterior of the rustic cabin from the ground up on a patch of land at Sleepy Hollow Farm in Powder Springs, Georgia. "Our thinking was, it's a hunting cabin," Trujillo

says. "It's been in Hopper's family probably since before his grandfather—or it's a cabin that his grandfather built when he was a young man. [We] wanted it to feel like it's mostly been sitting there. Maybe Hopper spent some time there as a boy, and it just slowly has fallen into relative disrepair. But he just has continued to keep it for some sentimental reason, and he's been using it to store things. It became this sort of repository for all of his history, his past."

Trujillo adds, "We found this really lovely spot that feels like it's deep in the woods but it's actually very accessible. They let us clear a footprint and build our exterior cabin there."

The project took roughly six weeks, start to finish. The corresponding interior was constructed on the Screen Gems stages. "We built everything around one massive

eighteen-inch cedar column," says art director Sean Brennan. "If you look at the center of that set, there's a cedar column that rises out of the floor, and everything else is tied off of it to allow us to have that open, expansive space."

Because it was all newly constructed, the show's scenic artists and painters were tasked with transforming the cabin into a structure that appeared to have been standing for generations. "That cabin, it's all raw, clean, fresh lumber until [the scenic artists] come in," Trujillo says. "They have all kinds of methods [for aging materials]. Sometimes it's as physical as hitting the wood with chains and denting it. They have instruments that look like torture devices that they use to add texture so that it looks like this cabin has been exposed to the elements and has been being bumped into and banged against for years. It's a laborious process. It's its own kind of

art form, taking something brand-new and making it look like it's aged naturally over the course of decades. You can rush-age something, and it looks like a haunted house."

Art director Brennan adds, "Our poor painters were in there scraping and milling down the wood and really getting in there and pitting it out, chinking it, and adding all kinds of character, and coming back over and making it look very, very, very old."

The finished product speaks volumes about Hopper as a character—in many ways, it reflects its owner. It's battered and worn, but there's no question it's still standing. "There are all these funky little artifacts kind of hidden throughout the cabin that tell of his past, his daughter," Brennan says. "It brings a lot of those elements back in without having to overly explain it."

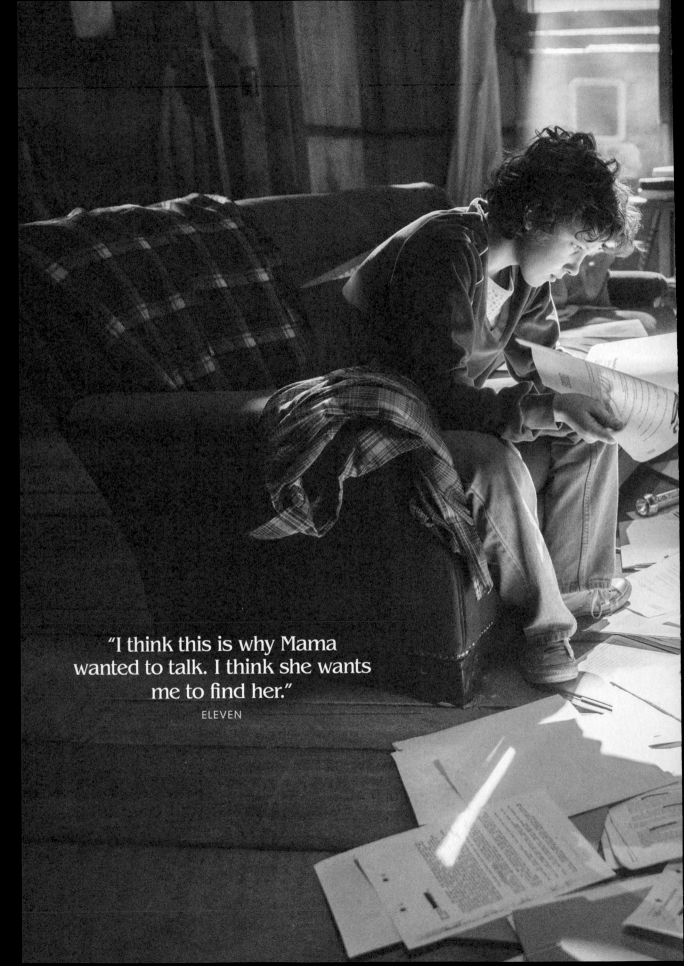

"I think this is why Mama
wanted to talk. I think she wants
me to find her."
ELEVEN

THE LOST SISTER

The most polarizing hour in *Stranger Things* history is "The Lost Sister"—a "bottle episode" (a term for an almost entirely self-contained episode of a show) in which Eleven (Millie Bobby Brown) goes to Chicago in search of Kali (Linnea Berthelsen), her missing "sister" and former test subject number 008 at Hawkins National Laboratory. Kali's life is a world away from what El has come to know in Hawkins. First glimpsed in the season's opening moments using her powers of mental manipulation to escape police pursuit, Kali has formed a gang to hunt down laboratory employees who were either directly involved or complicit in the terrible experiments—and murder them.

"It was something that early on, moving into season two, we were excited about exploring," Ross Duffer says. "Everybody kept asking if there were other numbers. Because Eleven's journey in season two was really disconnected until the very end from the rest of the main story, we wanted her to go on this emotional journey, where she's learning more about her past—about where she belongs."

He adds, "We were excited about not repeating ourselves. We were excited about playing with format in the second act—we thought, Let's pause for a bit and take her on this different journey before we bring her back into the action."

Eleven runs with the group briefly (long enough for a rad MTV-style makeover), but as desperate as she is to forge a familial connection with Kali, she knows the young woman's actions are deeply wrong. She returns to Hawkins with a better understanding of who she is, and who she wants to become, just in time to save her friends from a hungry pack of Demodogs.

Not everyone responded favorably to the narrative and tonal digression—many critics balked at an hour so incongruous with typical Hawkins happenings—but Brown says the story let Eleven mature in ways that were vital to the character's continued development. "It was important for Eleven to kind of go through that moment at the time because Eleven doesn't know who she is as a person," Brown says. "I know that my little sister influences me, so in real life Eleven's older sister really influenced her. I think she didn't want to be like that—she didn't want to be punk and different."

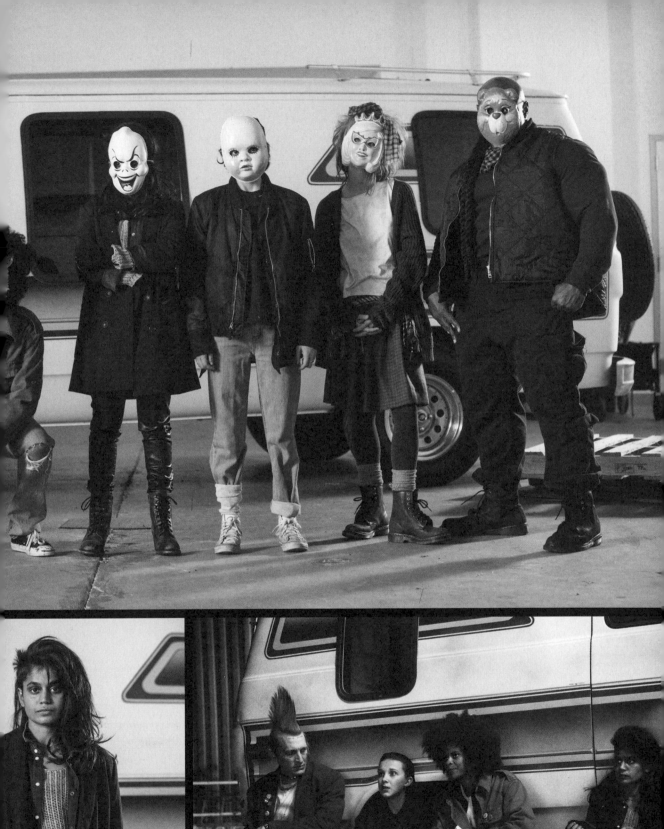
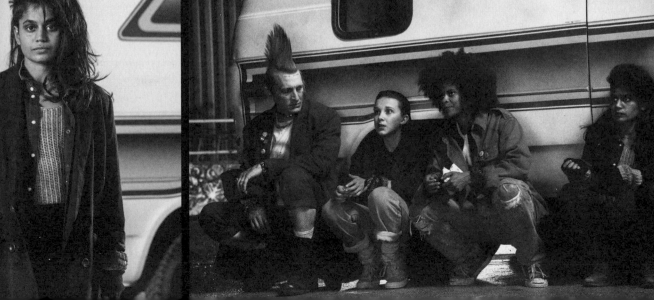

"I'm going to my friends.
I'm going home."
ELEVEN

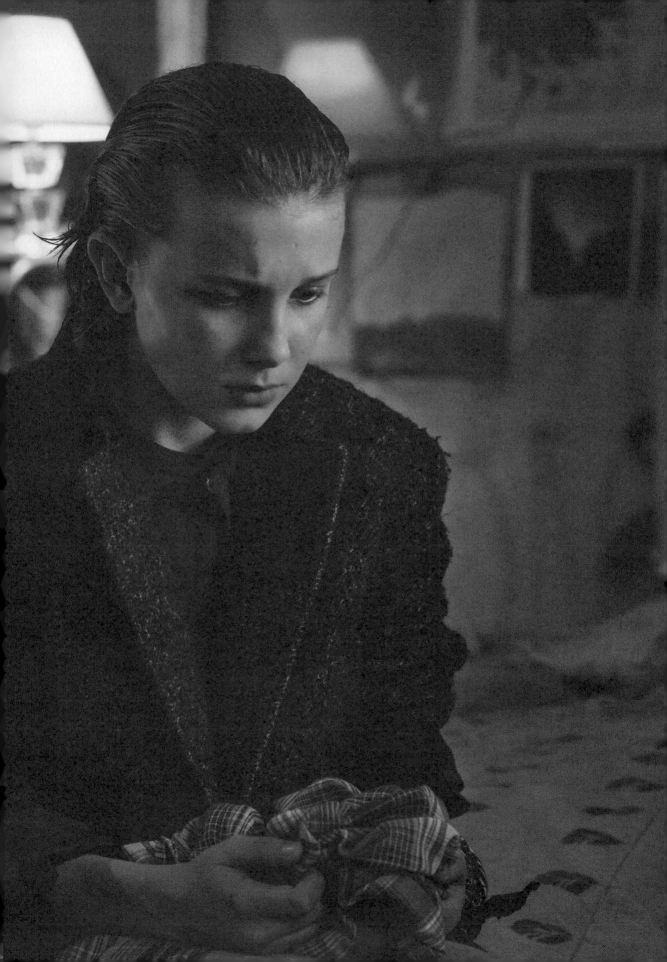

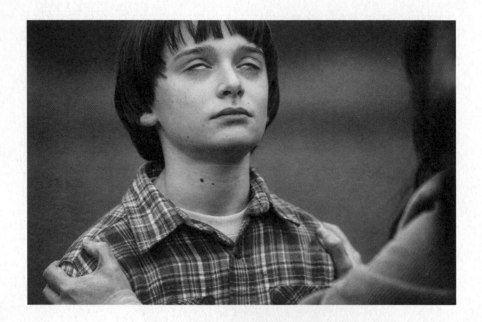

A VIRUS TAKES HOLD

BROWN WAS not the only young actor in the cast to deliver an astonishing performance in *Stranger Things 2*. Although Noah Schnapp had relatively little screen time in the first season, he moved to the forefront of the sequel with a possession story line that launched in the fourth episode, "Will the Wise."

Once the Shadow Monster takes control of Will's body, his consciousness is assimilated into the being's hive mind, and the creature can see through the boy's eyes and use him as a puppet to manipulate those around him. To prepare for those scenes, Schnapp watched the ultimate possession film, the 1973 classic *The Exorcist*,[11] and he also studied the scientific aspects of what happens to the body during a seizure for the sequence on the ball field when the monster actually takes control of him.

11 William Friedkin's terrifying, Oscar-winning film about a young girl (Linda Blair) whose body becomes host to a formidable demonic force is a master class in child acting. Blair's Regan MacNeil transforms from sunny student to levitating instrument of pure evil. When preparing for the scenes in which Will was controlled by the Shadow Monster, Noah Schnapp carefully studied her head-spinning performance, taking important cues from her physicality and demeanor.

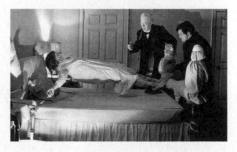

"There were a lot of technical aspects to a lot of the scenes that I filmed for season two. That was one of the only scenes where I actually used a green screen. When I was yelling at the monster, there was no green screen. I was just yelling at the sky. It was definitely harder working off the green screen than working off of real actors," Schnapp says.

"I remember filming that scene," Schnapp adds, "and it made me actually feel really good because Winona came up to me and she said, 'Oh, my baby, are you OK? Please tell me if anything's wrong.'"

Senior visual-effects supervisor Paul Graff says the crew members watching Schnapp's performance in those moments were equally impressed. "It was really amazing to see Shawn Levy and Noah," says Graff. "There's all of these guys and the big gear around him, and then Shawn walks up to him and whispers something into his ear. There's like this eerie moment where he kind of freezes and looks down into the lens or below the lens. And it's like when the Shadow Monster reaches his heart. It looks so amazing. It wasn't scripted like that. That night, I remember everybody was like, 'Oh, my God. This is just amazing.'"

"He stepped up his game so much once he was the center," adds Ross Duffer of Schnapp. "We had no idea that he had all of that in him. He gave us chills. What that kid did was truly incredible. Obviously season two does not work without that performance that he gave. It still blows my mind."

As the Shadow Monster gains a deeper understanding of Hawkins, its insidious influence expands. Vines stretch out from the Upside Down through a series of subterranean tunnels. Will can sense the decay[12] growing as abstract images race through his mind—the only way he can communicate what he's seeing is by furiously scribbling images down on paper with crayons. Eventually, his pictures piece together to form an elaborate map of the network running belowground.

12 Danny Lloyd starred alongside Shelly Duvall in Stanley Kubrick's 1980 adaptation of Stephen King's *The Shining* as Danny Torrance, a boy blessed (cursed?) with second sight. Will also develops a kind of clairvoyance as his consciousness becomes a part of the hive mind serving the Upside Down's overlord.

RUNS FOR HIS LIFE. STILL TRAPPED IN THE
UPSIDE DOWN.
360° ENVIRONMENT CAPTURE NEEDED
PRACTICAL ON LOCATION WITH ROTO
SEE IF WE CAN ADD FOG

2 AS HE RUNS, WE HOLD TIGHT ON HIS FACE
AND...
PRACTICAL ON LOCATION WITH ROTO
SEE IF WE CAN ADD FOG

3 MEMORY FLASH:
TO THIS MORNING. TO BOB'S STORY.

BOB: "...BUT THIS TIME... I DIDN'T RUN."

MEMORY FLASH:
"THIS TIME - - I STOOD MY GROUND"

5 WILL SLOWS..
PRACTICAL ON LOCATION WITH ROTO
SEE IF WE CAN ADD FOG

6 - - TO A STOP.
PRACTICAL ON LOCATION WITH ROTO
SEE IF WE CAN ADD FOG

ATHING HARD. HE'S NOW REACHED THE
ALL FIELD. HE'S STILL SCARED TO DEATH.
GREEN SCREEN / CLEAN PLATE

- JOYCE & WILL CIRCLED - V3 - 12/2/16

8 BUOYED BY BOB'S WORDS THIS MORNING - -
GREEN SCREEN / CLEAN PLATE

9 - - HE GATHERS HIS COURAGE AND. . .
WONDERVIEW

WE RUSH TOWARDS WILL WHO'S
ANDING IN THE MIDDLE OF THE FIELD.
OT MOVING. MOTIONLESS. MIKE IS BY
HIS SIDE.

(PERHAPS HANDHELD HERE)

RUNNING FEET ENTER THE FRAME -

3 IT'S JOYCE AND DUSTIN RUSHING TO WILL!

HEY'RE FOLLOWED BY MAX AND LUCAS.

FROM JOYCE'S POV:
RUSHING TOWARDS WILL. IT'S CLEAR SOMETHING
IS WRONG. HIS EYES ARE CLOSED. IT'S EERIE
AND UNSETTLING.

6 REVERSE ON
JOYCE AND THE GANG COMING TO A STOP.

MIKE IS AT HIS SIDE:

I - - I JUST FOUND HIM LIKE THIS - -
NK HE'S HAVING ANOTHER EPISODE - -"

8 JOYCE: "WILL!"

SHE SHAKES HIM TRYING TO SNAP HIM OUT OF IT,
BUT HE DOESN'T WAKE. HIS EYELIDS MOVE BACK
AND FORTH.

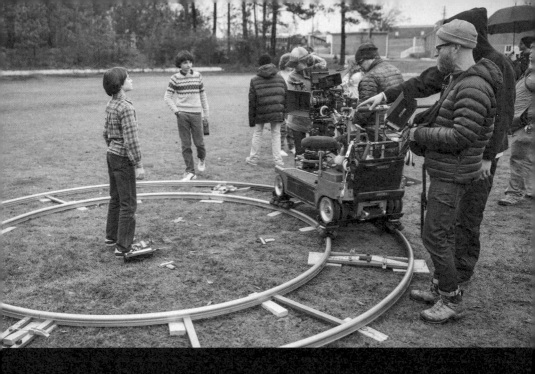

SCENE BREAKDOWN:

WILL VS. THE SHADOW MONSTER

Of the many visual special effects–intensive sequences in *Stranger Things 2,* one of the most complex comes at the beginning of the fourth episode, "Will the Wise," when the Shadow Monster begins to funnel itself into Will Byers using its myriad tentacles to access his body in the stormy, dark environs of the Upside Down. In the real world, it's broad daylight, and Will stands paralyzed on the school baseball field, locked in what appears to be the grips of a seizure, as his mother desperately tries to rouse him.

Concept artist Michael Maher Jr. created storyboards for each shot. "Maher did a concept of what it looks like with the particles going into his mouth and ears and everything," says senior visual-effects supervisor Paul Graff. "We felt like those are really strong images. They're like black-and-white drawings, kind of a comic strip."

The scenes were filmed on the grounds of Patrick Henry High School with actor Noah Schnapp standing in the center of a circular camera track six feet in circumference. "To really feel that full circular motion, you need to actively run the camera around [him]," Graff says. "You can't just twist him in space. His eyeline needs to be set. He needs to be looking at something and be standing and screaming, and the camera needs

to dolly around him and the green screen to be on the other side. We needed to be able to separate him from his environment, so you have to always have a green screen behind him, especially when the wind is blowing and his hair is going all crazy."

Hydraulx, a VFX shop based in Santa Monica, California, digitally added the Shadow Monster and transformed the background into the Upside Down—a process dubbed "Netherization" after the original name for the alternate dimension. Graff enlisted Maher once more to help guide their efforts. "Once we had the footage we picked a few still frames out of the footage and had him paint over it to give the vendor an idea of what we wanted it to look like," Graff says. "The finished product looked very much like these concept paintings."

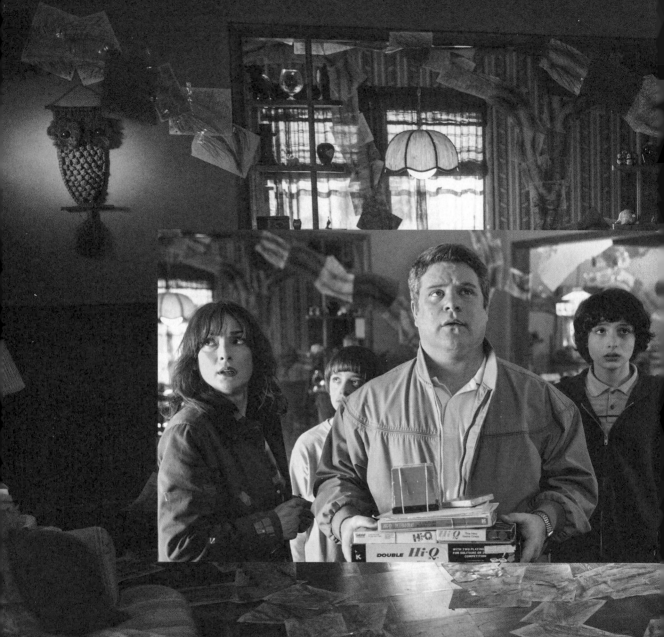

"IT'S NOT A PUZZLE, IT'S A MAP.
IT'S A MAP OF HAWKINS."

BOB NEWBY

Property master Lynda Reiss created the actual drawings that Joyce hangs throughout her home as she tries to puzzle out the meaning behind them. "The tunnel drawings in the house, we created thousands and thousands of them," Reiss says. "Trying to figure out what they were, how big they were, what they looked like, the color of them, what they mapped out, how they all fit together, what they were made of—that was a good four months of my life."

They were an enormous undertaking, too, for production designer Chris Trujillo and the other members of the art department who were tasked with crafting roughly 80,000 square feet of tunnels on a vast, empty soundstage. "I think your average show would have just green-screened all of that," Trujillo says. "We ended up actually physically realizing thousands of square feet of tunnels. We built multiple sections and half sections and [points] where multiple tunnels converge. It was really important to the Duffers that we build all of that stuff and have it be real and have the actors in real physical spaces."

The tunnels were built from a series of six- to fourteen-foot-diameter wooden ring sets that were elevated at different heights to give them what Trujillo calls an "undulating" architecture. "We had chambers that broke apart in multiple pieces for shooting," adds art director Sean Brennan. "We had access bays that were on chain motors that opened up so the camera could get inside and be able to shoot. Everything was constructed with the purpose of being shot. A full-sized human could run through there, no issue. We had an overall idea that essentially they went on for infinity. Nobody knows how far these tunnels actually went."

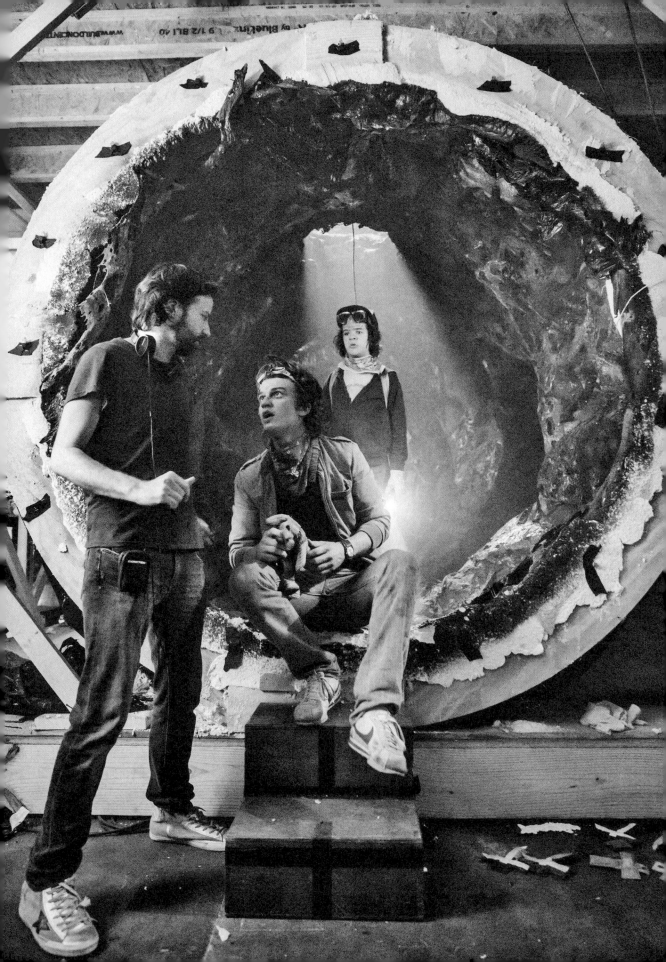

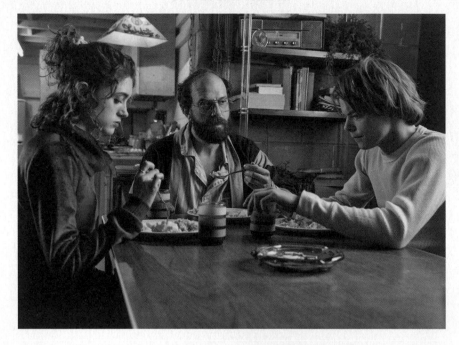

NEW BLOOD

AS THE Shadow Monster spreads its tendrils throughout Hawkins and uses its powers to manipulate Will, a newly single Nancy is determined to bring closure to Barb's parents, who believe their missing daughter might still be alive. Nancy recruits Jonathan to aid in a scheme that will expose some of the nefarious happenings at Hawkins National Laboratory—and finds another ally, too, in conspiracy-minded former journalist Murray Bauman (Brett Gelman).

"We always wanted that conspiracy theorist," Ross Duffer says. "As you do research on programs like MKUltra, there are always those men and women who are obsessed with it, and they're making some really crazy and bold accusations about our government. So it was always fun to us to go, 'Well, what if one of these guys is right about this?'"

Murray may also be the only character willing to call out Nancy and Jonathan on their obvious feelings for one another, something that *Stranger Things* staff writer Kate Trefry underlined in the sixth episode of the second season, "The Spy." "I love that bickering-John-Hughes,

A wall of old television sets in Murray's conspiracy-themed bachelor pad.

pick-each-other-apart, teenage, hyper-verbal-analysis stuff, so it was really fun to have the character of Murray be able to tear these two apart in ways that they wouldn't even dare,"[13] Trefry says.

For the sequence when the teens finally do come to terms with their attraction, the show reached back to 1984 film *Indiana Jones and the Temple of Doom*[14]—specifically the scenes in which Harrison Ford's archaeologist and Kate Capshaw's nightclub singer flirt and quarrel and brood over one another in adjoining rooms.

13 Nancy and Jonathan's quest evokes that of another teen couple—David (Matthew Broderick) and Jennifer (Ally Sheedy) who seek the help of Falken (John Wood) in the iconic *WarGames* (1983).
14 The push-pull romance between Dr. Jones (Harrison Ford) and Kate Capshaw's Willie Scott also influenced Nancy and Jonathan's rapport.

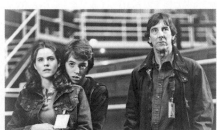

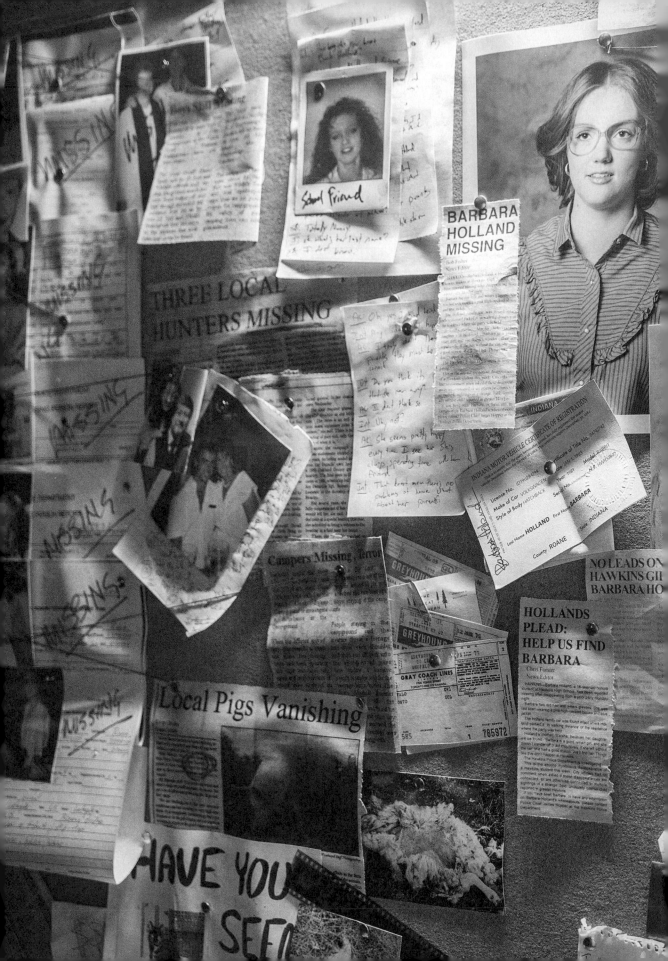

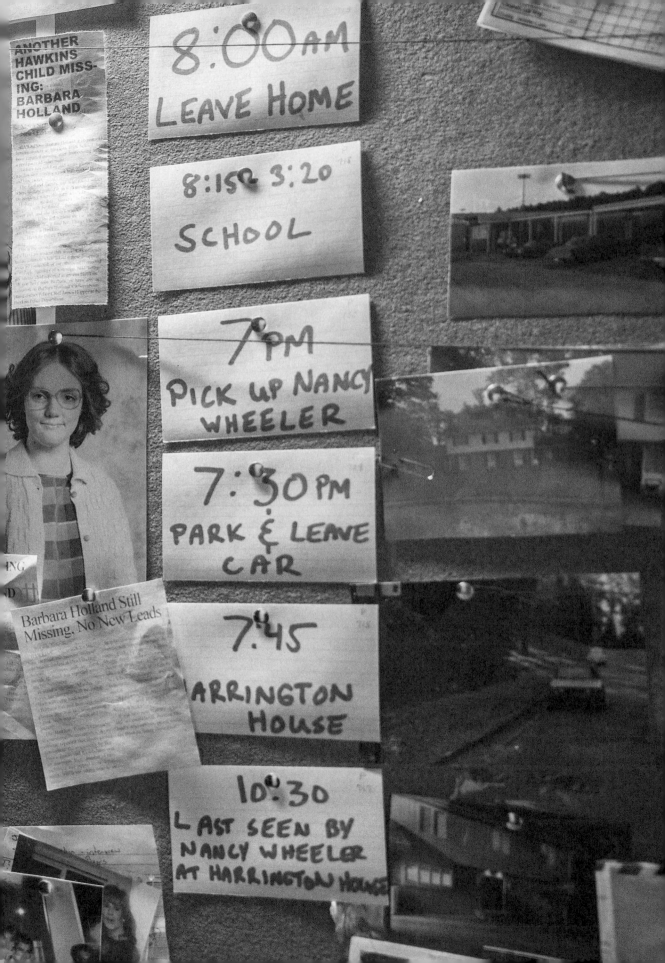

ANOTHER
HAWKINS
CHILD MISS-
ING:
BARBARA
HOLLAND

8:00AM
LEAVE HOME

8:15@ 3:20
SCHOOL

7PM
PICK UP NANCY
WHEELER

7:30PM
PARK & LEAVE
CAR

Barbara Holland Still
Missing, No New Leads

7:45
HARRINGTON
HOUSE

10:30
LAST SEEN BY
NANCY WHEELER
AT HARRINGTON HOUSE

"They have this I hate you/I love you kind of thing, and I think there's a little bit of that between Jonathan and Nancy," says actress Natalia Dyer. "Those days filming with Brett Gelman were some of my favorite days of the whole shoot, because we had two or three solid days of just getting to play in this weird space. Brett was so fun and funny, and he was different every take."

For both the fifth and sixth installments of the season, Oscar-winning filmmaker Andrew Stanton (*WALL-E, Finding Nemo*) stepped in to direct. "Andrew, I couldn't believe it, he called Shawn up and said, 'Hey, if you need a director, I'm

> ## "Hopper and Eleven are two profoundly nonverbal communicators. To get either one of them to a place of really spilling thoughts is basically a season-long journey."
>
> — KATE TREFRY

in,'" Matt Duffer recalls. "We learned how to screenwrite by studying the *Toy Story* screenplay, which Andrew cowrote, and *WALL-E*, another great film that Andrew wrote. Structurally, they're a dream. He's an incredible storyteller."

Matt continues, "There's a precision to his filmmaking that is amazing to me. I think a lot of that has to do with the fact that he comes from an animation background. He storyboards literally everything—every sequence, even the dialogue sequences. You just don't see that in TV—there's a choice behind every single shot."

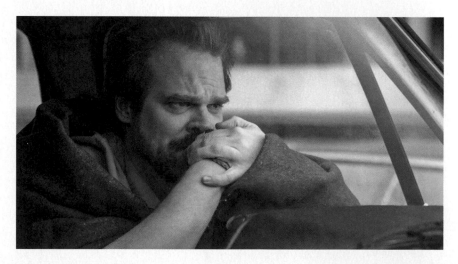

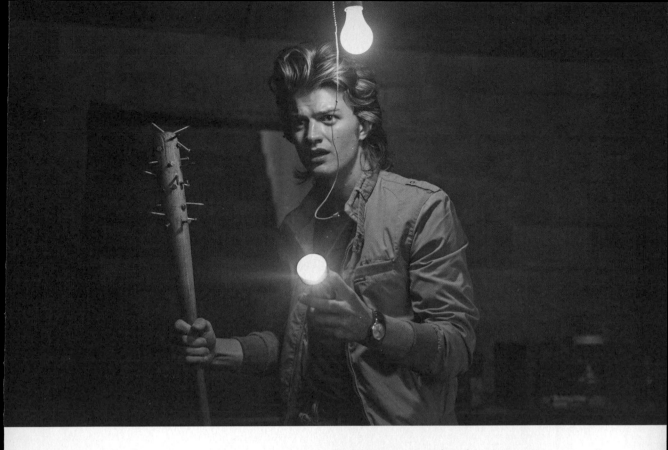

Stanton's episodes were rich with poignant moments—in addition to Nancy and Jonathan's encounter, he was behind the camera when Steve confesses to Dustin the secret to achieving perfect hair while walking along the train tracks, and for the gripping scene when Hopper delivers a tearful apology to an absent Eleven over the CB radio in his truck.

Writer Trefry notes, "Hopper and Eleven are two profoundly nonverbal communicators. To get either one of them to a place of really spilling thoughts is basically a season-long journey. You really have to earn it. Hopper's a cowboy. He's a man's man, and you really have to work him to get him to that place. But Harbour is amazing, and when you give him that stuff, you really buy it. It's finally the crack in the veneer—the terror of parenthood that I think is fundamental to his character."

The director had an opportunity to stage action sequences, too. Steve goes into "babysitter" mode to protect the young heroes from a nocturnal Demodog attack at the junkyard. "Action is a way for us to deliver emotional payload," Trefry says. "In the junkyard, it's really about this fractured group coming back together, having each other's backs—Lucas and Dustin taking the first steps of reconnecting after being at odds over Max all season, and Steve starting to assume the mantle of 'Dad Steve' in this bizarre misfit group."

199

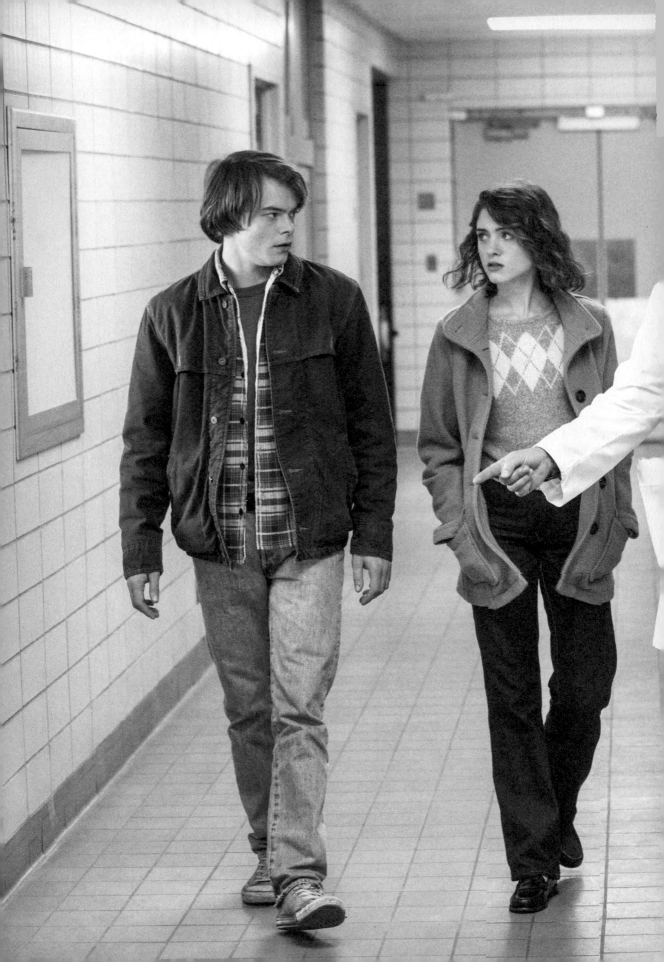

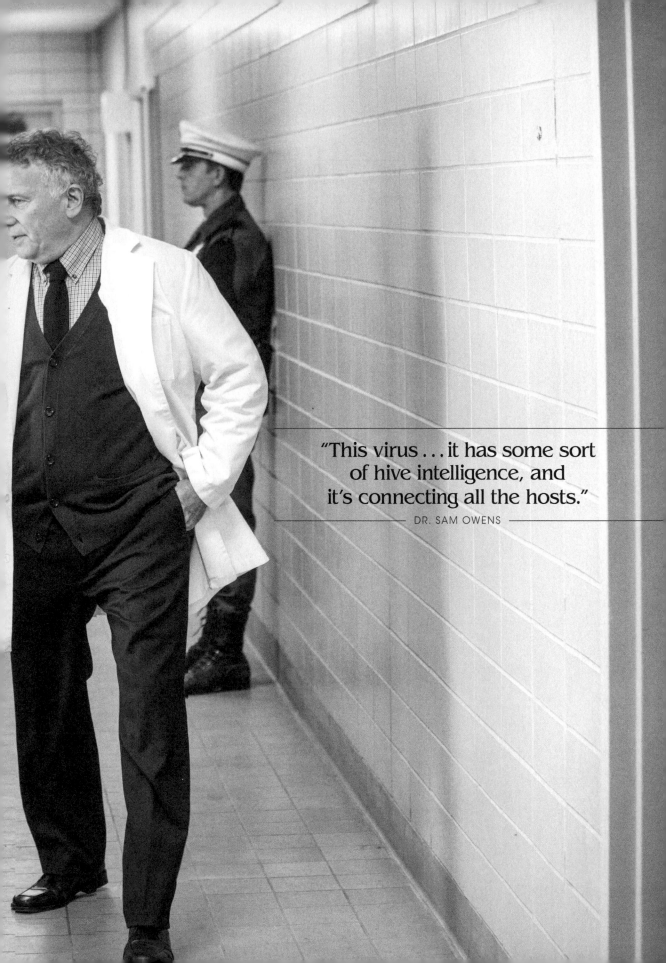

"This virus . . . it has some sort
of hive intelligence, and
it's connecting all the hosts."

DR. SAM OWENS

Inside the Hawkins National Laboratory set.

Tragically, the Demodogs do claim one victim, however: Bob Newby, who loses his life in heartbreaking fashion in the run-up to the finale. A power failure traps the adults in the lab[15] as they're attempting to leave the facility with Will, and Joyce's technically minded beau volunteers to reset the system, even though it will put him in danger. He succeeds, but before he can leave the lab with everyone else, he's attacked by the pack of creatures and killed.

"Bob was always intended to die, but you weren't supposed to be that sad about it," Ross Duffer says. "But Sean Astin proved so likable that Bob's death got pushed from episode four to episode eight because we kept wanting to keep him alive. It was important to us and also to Sean to give him a bit of a hero's death. We wanted him to

15 A sense of anxious doom haunts Hawkins Lab (which sometimes operates under the cover of Hawkins Power and Light); its scientists are fearful of forces too large for them to control and suspicious of outsiders. The atmosphere recalls that of *The China Syndrome* (1979), in which Jane Fonda plays a reporter investigating the cover-ups at a nuclear power plant as it grapples with a reactor meltdown.

accomplish something meaningful. That's how this idea came about: what we call our *Jurassic Park*[16] sequence in the lab, where Bob has to go down into the basement and reset the breakers. He may not be a traditional action hero like Hopper, but he's able to use his brain to ultimately save the day."

THE FINAL SHOWDOWNS

DETERMINED TO reclaim Will from the Shadow Monster, Joyce stages a kind of impromptu exorcism. She intends to drive the creature out of her son by using bright lights to blind the monster to the boy's surroundings while calling out to Will through loving memories she shares with him. Jonathan and Mike offer their recollections, too. Although Will remains trapped, a prisoner inside his own body, he manages to tap out a message to his loved ones in Morse code: "Close Gate."

"There was a lot going on during that scene," says Schnapp. "There was the whole Morse code thing—the Duffers asked me to watch a video on Morse code the day before [that tells you] where you

16 As part of the thrilling conclusion of 1993's *Jurassic Park*, Laura Dern's paleobotanist Dr. Ellie Sattler successfully makes it to a bunker to manually restore power to the island after an outage—and is promptly attacked by a waiting velociraptor. Unlike Bob, she escapes.

have to put your fingers and how to tap. There's a certain rhythm to it. I had to learn the actual Morse code for the words before the scene. I was tied down to the chair for a while, but that was cool because I've always watched those action movies[17] where the guys are tied down to the chair and they're trying to escape. I've always wanted to do one of those scenes."

Cinematographer Tim Ives lit the scene simply and for maximum effect. "Believe it or not, some of the best scenes come down to a $1.99 light, which is what that was," he says. "It just was the right tool. They're basically those little photo flood clip-on lights. I think Winona looks really beautiful in that scene, where she's trying to connect with her son. That light was bouncing off Noah Schnapp's chest back on to her."

When her first attempt at exorcism doesn't work, Joyce, accompanied by Nancy and Jonathan, takes the boy to Hopper's cabin and burns the creature out of him with heat. Actor Charlie Heaton says he was astonished by Schnapp's performance in those scenes. "It was kind of terrifying," Heaton says. "He would literally be convulsing on this table. It was so scary. This is no lie. What you see is what he was doing. It was shocking because of his age, and he's a child and he's strapped down. His performance was just so honest and so truthful. Then—'Cut!' And he'd be like, 'Can I have a tea?'"

17 *The Avengers* (2012) took the action-movie trope and turned it on its head—with Scarlett Johansson's Black Widow tied to a chair at the opening of the film yet telling her contact that she had her interrogators "right where she wanted them." She then fights her way free.

Will's exorcism scene was just one part of an action-packed finale. Max, too, finally has an opportunity to stand up to the monster in her life. When Max's sadistic stepbrother, Billy, turns up at the Byerses' home looking for her, a fight breaks out between him and Steve. Max puts a stop to the violence by threatening her stepbrother with Steve's Demogorgon-fighting bat. Actress Sadie Sink, who plays Max, saw the exchange as a truly empowering moment for her character. "That was great," Sink says. "She finally gets her revenge. The whole season, you just feel so bad for her, like, 'Oh, my gosh, he's so mean,' and in the end, she's like, 'Nope, not anymore.'"

The kids then head into the tunnels to draw the attention of the Demodogs away from Eleven and Hopper, who have returned to Hawkins National Laboratory to close the rift and permanently banish the Shadow Monster to the Upside Down. Property master Reiss outfitted the party with the gear they wear to protect themselves from the toxicity of the underground atmosphere.

Reiss reports, "It was scripted they had snorkel masks on.[18] I looked at that [and thought that] whatever they have needs

18 Reiss took this snapshot of the crew testing out their tunnel gear.

Nancy ruminates on the best strategy to defeat the Shadow Monster.

to have come from the Byerses' house. They didn't stop off somewhere else to get more things. So I created a box—you don't actually see it, but when they're tipping everything out from the shed, it's there. It has flippers, and it had a series of snorkel masks and goggles in there, like from some trip to the beach. If you look at all the kids individually, Lucas has his bandanna. Dustin has a dish towel, and I think he has ladies' gloves on. And then Max has some old ski gloves on and a pair of safety goggles."

Matarazzo says shooting in the tunnels was one of the most memorable experiences of the season—in good and bad ways. "Those tunnels were spectacular," he says. "They made it so realistic. All the spores in the air—they used dandelion seeds. That was floating through the air. It was beautiful to look at. It's scary, but it was beautiful. If there wasn't a random opening for the camera to be there and a bunch of people standing there, you would be in the Upside Down."

Dustin encounters Dart one last time inside those tunnels, and Matarazzo says he was delighted that there was a physical representation of his character's former pet to which he could react. "They had a Demogorgon head on a stick, which isn't much, but the guy working the thing gave it personality," the actor says. "He would arch its head as I would speak to it, and he would make it seem almost like a lost puppy. It really did help out."

206

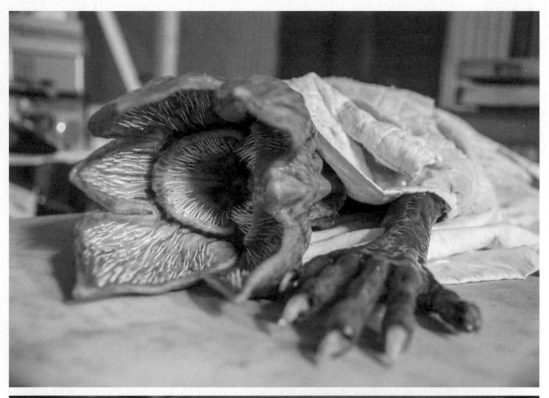

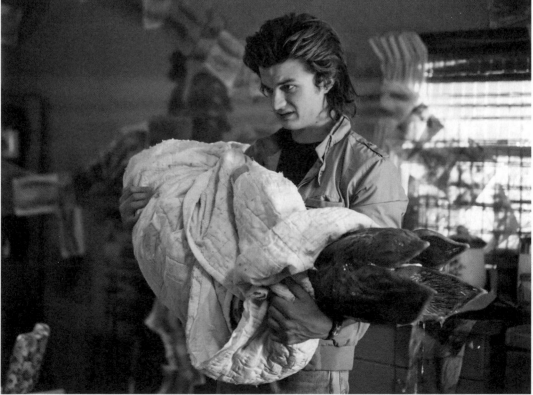

Steve swaddles the dead Demodog before stashing it in the fridge.

For the Duffers, the most technically challenging sequence involved filming Eleven using her powers to close the gate to the Upside Down. The sequence was made up of more than one hundred individual shots, each of which was storyboarded in advance and shot over the course of two days on a largely empty soundstage so that the environment could be constructed entirely using digital effects in postproduction.

"It felt like we were shooting a Marvel movie, or what I imagine shooting a Marvel movie would be like," Matt Duffer says. "We had two cameras on technocranes, and we had a cage[19] suspended a bit in the air. And then all around David and Millie there were just green screens. It was almost mathematical in the sense that we crossed off the shots one by one. You can get really lost in terms of where you are in space and time when everything looks the same. It wasn't the most fun sequence to shoot, but it was great fun to see it slowly come alive in postproduction."

Special attention was paid to the way the stage was lit, according to senior visual-effects supervisor Paul Graff. "We needed red light and white light, and we needed it to be pulsing because the rift sort of has this pulse, and the pulse increases, of course, over time through the sequence," Graff says. "Basically, the light turns from red light to almost white light at the end. We needed to simulate that, and then the rest was really just jumping around with the camera in front of nothing around this shark cage and imagining all these things."

19 Richard Dreyfuss's Hooper descends below the depths inside an iron cage only to find himself face-to-face with a deadly creature in Steven Spielberg's thriller *Jaws (left)*. In *Stranger Things 2*, Eleven similarly confronts the Mind Flayer while suspended outside the rift between dimensions. In both productions, the cage at first seems to offer some level of security but then serves only to intensify the vulnerability of the heroes.

THE SNOW BALL

STRANGER THINGS 2 concludes on a homespun note, with the gang attending the big school dance, the Snow Ball. The scenes required some 250 extras in period attire. "We intentionally went larger than life a little bit, but also wanted to keep it feeling real," says production designer Trujillo. "We wanted to keep the bleachers in evidence, so you would still feel like you're in a gym, but we wanted everything to feel very magical. We wanted every angle to have something sort of shimmering and lit up."

"The idea was to go back to the sweetness of the show and pay tribute to, I would say, more of a season one–style photography," adds Ives. "By the time we got to the end of season two, it had gotten pretty slick. We've been in all these tunnels, and we've been in situations that seemed very foreign and supernatural. Everybody wanted the Snow Ball dance to feel like it was made by high-school and middle-school kids, to really have that sense of innocence to it. We rigged a big disco ball in the ceiling off camera that gave us most of the light in there combined with the Christmas lights, which always look beautiful. And I felt that's something that kids would grab to decorate a place."

Sink says walking onto the set felt like being transported into another era. "It was so cool," she says. "You would walk in, and you felt like you had time-traveled back into the 1980s. It was so perfect."

The Snow Ball is the site of two first kisses: one between Mike and Eleven and the other between Lucas and Max. "I wasn't that nervous," says Wolfhard. "I was more nervous about getting my lines and being convincing in general, just being convincing as a character and an actor and having as much fun as possible."

Just as the first season of *Stranger Things* closed with an ominous image, so did the sequel. As the strains of "Every Breath You Take"[20] by The Police fade into dissonance, the camera begins to tilt until the image is literally upside down, and there, raging in the distance, is the Mind Flayer, temporarily banished, but certainly not defeated.

20 The Grammy-winning song from the iconic English trio remains a defining standard for a generation, but for the young stars of *Stranger Things*, The Police's "Every Breath You Take" is just straight-up creepy. Gaten Matarazzo even began referring to the track (in which frontman Sting sings over and over again to the object of his desire "I'll be watching you") as "the stalker song."

"OUT OF ALL MY BROTHER'S FRIENDS . . .
YOU'VE ALWAYS BEEN MY FAVORITE."

NANCY WHEELER

MIX TAPE

SEASON ONE

JOY DIVISION
"Atmosphere" [1980]

Ian Curtis's brooding baritone is gorgeous and melancholy on "Atmosphere," a single released by the post-punk pioneers only two months before their troubled front man committed suicide. It plays at the beginning of episode 4.

☐ CASSETTE 4-791 ☐ LP 4-792 ☐ 8-TRACK 4-793

COREY HART
"Sunglasses at Night" [1984]

If there's such a thing as peak-1980s pop rock, this is it. Canadian Corey Hart's ode to daytime accessories can be heard as Steve and pals Tommy and Carol drive to Nancy's house so Steve can talk to her. Trouble is, he sees her with Jonathan and gets the wrong idea.

☐ CASSETTE 6-421 ☐ LP 6-422 ☐ 8-TRACK 6-423

TANGERINE DREAM
"Exit" [1981]

The title track from the German art-rock legend's sixteenth album plays during the conclusion of the sixth episode of the show during Steve and Jonathan's alleyway fight over Nancy. The song choice is especially fitting in relation to Steve Harrington, who, at least initially, sees himself as the Hawkins equivalent of a *Risky Business*–era Tom Cruise; Tangerine Dream scored the landmark 1983 coming-of-age film.

☐ CASSETTE 5-721 ☐ LP 5-722 ☐ 8-TRACK 5-723

THE CLASH
"Should I Stay or Should I Go" [1982]

The hit anthem from London's punk-rock icons was one of two smash singles from the album *Combat Rock* ("Rock the Casbah" was the other). To the Duffers, the song's infectious, rebellious energy felt like something that would deeply appeal to Jonathan Byers, so much so that he'd want to share the song with his younger brother. "We're big fans of The Clash," Matt Duffer says.

☐ CASSETTE 8-431 ☐ LP 8-432 ☐ 8-TRACK 8-433

MODERN ENGLISH
"I Melt With You" [1982]

The upbeat New Wave love song is an enduring classic of the early 1980s—popularized in part thanks to its presence on the *Valley Girl* soundtrack. The hit song pops up in the second episode.

☐ CASSETTE 2-311 ☐ LP 2-312 ☐ 8-TRACK 2-313

ECHO & THE BUNNYMEN
"Nocturnal Me" [1984]

It's deep-cut time. From the album that contained the hit "The Killing Moon" comes a far more obscure closing-credits track for the fifth hour. "Nocturnal Me" might be slightly more upbeat and way more romantic than the New Order elegy, but it's got a similar hypnotic swoon that ends the action on an enthralling otherworldly note.

☐ CASSETTE 9-731 ☐ LP 9-732 ☐ 8-TRACK 9-733

NEW ORDER
"Elegia" [1985]

The magnificent seventeen-minute minor-key instrumental from the band's album *Low-Life* has the same plaintive qualities as some of Joy Division's best work, perhaps not surprising given that New Order formed in the wake of Joy Division front man Curtis's demise. Guitarist and keyboardist Bernard Sumner, bassist Peter Hook, and drummer Stephen Morris continued performing together under the new moniker. The song captures much of the same supernatural foreboding as Survive's instrumental score and plays over the montage of Will's loved ones preparing to attend his funeral.

☐ CASSETTE 3-951 ☐ LP 3-952 ☐ 8-TRACK 3-953

Also available in LP and 8-track!

TOTO
"Africa" [1982]

The strains of Toto's soft-rock ode to a continent that its songwriter, David Paich, hadn't yet visited can be heard as Steve cozies up to Nancy in her bedroom in the first episode. The number-one hit has enjoyed a longevity that surprises even members of the band. "'If this is a hit,' I said, 'I'll run naked down Hollywood Boulevard.' Now I have to sit here and eat my words because 'Africa' has become a standard," Toto guitarist Steve "Luke" Lukather told *The Guardian* in a January 2018 interview.

☐ CASSETTE 0-211 ☐ LP 0-212 ☐ 8-TRACK 0-213

DELIVERING HIGH FIDELITY. SEASON AFTER SEASON.

Stranger Things wouldn't sound like *Stranger Things* without Survive's enthralling electronic score. But a catalog of pop songs from the 1980s and beyond also contributes to the singular soundscape of the hit series. Here's a breakdown of some that are ripe for repeat listening, starting with season one.

Just as the scope of the Duffer brothers' storytelling for the *Stranger Things* sequel expanded, the show's pop-music soundtrack grew to include upward of thirty songs—some of the biggest hits of the era among them.

Nothing but the HITS!

SEASON TWO

OINGO BOINGO
"Just Another Day" [1985]

Danny Elfman's New Wave outfit always was ahead of the curve. Although this track wouldn't be released until the year following the sequel's 1984 setting, it set a tone for the action. After all, "just another day" in Hawkins isn't quite like just another day anywhere else. Plus, it served as a quick tribute to one of the Duffers' favorite film composers. "Growing up, we were nerds," says Matt Duffer. "We were super into movie music, like Danny Elfman. That's what we were listening to. So we were thrilled to get some of his early music into the show."

☐ CASSETTE 4–981 ☐ LP 4–982 ☐ 8-TRACK 4–983

THE POLICE
"Every Breath You Take" [1983]

Executive producer Shawn Levy says the choice of this song "alludes creepily to the fact that the Shadow Monster is looming above Hawkins in our last image of Season 2, and he will remain there, lying in wait."

☐ CASSETTE 1–521 ☐ LP 1–522 ☐ 8-TRACK 1–523

SCORPIONS
"Rock You like a Hurricane" [1984]

What better walk-up music for the new psychopath in town? Billy Hargrove drives into the high-school parking lot in his black muscle car, windows down, mullet in place, to the wailing guitars of the German hard-rock outfit's best-known anthem. The Duffers report, "Our editor Kevin Ross put this in his first cut. We've honestly never seen the scene without this song. It's obviously super on the nose, but that's precisely why we like it. It makes us smile every time we see it."

☐ CASSETTE 7–321 ☐ LP 7–322 ☐ 8-TRACK 7–323

OLIVIA NEWTON-JOHN
"Twist of Fate" [1983]

After a thorough cool-guy makeover from babysitter Steve, Dustin enters the Snow Ball confident that his night is destined for romance, as this upbeat, synth-heavy dance track from the film *Two of a Kind* plays in the gymnasium. The Duffers "tried out a lot of different songs at the dance. The kids would always react to our choices; sometimes the songs were too cheesy and made them laugh. This one seemed to strike that perfect balance—it felt super 1980s, but it didn't feel like a joke. It felt authentic."

☐ CASSETTE 3–561 ☐ LP 3–562 ☐ 8-TRACK 3–563

RATT
"Round and Round" [1984]

A cigarette hangs from Billy's lips as he lifts weights to the breakout hit from the California band. Glimpsed on the television in the background is the video for the song, which played in heavy rotation on MTV and inexplicably featured a guest appearance by comedian Milton Berle. The Duffers say, "This was picked by Andrew Stanton, and we feel it's the perfect choice for Billy's workout."

☐ CASSETTE 8–241 ☐ LP 8–242 ☐ 8-TRACK 8–243

RAY PARKER JR.
"Ghostbusters" [1984]

Who you gonna call? It was the question everyone asked in the wake of the mammoth release of the smash horror comedy starring Bill Murray, Dan Aykroyd, Harold Ramis, and Ernie Hudson in 1984. For four nerdy friends who'd recently had close encounters of the supernatural kind, *Ghostbusters* would have been the event film of the summer. Matt and Ross Duffer remember, "We must have listened to this song a thousand times growing up. Just hearing those first notes brings back so many memories. So when we wrote an episode featuring our characters in *Ghostbusters* outfits, we knew we had to use this song!"

☐ CASSETTE 2–651 ☐ LP 2–652 ☐ 8-TRACK 2–653

JIM CROCE
"You Don't Mess Around with Jim" [1972]

No, you do not, especially when the Jim in question is Jim Hopper. The police chief puts on the song that launched 1,000 GIFs when showing Eleven around their new home—a very old cabin that's been in Hopper's family for generations. David Harbour fans quickly embraced the scene, which sees Hop show off his moves for the very unimpressed girl. Executive producer Shawn Levy and the Duffers hit upon the song one day when Harbour happened to walk by their office. Levy says, "We asked him what oldie song Hopper should put on in that scene, and Harbour suggested the Croce song. And now his infamous Hopper Dance will forever be linked to it!"

☐ CASSETTE 0–421 ☐ LP 0–422 ☐ 8-TRACK 0–423

Artist Kyle Lambert's poster for *Stranger Things* had to accomplish many different things all at once: the image had to capture the spirit of the show and communicate to the audience basic ideas about its themes and characters. It also had to function on its own as a piece of visually arresting art. Lambert, who had previously done a poster for the J.J. Abrams film *Super 8*—also inspired by the Steven Spielberg oeuvre—looked to the classic work of poster artist Drew Struzan for the project. "Drew's posters were very successful at combining the people and the story elements in a well-composed way."

The *Stranger Things* poster incorporated narrative elements from the series (the Christmas lights, the Ouija wall, the barbed-wire fence surrounding Hawkins National Laboratory) alongside representations of the principal characters. "We had to make it feel dark and tense but without showing the [monster]," Lambert says. "One of the things that was a challenge was communicating that Eleven had these powers. I suggested that she have her hand out, because traditionally in movies or TV series where people have mind powers, they basically stick their hands out and control things. But the problem was in the [early] episodes, she didn't stick her hand out. Then at the very end, the last episode, when Eleven's confronted with the Demogorgon and she's literally just about to kill the thing, she raises a hand and delivers the final blow."

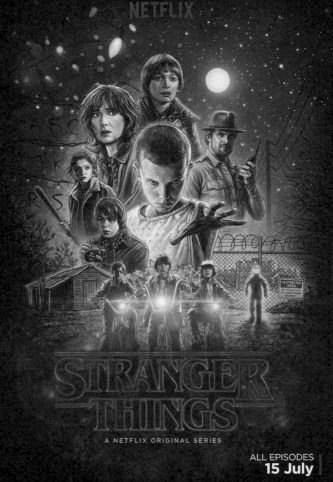

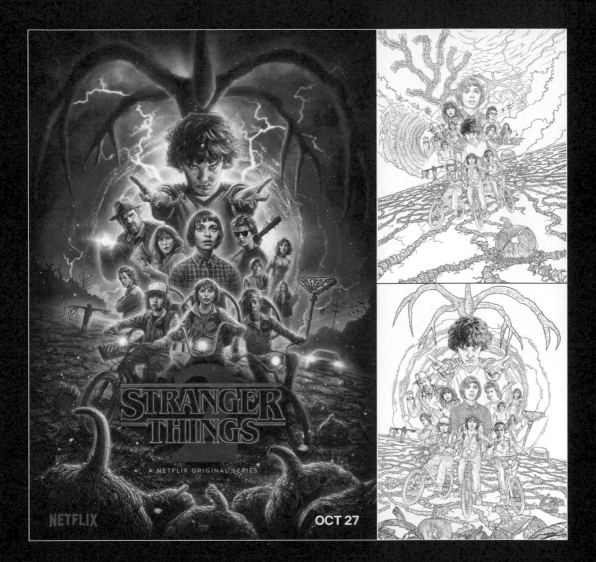

OCT 27

SEASON 2

As he had for the first season of *Stranger Things*, artist Kyle Lambert created a striking poster for *Stranger Things 2* that saw the Shadow Monster looming over the main characters; once more, Eleven is at the center of the image. "It was one of the most challenging projects I've ever done," Lambert says. "It was a lot of story elements to try and combine—the pumpkins, the Mind Flayer, the arcade, the scarecrow—yet make something that looked beautiful and didn't look crowded. I always try to communicate story elements as clearly as possible

and as big as possible. Those two things fight each other—having lots of stuff in there and then having it be big and bold and visually clear. I think the large Mind Flayer really helped establish the visual language for that poster. Then, as you go down the poster, the world is starting to turn, which is consistent with what happens in the season, where the whole of Hawkins is starting to be affected by this thing. That's one of the things that's quite successful about both posters—they tease all these different aspects of the show."

Opposite and above: Artist Kyle Lambert used digital technology to create the now-iconic posters for Stranger Things *and* Stranger Things 2; *here, a close-up look at how the images evolved.*

EPILOGUE
THE SHAPE OF *THINGS* TO COME

GUYS. GALS. KIDS. LEVI'S. White words on an enormous red sign displayed in the window of the Gap advertise the shop's array of casual fashions to the patrons of the cool new hangout in Hawkins, Indiana—the gleaming Starcourt Mall. The place is thronged with hundreds of shoppers sporting perms[1] and polka dots, florals and fluorescents, and in the midst of them stand Matt and Ross Duffer, surveying the scene.

It's May in the suburbs just north of Atlanta, and in one wing of a largely deserted shopping center, the T-shirt-clad writer-directors are seated in front of a bank of monitors watching as buddies Steve Harrington and Dustin Henderson reunite after several months apart. In the world of *Stranger Things*, it's the summer of 1985—*Fletch* is playing at the mall's multiplex; so are *Return to Oz* and the alien-invasion thriller *Lifeforce*. Ads for Stephen King's *Skeleton Crew* hang in the windows of the Waldenbooks[2] store. Shoppers in need of refreshment can head over to the food court to visit Orange Julius or Hot Dog on a Stick.[3]

In the chronology of *Stranger Things*, not quite a year has passed since the tumultuous events of October 1984, when Dustin unknowingly brought home a baby Demogorgon and Eleven briefly went punk, but for the heroes

1 A "permanent wave" ("perm" for short) uses heat and chemicals to give body and curl to typically straight hair; the results typically last for about six months. It was the go-to hairstyle for both men and women, and like many trends, it appears on the verge of making a comeback.

2 In the days before ecommerce, Waldenbooks was one of several popular bookstore chains that could be found at the local mall. B. Dalton Bookseller was another.

3 No mall was complete without a food court offering pizza, Chinese food, and enormous frosted cookies. Hot Dog on a Stick still operates eighty different locations.

at the heart of the beloved series, a lot has changed. Steve's a high-school graduate. Mike and Eleven are officially a couple, and so are Lucas and Max. We can't quite say what's happening between Joyce and Hopper, except perhaps that they have a swell new place to purchase jeans.

After two very intense seasons in dark spaces with grim monsters and claustrophobia-inducing tunnels, Matt and Ross Duffer decided it was time to brighten things up—literally—with a summer-set story line fueled by young love and raging hormones. "Aesthetically it's going to feel very different," Ross Duffer says. "Everyone is going to this new mall, seeing movies, and, of course, the Hawkins pool is open for business. I think there'll be a sense of fun and joy."

And also dread. *Stranger Things* wouldn't be *Stranger Things* without a sinister supernatural threat, and no one understands how to pair earnest character drama with straight-up scares better than the Duffer brothers. Borrowing inspiration for the third season from the master of body horror, David Cronenberg,[4] the showrunners came up with a truly terrifying premise that ventures into some uncomfortably gory territory. The faint of heart (and stomach) would be well advised to prepare for serious eye-covering.

"While it's our most fun season, it also turns out to be our grossest season," Ross Duffer says. "We're inspired by John Carpenter's *The Thing*.[5] We're inspired by Cronenberg. We have a little bit of a George Romero vibe in there as well. There are horror movies and horror masters that we haven't really paid tribute to as much in previous seasons that we are definitely going to get into this season." (This might be the right time for a reminder that one of Romero's

4 *Body horror* can be applied to any category of story concerned with gruesome or unsettling distortions to human anatomy. Canadian auteur David Cronenberg proved himself a master of the subgenre, particularly with his early films, such as 1975's *Shivers* (left), in which a rogue doctor's experiments go disastrously awry. Cronenberg's influence on the Duffers comes through especially in scenes such as the season-one moment in which Will coughs up what turns out to be a larval form of a Demogorgon.

5 *The Thing* centers around a lethal alien creature who can mimic and control other life-forms. Now considered a masterpiece of modern sci-fi, the film flopped at the box office, with audiences vastly preferring Steven Spielberg's family-friendly story about an otherworldly visitor, which had been released only two weeks prior.

zombie classics, *Dawn of the Dead*[6] from 1978, was a blood-splattered indictment of the hollowness of consumerism set inside a shopping mall.)

Naturally, the exact nature of the antagonist(s?) is top secret, but don't rule out return appearances from two very familiar bad guys—the first being charismatic bully Billy Hargrove. ("Big-time Billy in season three," promises executive producer Shawn Levy.) The character's story line might surprise some fans, according to actor Dacre Montgomery, and he was excited to take the villain in some unexpected directions. "There's much more depth to him, but also much more darkness in this particular season," Montgomery says.

The Mind Flayer hasn't lost interest in Hawkins yet either. The tentacled creature continues to loom near Hawkins inside the Upside Down, and its malevolent influence isn't absent from the new season. "We ended season two with a clear signal that the Shadow Monster was not eliminated, and maybe he's even identified his foe," says Levy. "And that darkness, and the battle that it will require, grows in season three."

But the biggest battle young heroes Mike, Dustin, Lucas, and Will are facing may simply be growing up. Burgeoning romance already has strained the ties among the original members of the party of *Dungeons & Dragons* adventurers, and each of the boys is struggling with awkward entry into full-blown adolescence—a stage of life when nothing is quite as simple as it once was.

"It's really the final summer of their childhood," Ross Duffer adds. "They're dealing with growing up, with these complicated new relationships. They're starting to fall apart a little bit, and maybe they don't love

6 Few filmmakers embraced the idea of monster as metaphor as expertly as George A. Romero (1940–2017), the father of the modern zombie. His revolutionary *Night of the Living Dead* (1968) offered a powerful meditation on civil rights. Ten years later, the follow-up *Dawn of the Dead* (right) tackled the shallowness of obsessive materialism: as the dead walk the Earth, they find themselves drawn to the shopping mall, mindlessly wandering by deserted storefronts. Romero shot it on location at Pennsylvania's Monroeville Mall. His legacy certainly influenced the Duffers' decision to shoot in an actual mall as well.

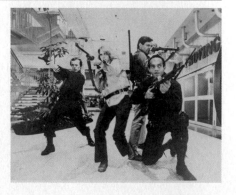

playing *Dungeons & Dragons* as much as they used to. Naturally, that's going to generate conflict."

Adds Levy, "If season two was about the desperate desire for normalcy and the impossibility of normalcy in Hawkins, season three's about change. It's about changes in the kids' relationships with each other. It's about romantic relationships that change friendships. It's about adult relationships that maybe change in tone. It's about Hawkins, as a town, changing with the arrival of a new mall and what that means for the small town in the mid-1980s."

As it did with *Stranger Things 2*, the show's cast itself has undergone some changes—principally through three new additions: Maya Thurman-Hawke,[7] who plays a young woman named Robin, who is bored with her job until she learns about the dark secrets of Hawkins; Jake Busey,[8] who plays a reporter for *The Hawkins Post* named Bruce "with questionable morals and a sick sense of humor"; and Cary Elwes,[9] the star of the 1980s fantasy classic *The Princess Bride*, as the image-conscious Mayor Kline, a politician who might not always have the best interests of the small town in mind.

It's possible Kline has something to do with bringing the Starcourt Mall to Hawkins, but if there are nefarious origins to the place, they're hard to spot—candle purveyor Wicks 'N' Sticks[10] doesn't exactly scream evil. To create the mall, production designer Chris Trujillo and his team went to great lengths, taking over parts of two floors of an existing shopping center and retrofitting it like it was 1985. "We found an incredible location and did a massive overhaul to a huge section of it," he says. "We're sparing no pain and no expense on all of our storefronts, our food court."

"There's no faking stores, no faux fronts or anything," adds set decorator Jess Royal. "Every store that we're selecting is a real store, with a couple exceptions just for script reasons. You could walk into any of these stores in theory, and all the products there are from 1985."

7 Maya Thurman-Hawke enjoyed a breakout role as Jo March in PBS's 2017 adaptation of *Little Women*. She's the daughter of actors Uma Thurman and Ethan Hawke.

8 Son of actor Gary Busey, Jake Busey has been acting for decades in film and television, amassing a résumé filled with dozens of credits—among them 1997's *Starship Troopers*, 2014's *From Dusk Til Dawn: The Series,* and 2018's *The Predator*.

9 Cary Elwes remains best known for his role in 1987's fantasy romance *The Princess Bride*. He's worked steadily over the decades in films ranging from *Robin Hood: Men in Tights* (1993) to *Saw* (2004), and his television appearances include *Psych, Family Guy*, and *Life in Pieces*.

10 Founded in 1968, Wicks 'N' Sticks sold candles and accessories in every size and shape imaginable at shopping malls across the country.

To dress the mall, Royal scoured the Internet, magazines from the time, and other archival materials to study the architecture[11] of shopping malls from the mid-1980s and what businesses were popular in Indiana at that time. The design process alone took upward of five weeks, followed by two months of construction.

"Our mall is kind of a recently opened thing, so it couldn't look like a mall built in the 1960s or '70s. "It has to feel very much like a current 1985 shopping mall. So there's a Gap from 1985. [We spent time] just creating these exact replicas of what the Gap looks like and then dressing out the exact fashions of that time. It's pretty authentic."

Spend any time on the *Stranger Things* set, and you'll hear a lot not only about the importance of authenticity, but also about how the people who make the show are part of a close-knit group, almost like a family. That's especially true on a day when the Duffer brothers' parents drop by to watch their sons at work.

It's another day at the shopping mall, and Mike, Lucas, Max, and Will politely push their way past other shoppers to make their way down the escalator. They're heading straight for Steve Harrington to ask him a favor. Before they can find him, though, they have to endure the taunts of Lucas's sassy, scene-stealing[12] little sister, Erica Sinclair (Priah Ferguson), who'll be returning in season three. "Watch it, nerds!" she calls out to her brother and his pals.

As the action unfolds, actor Joe Keery, who plays Steve Harrington, stands behind the dual monitors where the Duffer brothers are seated. Keery is wearing a robe over his costume, lest prying eyes get a glimpse of the new

11 The architecture of the American shopping mall typically included two floors of individual retailers with a central atrium and between two to four department stores "anchoring" the structure. Southdale Mall was the first to be constructed in Edina, Minnesota, opening in 1956. By the 1980s, there were roughly 3,000 malls in the country. Gwinnett Place Mall, the facility hosting the production of *Stranger Things*' third season, opened in 1984.
12 In one such scene, Erica takes over Lucas's walkie-talkie and messages Dustin on the other end of the line: "I got a code for you instead. It's called code 'shut your mouth.'"

look Steve's rocking for the day. With so many background actors and marks to hit, it takes a few tries to get the sequence right, but once everything goes perfectly, the Duffers leap up with an excited "Yes!" and spontaneous applause breaks out.

Between scenes, the writer-directors chat with Finn Wolfhard, who is sporting a yellow T-shirt and denim vest and maybe seems just a little lankier than he used to. Both the brothers and Levy stress that as the show moves forward, they've tried to adhere closely to the "*Harry Potter* model"— namely acknowledging that their young stars are getting older and crafting story lines that reflect that new maturity.

"They have developed very strong opinions on their characters, which is a function of both age and history with their characters, and that's very typical of series television," says Levy. "By season two, and certainly by season three, one often sees the actors know their characters better than anyone. Their confidence in their instincts, their articulation of their instincts has definitely grown. But they're still silly. They're still their age and, thankfully, none of them are grossly precocious."

"The kids are the heart of all this," Ross Duffer says. "Those performances, I think, are winning people over who aren't even nostalgic for the 1980s or this type of genre material. The kids and their joy is just infectious."

Matt Duffer adds, "What's great about this long-form type of storytelling is that we get to have the monster, we get to have all this supernatural fun. But you don't lose out on what really makes a story work, which is the characters and the emotions that you feel by caring for those characters. [This format] allows you to explore so many different types of relationships and so many different tones. You never get bored writing because of that. The minute you get tired of writing these bickering kids, you're writing a scene with adults, or you're writing a scene with teenagers, and it's got a completely different dynamic and feel. For me, that's a big reason the show connected with so many people."

AFTERWORD

by Shawn Levy

I THINK WE all knew early. All of us—those who make the show and those who watch it—we all knew early on that *Stranger Things* was something special. Did we know that it would be a success? Absolutely not. Did we know that it would become a worldwide phenomenon, with fans in more than one hundred countries? No way. But we knew that there was something unique, something captivating, from the very beginning. And it all started with a game.

The opening scene in the opening episode of the opening season. Who among us can forget it? Four boys in a basement playing *Dungeons & Dragons*. The game was part storytelling and part participation. Mike Wheeler devises a "campaign," inviting his friends to add to the story and join him in this fascinating make-believe adventure. And from those opening moments, we were hooked.

For me, the adventure began even earlier—in an office in Los Angeles, where I first read the magnificent pilot script. The Duffer brothers had written it as they had done most things up to that point: together and with a shared creative hive-mind, while the world wasn't paying attention. Their script was quite possibly the best one I'd ever read: propulsive and rich in both plot and character as few screenplays ever are.

What they wrote was essentially another form of that *Dungeons & Dragons* campaign: A flight of fiction that had daring and friendship and surprises and emotion, a story that was as much narrative as it was a call to action. Like a game of *D&D*, *Stranger Things* combines pre-planned ideas and inspired invention on the fly, a story that invites engaged participation from those who experience it. Like Mike Wheeler and his A.V. Club friends, Matt and Ross Duffer bring to their storytelling a boyish and delightfully nerdy enthusiasm as well as a sincere love for movies and stories and for the possibility of the unexpected and unexplained. Our show is an anthem for the marginalized and imperfect, precisely because the Duffer brothers know from experience that the popular and easy road is rarely the most interesting

CREDITS

THIS BOOK WAS PRODUCED BY

 MELCHER MEDIA

124 West 13th Street • New York, NY 10011 • melcher.com

FOUNDER, CEO: Charles Melcher
PRESIDENT, CRO: Julia Hawkins
VP, COO: Bonnie Eldon
EXECUTIVE EDITOR: Lauren Nathan

SENIOR EDITOR: Christopher Steighner
EDITOR: Megan Worman
PRODUCTION DIRECTOR: Susan Lynch
ASSISTANT EDITOR: Renée Bollier

Melcher Media gratefully acknowledges the following for their contributions: Chika Azuma, Jess Bass, Matt Caracappa, Keith Clayton, Natalie Danford, Arnell Davis, Ellen Deng, Paul Dichter, Sharon Ettinger, Shannon Fanuko, Hannah Flicker, Rand Geiger, Denise Gregarek, Dave Kang, Pinch Lee, Elena Magula, Michael Maher, Karolina Manko, Anya Markowitz, Emma McIntosh, Jennifer Milne, Erin Mumy, Morgan Paget, Amy Parris, Iain Paterson, Avery Quigley, Josh Raab, Jess Richardson, Elizabeth Schaefer, Erich Schoeneweiss, Scott Shannon, Gabrielle Sirkin, Victoria Spencer, Nadia Tahoun, Brittany Whiteford, Jennie Wilkes, Katy Yudin, and Gabe Zetter.

one, and that character, grit, connection, and soul are bred in the same moments that challenge us most.

Also like those boys in that Wheeler basement, the Duffer brothers—and those of us lucky enough to help them put together this show—have the thrill of making up a story as we go along. Unlike other shows that lay out detailed story lines in advance and then execute them, Matt and Ross draw their narrative road map in pencil, not pen; they remain constantly open to the exciting possibility of surprise. Whether it's an illuminating performance by an actor or the sudden arrival of a new and provocative idea, the Duffers have the fantastic audacity to throw out the plan when a fresher one excites them more. This keeps our show vital, organic, and constantly alive to unexpected moments of inspiration.

What's especially astonishing about *Stranger Things* is the way it has connected with fans around the world. Like that game of *D&D*, *Stranger Things* asks its audience to jump in, to participate in an active and passionate way with the narrative we are creating. Our fans have joined us in the campaign, responding to our characters and story with their own contributions. Whether it be elaborate theories shared on social media (sometimes prescient, sometimes far-fetched, but always entertaining) or fan art inspired by and inspiring to our work on the show, *Stranger Things* has touched its viewers in such uniquely emotional ways.

It's that collaborative experience—of both entertaining and connecting—that has made this crazy ride so memorable for all of us involved—the people crafting these stories behind the scenes as well as the actors on the screen bringing them to life. Then there are the millions of people everywhere who have done more than sit back and watch—they've joined us. Like Dustin, Lucas, Mike, and Will in that opening scene, *Stranger Things* fans—those of you who have taken the time to read this book—have jumped in and interacted with our show in such a passionate way, and with a ferocity of feeling that we never take for granted and will never forget.